December 1977

To Constance.

who I Nee a good line
all the Time.
:
Drawings too

Paul Cummings

American Drawings The 20th Century

American

A Studio Book

Drawings
The 20th Century

Paul Cummings

The Viking Press · New York

First published in 1976 by The Viking Press
625 Madison Avenue, New York, N.Y. 10022

Published simultaneously in Canada by
The Macmillan Company of Canada Limited
Printed in the United States of America

Library of Congress Cataloging in Publication Data
Cummings, Paul.
 American drawings.: the 20th century.
 (A Studio book)
 Bibliography: p.
 Includes index.
 1. Drawings, American. 2. Artists—United States.
I. Title.
NC108.C85 741.9'73 76-21729
ISBN 0-670-11784-6

Acknowledgments

To the artists, their dealers and representatives, the collectors, and the staff members of so many museums, my gratitude for replying to letters, endless telephone calls, offering productive suggestions, and most of all for supplying the many photographs from which the illustrations in this book were selected. These and many others have helped to increase my knowledge of drawings immensely, and any shortcomings in the book are quite my own.

Mohamed Abdel–Wahab of the Brooks Memorial Gallery; Mr. L. H. Aricson; Mrs. Sally Avery; Mrs. Betty Bailey of the Pennsylvania Academy of the Fine Arts; Amy Baker; The Baltimore Museum of Art; Thomas Beckman of the Milwaukee Art Center; Bertrand Bell; Richard Bellamy; Mrs. Robert M. Benjamin; Thomas Hart Benton; Charles Biederman; Flora H. Bloedel of the Williams College Museum of Art; Dorothey B. Bodger of the Toledo Museum of Art; Ilya Bolotowsky; The Grace Borgenicht Gallery; D. S. Brooke of the Currier Gallery of Art; Mrs. Betty Bowen of the Seattle Museum of Art; Jeffrey R. Brown of the Indianapolis Museum of Art; Mrs. Sally Guy Brown of the Corcoran Gallery of Art; Mrs. W. Glenn Bullock of the Dulin Gallery of Art; Frances Bunn of the Baltimore Museum of Art; William J. Burback of the Albright-Knox Art Gallery; Joseph G. Butler of the Butler Institute of American Art; Miss Doris Bry; Mrs. X. K. Cage of the Cooper-Hewitt Museum; Leo Castelli; Charles Cathey of the Museum of Art, Carnegie Institute; K. A. Christenson of the Flint Museum of Arts; Christo; Donald Clausing of the Smith College Museum; John Clancy of the Rehn Gallery; Robert Cohen of the Minneapolis Institute of Art; Mrs. Will Connelly; Bruce Conner; Miss Euphemia Conner of the Des Moines Art Center; Nada C. Conway of the Krannert Art Museum; Cordier and Ekstrom, Inc.; Beverly Crofoot of the Hopkins Center Art Galleries; Linda Crocker of the Corcoran Gallery of Art; Robert Dain; David Daniels; Nassos Daphnis; Mrs. Stuart Davis; Mrs. Terry Davis; Tibor de Nagy Gallery; Mrs. Seth Dennis of E. Weyhe, Inc.; Violette de Mazia of the Barnes Foundation; Terry Dintenfass, Inc.; Albert G. Dixon, Jr., of Mills College; Donald Droll of Fourcade, Droll, Inc.; Janet Dreiling of the William Rockhill Nelson Gallery; Edward H. Dwight of the Munson-Williams-Proctor Institute; Miss Pat Eargle of the Chapellier Galleries; Bruce H. Evans of the Dayton Art Institute; Richard S. Field of the Davison Art Center; Lucille and Walter Fillin; Mrs. Bella Fishko of the Forum Gallery; Lawrence Fleischman of Kennedy Galleries, Inc.; Janet A. Flint of the National Collection of Fine Arts; The Fogg Museum, Harvard University; Suzanne Foley of the San Francisco Museum of Art; Jerome Foreman; William Foster of the Portland Art Museum; Rita and Daniel Fraad; Mrs. Heidi Freiberger-Colsman; Claire Frierson of the Yale University Art Gallery; Allen Frumkin Gallery; Mariol Gallichio; Adelheid M. Gealt of the Indiana University Art Museum; Norman A. Geske of the Sheldon Memorial Art Gallery; Mrs. Fritz Glarner; Mrs. Sophie Goldberg; Noah Goldowsky; Joseph R. Goldyne; Manuel E. Gonzalez; James Goodman; Robert Graham of the Graham Galleries; Ellen Grand; Ernest L. Graubner of the University of Southern Illinois Gallery; Harry Greaver of the Kalamazoo Institute of the Arts; Richard N. Gregg of the Allentown Art Museum; Harold Hart of the Martha Jackson Gallery; Peter H. Hassrick of the Amon Carter Museum of Western Art; John Davis Hatch; Mrs. Patricia Heikenen of the Minnesota Museum of Art; Charles Helsell of the University Gallery of the University of Minnesota; Ben Heller; Robert Henning, Jr., of the Memorial Art Gallery of the University of Rochester; Therese Heyman of the Oakland Museum; Nancy Hoffman Gallery; Mrs. A. James Holly of the Joslyn Art Museum; Hom Gallery; Henry T. Hopkins of the Fort Worth Art Center Museum; Robert Indiana; Edward Jacobson; Sidney Janis; Connie Jesse of the High Museum of Art; Jim M. Jordan; Marilyn Kawan of the Andrew Dickson White Museum of Art; D. C. Kelly of the library of the Boston Athenaeum; Janet Kennedy of Vassar College; Mrs. Peggy Jo D. Kirby of the North Carolina Museum of Art; Jean Kondo of the Allen Memorial Art Museum; The Jill Kornblee Gallery; Katheryn Kortheuer of the Mint Museum of Art; Miss Antoinett Kraushaar; Carlo M. Lamagna of the DeCordova Museum; Mrs. Cecily Langdale of Hirschl and Adler Galleries; Jo Leadingham of the Art Gallery, University of Kentucky; Ellen W. Lee of the Indianapolis Museum of Art; Mrs. Gwen Lerner of the Walker Art Center; Miss Peggy Lipton; Mrs. Vera List; Mrs. Ruth Lloyd; Anne Lockhart of the Cleveland Museum of Art; Paul Love of the Kresge Art Center Gallery; Paul Magriel; Stephen Mazo; Garnett McCoy of the Archives of American Art; Donald McKinney of Marlborough Galleries, Inc., New York; The Metropolitan Museum of Art; The Midtown Galleries; Miss Jo Miller of the Brooklyn Museum; Mr. Robert Millonzi; Robert Motherwell; Dale J. Munday of the California Palace of the Legion of Honor; The Museum of Modern Art; Marilyn B. Myers of the Oklahoma Art Center; Pinkney Near of the Virginia Museum of Fine Arts; John Hallmark Neff of the Sterling and Francine Clark Art Institute; Bonnie Newman of the Grunwald Graphic Arts Foundation; The Lee Nordness Gallery; Claes Oldenburg; Sahny Olenikov; Nathan Oliveira; Dr. R. W. D. Ozenaar of the Rijksmuseum Kröller-Müller; The Pace Gallery, New York; Addison Frankin Page of the J. B. Speed Art Museum; Mrs. John Kyn Paris of the Columbus Gallery of Fine Arts; The Betty Parsons Gallery; Martin E. Petersen of the Fine Arts Gallery of San Diego; Mrs. Lee Krasner Pollock; The Poindexter Gallery; Deborah Remington; Stephen L. Rhodes of the Blanden Art Gallery; Mrs. Judith Richardson of the Sonnabend Gallery; Meshulam Rikles; Margaret Ringo of the Contemporary Arts Center; Mrs. Mary Riordan of Cranbrook Academy; Mrs. Wahneta T. Robinson of the Long Beach Museum of Art; Merrill C. Rueppel of the Dallas Museum of Fine Arts; Ludwig Sander; Francis Sanguinetti of the Utah Museum of Fine Arts; Mrs. Winthrop Sargeant; Charles H. Sawyer of the University of Michigan Museum of Art; Robert Schoelkopf Gallery; Mr. and Mrs. Robert C. Scull; Schweitzer Gallery; Miss Ellen Sharp of the Detroit Institute of Arts; Lewis A. Shepard of Amherst College; The Shepherd Gallery; The John Sloan Trust, Delaware Art Museum; Mr. and Mrs. Richard Solomon; Staempfli Gallery; Miss Linda Stewart; Dr. and Mrs. George D. Stoddard; Allan Stone Galleries; The Toledo Museum of Art; Mrs. Pat Trenton of the Denver Art Museum; James E. Tucker of the Weatherspoon Art Gallery; The University Museum, Berkeley; Mr. and Mrs. Maurice Vanderwoude; Joan Washburn Gallery; Murray Wax; John Weber Gallery; Michael J. Wentworth of the Rose Art Museum; Richard V. West of The Bowdoin College Museum of Art; The Willard Gallery; John M. Wisdom of the William Hayes Ackland Memorial Art Center; Miss C. Wistar of the Philadelphia Museum of Art; Miss Francie Woltz and Mrs. Lawrence McCabe of the Joseph H. Hirshhorn Museum and Sculpture Garden; Mrs. Jane Wyeth of Sotheby Parke-Bernet, Inc.; Jack Youngerman; The Virginia Zabriskie Gallery; William Zierler Gallery.

To
Teri C. McLuhan

Contents

Introduction

At the turn of the twentieth century American taste and style were set primarily by European standards, as had been the case throughout the nineteenth century. American art students traveled to Paris to study with the academic painters Gérôme, Carolus-Duran, Cabanel, Lefebvre, and Bouguereau or at the Académies Colarossi, Moderne, and Julien. Munich, with its artists Piloty, Dietz, and Leibl, and Rome also attracted students, but French art—Barbizon painting in particular—was still an important force in American painting.

So Paris was the first choice, and it was to that city that artists as different in approach as Kenyon Cox, Thomas Dewing, John Singer Sargent, and Leon Kroll traveled to study. Robert Henri, who later emerged as one of the progressive twentieth-century teachers, visited Paris to complete his studies at the Académie Julien and the Ecole des Beaux-Arts.

The two major art schools in this country in 1900 were the Art Students League in New York, then twenty-five years old, and the Pennsylvania Academy of the Fine Arts in Philadelphia. The faculty of the League included H. Siddons Mowbray, George DeForest Brush, J. Alden Weir, J. Carroll Beckwith, Frank V. Dumond (who taught from 1892 intermittently to 1951), Kenyon Cox, and William Merritt Chase, all of whom had studied in European academies with representatives of mid-nineteenth-century French academic art and brought those attitudes and theories to the twentieth century. At the Academy in Philadelphia the leading teacher was Cecilia Beaux. Henry McCarter, an American impressionist, also taught there, along with Arthur B. Carles, who brought a contemporary modernist concept influenced by the Fauvists in Paris to his classes during his few years there, and who represented a transition from the still prevalent attitude of the academies that portrait painting was an artist's major occupation. Carles was, however, a great exception to the rule. Tastemakers such as Joseph Duveen and Bernard Berenson were helping to create in America a market for Italian painting and English portraiture; their influence would provide a stimulus for many younger painters of academic persuasion.

Mural painting at the turn of this century competed with portrait work for the artist's time. Murals had been revived to decorate with didactic, moralistic illustrations the many state capitols then being built. Edwin Blashfield, whose "Plea for Municipal Art," an essay addressed to mural artists that would set the standards for the Federal Art Programs inaugurated in the early 1930s, could be considered the father of municipal art in this country. Other noted muralists were Kenyon Cox, Abbott Thayer, and John LaFarge, who revitalized religious subject matter in public art, and Will H. Low and E. A. Abbey, who were also well known as illustrators. Most of these men programmatically looked to ancient Greece and Italy for inspiration in their

subject matter, and also adapted their styles from medieval or early Renaissance painting and sculpture. Behind much of their activity was the idea that the artist was a craftsman who would respond to a patron's demands with portraits, mural decorations, book illustrations, or whatever was called for at the moment. Most of them were successful artists with little awareness of or interest in the developments of the European avant-garde.

The illustrators Will Low, E. A. Abbey, N. C. Wyeth, Charles Dana Gibson, Frederic Remington, J. C. Leyendecker, and Howard Chandler Christy were important influences on the thinking of such widely differing young artists as Rockwell Kent and Mark Tobey. Their drawings shared a common style—the use of bold slanting lines and highly contrasted lights and darks that could easily translate into newspaper and magazine printing processes. For the large number of young artists who came from small towns, the illustrated weeklies, *Century, Harper's,* and *Scribner's,* often were their first view of art.

Whatever the particular style or direction of the teachers, the standard fare for students was drawing from plaster casts usually of classical Greek or Renaissance figures. Charcoal drawings were to be carefully made and finished with the aid of a stump—a tightly rolled pencil-shaped piece of paper. The surface was a variety of darks and lights held together in a continuous surface of grays. Once a student had developed skills in the drawing of plaster casts, he was given permission to move into life class, where he was encouraged to emulate the style of the instructor. The young artist was advised to stick close to tradition rather than to attempt individual expression.

Reacting against this rigorous academic regimen were a group of older artists who had received this training themselves. John Sloan, William Glackens, George Luks, Everett Shinn, and Robert Henri were a group of newspaper illustrators who rejected the accepted subject matter and attempted to make art relevant to everyday life. These members of the Eight (as they called themselves) or the Ashcan School (as they were called in the press) tried to relax the rigid academic standards by painting in a looser style and using as their subjects realistic views of the city and its people.

In spite of these important traditions of mural painting and illustration, however, Europe still remained the focal point for young artists, and most students who could afford to go there made extended visits to study at established academies or studios.

Two visitors to Europe in 1900 were Kenneth Hayes Miller and the photographer Edward Steichen; Miller was never to become interested in contemporary avant-garde art, but Steichen was stimulated by it throughout his life. During the next few years Walt Kuhn, Bernard Karfiol, Maurice Sterne, and the entire William Merritt Chase class from the League, in which Charles Sheeler and Charles Demuth were students, went abroad. Max Weber, John Marin, A. B. Carles, and Morgan Russell went abroad in 1905, and soon to follow them were Abraham Walkowitz and Patrick Henry Bruce, who became a student of Matisse; Arthur Dove, Charles Demuth, Marguerite Thompson Zorach, and Stanton Macdonald-Wright left for extended stays in Europe in 1907. In 1913 Macdonald-Wright and Morgan Russell founded synchromism, the first modern movement originated by American artists to have impact abroad. Other artists visiting pre-World War I Europe were Thomas Hart Benton, Andrew Dasburg, William Zorach, Preston

Dickinson, and John Storrs. Marsden Hartley spent 1912–1913 abroad, partly in Germany where he encountered the expressionism and abstractions of Franz Marc and Kandinsky. The modern movements current in Europe, such as fauvism and cubism, were known to many of the American artists who traveled there from 1905 on. Cubism undoubtedly made the deepest impression, but after a brief investigation of modernism most Americans rejected it in favor of more conservative modes of working, though this was partly because patronage, social acceptance, and an enlightened critical response to advanced contemporary art in the United States were almost nonexistent.

In December 1911 the founding of the Association of American Painters and Sculptors was to lead to the most publicized exhibition in the history of American art. The Armory Show was organized with the avowed purpose of "holding exhibitions of the best contemporary work that can be secured, representative of American and foreign art." Arthur B. Davies, after seeing the catalogue of the 1912 Cologne Sonderbund exhibition, wanted to make the work in it the core of the new show. Walt Kuhn was elected to visit Cologne to make selections, and from there he traveled to The Hague, Munich, Berlin, and Paris. Together with Davies he visited Roger Fry's "Second Post-Impressionist Exhibition" at the Grafton Gallery in London. Finally, in February 1913, the exhibition opened in New York (it would be seen later in Chicago and Boston), and without question it provided the most representative selection of modern European art ever seen in America.

The Armory Show served to emphasize that Europe, especially Paris, was the artistic center of the Western world, and the show opened up a new market in America for works of the modernist School of Paris. The traditional academic work of the American painters suffered badly by comparison. Even the exhibition's great promoter, Frederick James Gregg, reviewed the American section of the show as a case of "arrested development." European styles such as cubism or fauvism seem to have been only partially absorbed and rarely with success, as in the paintings of Arthur B. Davies and younger artists such as Konrad Cramer, Andrew Dasburg, Lorser Feitelson, and Henry McFee. Although they continued to explore the cubist principles after the show's end, they were too removed from the sources of the movement for it to have a continuing effect. The Americans who best understood cubism were Stuart Davis, Charles Demuth, and Charles Sheeler.

The concentrated array of modernism at the Armory Show induced a cultural shock, but it failed to engage the young generation of American artists, and for the next three decades no major art movement developed in America. Dada, surrealism, neoplasticism, and other movements flourished abroad, but the only original contribution of Americans—the movement called regionalism—would not emerge until the late 1920s and 1930s. (One of the reasons for the lack of inventive stylistic development here may be that cubism and other major movements in Europe almost always developed out of a great mass of exploratory drawings. Drawing had long been held in low esteem in this country—treated as an activity for students but not an exercise to be maintained in an artist's mature years. Had the Armory Show been its touted success as a stimulus to modernist art concepts, it would not have required two generations for American art to emerge on the international scene.)

Innovative art by Americans during the 1920s received very meager support from the established art community and consequently few young artists were attracted to it. Stieglitz continued his support of the few chosen to be represented by his gallery, and Charles Daniels, the Montross Gallery, and the Rehn Gallery showed some of the newer artists. But there were few collectors interested in these artists, and few museums were willing to venture their approval. Nevertheless, there were some artists committed to finding new means of expression: Marsden Hartley, Stuart Davis, Arthur Dove, Joseph Stella, Charles Sheeler, and a few others struggled to maintain their individualism, but it was Paris, not America, that offered them lively inspiration. Writers and artists flocked to enjoy the City of Lights while New York countered with Prohibition and the traditional views of Eugene Speicher, Paul Manship, Gutzon Borglum, and K. H. Miller. For those interested in modernism who stayed home, there were little magazines published both here and abroad which provided access to new ideas. Christian Zervos's *Cahiers d'Art,* for one, later became one of the important publications from Europe to keep the modern spirit alive in America.

Some public attention had, however, been paid to the new art being produced in Europe. In 1918 the Phillips Memorial Gallery in Washington, D.C., became the first museum devoted to advanced contemporary art. Two years later Katherine S. Dreier, Marcel Duchamp, and Man Ray founded the Société Anonyme for the specific purpose of "the promotion of the study in America of the Progressive in art." They presented in America, for the first time, works by Schwitters, Campendonck, Klee, Malevitch, Miró, Baumeister, Vantongerloo, and many others. The Société arranged many important one-man exhibitions here, among which were, in 1922, Archipenko and Villon; 1923, Kandinsky; 1924, Klee; and in 1925, Léger. In 1941 the collection formed by them was placed at Yale University. At the Brooklyn Museum, in 1926, the Société presented what was probably the most important exhibition of modern art in America since the Armory Show. In that same year Willem de Kooning arrived here.

The following year, 1927, the Gallatin Cubist Collection, later called the Gallery of Living Art, was established in the New York University Library in Washington Square, where it remained until 1942 when it was transferred to the Philadelphia Museum. Over the years many artists visited this changing exhibition, which included works by Picasso, Braque, Léger, Mondrian, and others. During the 1930s it served as a source of reassurance and support to the growing number of artists committed to abstract painting. The Museum of Modern Art opened in New York in 1929, roughly formulated upon the broad arts-and-crafts concepts of the Bauhaus. This museum was to become the world's foremost institution for the presentation of modern art from the Impressionists onward.

Even the minimal attention given to American avant-garde art during the 1920s and 1930s continued to be decried by the artists who matured during those years. But these same people recognized the importance of the numerous exhibitions of works by Picasso, Matisse, and Bonnard, as well as the cubist, dada, and surrealist shows held in New York during that time. The Whitney Museum of American Art continued its presentation of American art much as it had done when it began in 1908 as the Whitney Studio Gallery. While it was always hospitable to current American art movements, the Whitney has never managed to exert the influence of the Museum of Modern Art.

With the same desire to find a new fulfillment in life that brought others here, many artists began to emigrate to America and by the 1920s this influx became an important addition to our cultural life.[1] Almost all of these have spent the major portion of their lives here working or teaching and have become major contributors to our artistic heritage.

Travel abroad still remained important to the young artists, and Hans Hofmann's studio was a particular attraction. Carl Holty studied with Hofmann from 1925 to 1926, Ludwig Sander in 1927; as late as 1931, Louise Nevelson studied with him briefly in Munich. In 1930 Hans Hofmann came to the United States to teach at the University of California at Berkeley, and by 1932 he was at the Art Students League; the following year he founded his own school in New York. In the summer of 1934 he opened a summer school in Provincetown and continued to teach until he retired in 1958 to paint full time. Among Hofmann's students after World War II were such artists as Helen Frankenthaler, Larry Rivers, Richard Stankiewicz, Nicholas Krushenick, and Allan Kaprow.

The economic collapse of 1929 brought home the Lost Generation, and increasing political unrest in Europe toward the end of the 1930s attracted many European artists, scientists, and intellectuals to America. Also in the 1930s arrived the Mexican mural painters Rivera, Orozco and Siqueiros, whose populist subject matter was to influence many of the mural projects developed under the Federal Arts programs. These three artists represented revolutionary ideas, and because they were colorful personalities they were quickly promoted by the press. Their primary appeal was to the younger generation rather than to establishment artists such as John Sloan, Walt Kuhn, or K. H. Miller. During this same period the Miller students, including Raphael Soyer, Alexander Brook, and Yasuo Kuniyoshi, began to exhibit on a regular basis and to develop a considerable following. Picasso and Matisse remained heroes for the younger abstract artists, and toward the mid-1930s Mondrian was, for a few, another stimulating influence.

The close of the 1930s, with the war's onrush, brought more established European artists to this country. Amédée Ozenfant arrived here in 1938 and established a school which remained active for many years. Yves Tanguy, half of whose painting career was spent here, arrived in 1939, as did Matta. Max Ernst and Ossip Zadkine arrived in 1941. Marc Chagall was here from 1941 to 1947, and Piet Mondrian spent the last four years of his life in New York City. Léger lived in New York and Connecticut from 1940 to 1945. André Breton remained in New York during the war, still committed to surrealism. The continuing dichotomy of American art life can be demonstrated by publication in the late 1930s of two books as different as John Sloan's *Gist of Art* and John D. Graham's *System and Dialectics of Art*. The two books were to stand

1. First among this group were Joseph Stella, who arrived in 1896; Lucian Labaudt, 1906; Saul Baizerman, 1910; in 1912, Ernest Fiene, Leon Hartl, and Emil Ganso; 1914, Elie Nadelman; 1915, Marcel Duchamp; 1920, Eugene Cavallon, John D. Graham, and Arshile Gorky; 1921, Chaim Gross; 1922, David Burliuk; 1923, Ilya Bolotowsky, Louis Bosa, Nicolai Cikovsky, and Alexander Archipenko; 1924, Hans Burkhardt and Rico Lebrun; 1926, Willem de Kooning and Frederick Kiesler; 1929, Alfonso Ossorio and Jose DeCreeft; 1930, Harry Bertoia, Nassos Daphnis, Werner Drewes; 1932, George Grosz and Hans Hofmann; 1933, Josef Albers; 1934, Morris Kantor, Enrico Donati, Dali, and Tchelitchew; 1935, Eugene Berman; 1936, Esteban Vicente and Fritz Glarner; 1937, Laszlo Moholy-Nagy; 1938, Herbert Bayer and Karl Scharg; 1939, Kurt Seligmann and Yves Tanguy; 1940, Piet Mondrian and Constantino Nivola; 1941, Richard Lindner and Jacques Lipchitz; 1942, Saul Steinberg; 1943, Adja Yunkers and Mauricio Lasansky; 1946, Len Lye, Antonio Fransconi, and Naum Gabo; 1950, Kenzo Okada; and in the 1960s, Arman, Christo, and Arakawa.

representative of the past and the future. One manifestation of the increased interest in abstract art was the founding of the American Abstract Artists in 1936.

The war brought an end to the Federal Art programs. Artists either became associated with the war effort as "war artist reporters," or remained in their studios while engaged in factory work or other war-related activities. Peggy Guggenheim's Art of This Century, a gallery designed by Frederick Kiesler, provided a stimulating atmosphere for the exposition of new ideas, and the exhibition of many of the European artist-residents, as well as of the adventurous young Americans, such as Jackson Pollock, Robert Motherwell, and William Baziotes. Many of the Europeans returned to Europe at the end of the war, but the gallery scene for modern art had been changed by their presence. Betty Parsons, Charles Egan, and Sam Kootz began showing the new art in their respective galleries. During the late 1940s Parsons exhibited the work of Clyfford Still, Mark Rothko, Ad Reinhardt, Hans Hofmann, and Barnett Newman. Egan gave De Kooning his first one-man show in 1948 and put on Franz Kline's important show of 1950. Julien Levy continued showing the surrealists, Arshile Gorky, and Joseph Cornell. Sidney Janis opened his gallery in 1948, exhibiting for years the newer Americans alongside modern European masters.

The postwar period offered the young artists another chance to return to the tradition of traveling to Europe subsidized by the GI Bill; later the opportunity was offered to college students through the Fulbright-Hayes Act. Léger, Zadkine, and Ozenfant operated schools in Paris that were filled with American students. The ideas formulated by artists of abstract or nonfigurative tendencies during the WPA days were in the late 1940s and early 1950s to emerge as abstract expressionism and other non-objective styles. But as few of these men were teachers, Americans chose to study in Paris where their GI Bill stipends allowed a better way of life. Among the Americans to live in Paris were Sam Francis, Norman Bluhm, Paul Jenkins, and John Hultberg. Many Fulbright students were abroad during the late 1950s and through the 1960s, when the focus of artistic attention was shifting to New York.

The 1950s saw the establishment of abstract expressionism as the first New York art movement to have an international impact. The term, while not denoting a single prevailing school or style, does associate certain individuals with related philosophical positions who nevertheless remained stylistically individualistic. Their success enabled the next generation to react against them, for they did not impose a given teacher or tradition as had the pre-1940 generations.

The opening of the Leo Castelli gallery at the end of the 1950s, and the exhibitions of Jasper Johns and Robert Rauschenberg, signaled the emergence of this generation of post-abstract expressionists. A few years later the Green Gallery of Richard Bellamy offered the work of Claes Oldenburg, Lucas Samaras, James Rosenquist, and George Segal, all draftsmen of invention and skill. Working concurrently were a group of color field painters to whom drawing was not important, at least in the development of their imagery.

The 1960s saw a proliferation of art galleries in New York and other leading cities. By the end of the decade the few dozen galleries in New York had grown to more than four hundred. This patronage encouraged the development of many individuals and the emergence of a wide

14

variety of styles, among them environments, minimal and concept art, film, video, earth art, fluxus, and new realism. An increasingly international audience for American art affected the lives of the artists, who often were as mobile as their work was varied. The magazines *Art International* and *Artforum* were influential in spreading the ideas abroad, and the increase of museum-sponsored traveling exhibitions brought the works themselves to other American cities and foreign countries within a short time of their creation. For the first time dealers in Europe and around the world began representing American artists in large numbers. The "expressionist excesses" of the late 1940s and 1950s, as many critics termed them, were rejected for a clean, bright, hard-edged application of color which ranged from neoplastic sources to many styles of figurative painting. The late 1960s and early 1970s saw the return of a conservative imagery in the evolution of the sharp-focus realists, who magnified the scale of the detailed paintings of the academic realists of a generation earlier. The new subject matter was reminiscent of the social realists of the 1930s, the decade when many of them were born. Their skillful use of a glossy, glittering adaptation of the slick commercial art of magazines applied to banal subject matter often reminds one of the huge "academic machines" of the nineteenth-century, those vast compositions produced regularly for display in the annual salons.

I have attempted in this brief introduction to offer an outline of the times in which the drawings in this book were produced and to offer a broad survey of the many concurrent tendencies progressing through the twentieth century. My hope is that this collection of drawings will serve as an impetus for the investigation of this vital expression, which is often a seminal activity in which artistic development takes place. The value of drawings in the study of an artist's major work is inestimable, yet they are also frequently significant works of art in themselves, deserving of special attention and enjoyment.

The selections for this book were made with a view to the range of work produced by the individual artists and also to reflect the wide variety of styles and tendencies in recent art. The works of each artist are presented in the order of the artist's birth; this scheme is admittedly arbitrary, but it does serve to emphasize the extraordinary complexity of artistic activity and expression of a relatively short period of time. Although there is insufficient space to include all those one might like to, nearly three hundred public museums, university collections, dealer stocks, and private holdings have been surveyed. The poverty of our public collections in terms of drawings is reflected in the attitude of Francis Henry Taylor, late director of the Metropolitan Museum of Art, who remarked that "prints and drawings are the wastebasket of the museum; it's where the paper goes." Yet, as I hope this group of drawings will show, drawing is a unique visual expression of the artist's imagination—an invaluable means by which he can explore his own psyche, his intellect, his vision of the visible and invisible world, and by which we as viewers can learn to develop a new emotional and intellectual insight into his work.

P.C.
New York City
1976

William Merritt Chase (Franklin, Ind., 1849—New York, 1916)

The most respected of American art teachers at the turn of the century, William Merritt Chase taught at the Art Students League and later at his own school as the major representative of the Munich school of painting. In this drawing Chase uses the charcoal to balance delicately a variety of textures in order to render an atmospheric effect in which the figure still remains specific. No lines are extraneous; each is deliberately used to mark an edge or to create a combination of planes.

William Merritt Chase Woman with Tambourine. 1891. Charcoal, 12¼ × 10¾. Courtesy Kennedy Galleries, Inc.

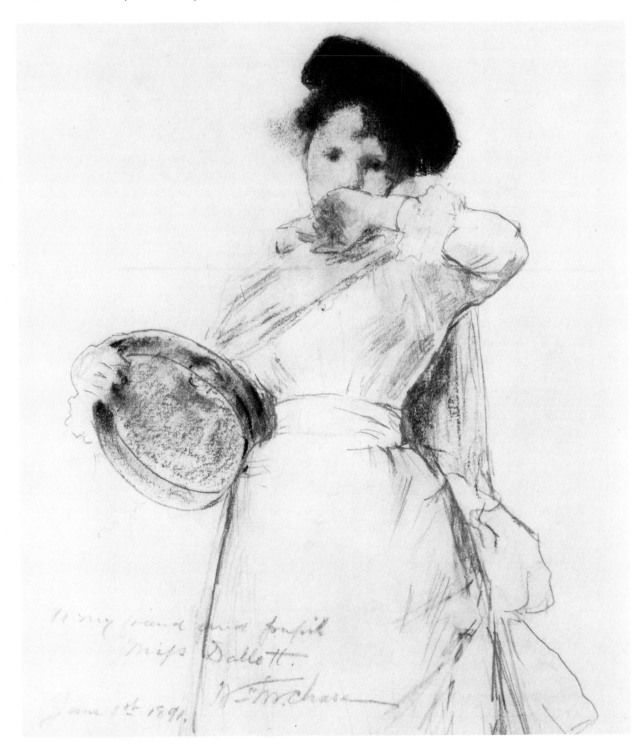

16

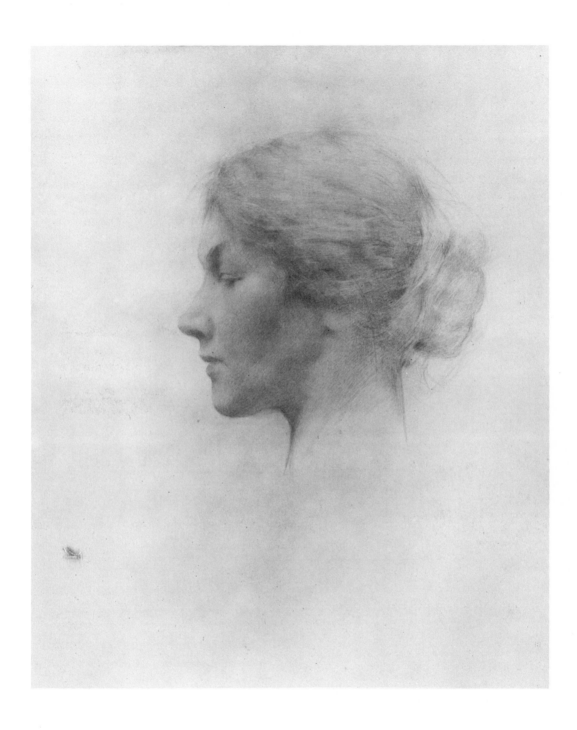

Thomas Dewing (Boston, 1851—New York, 1938)

Silverpoint is one of the most demanding drawing materials because once an artist has applied the paint to the prepared surface, it is almost impossible to change a line. Thomas Dewing's "Head of a Young Woman" demonstrates his mastery of this difficult medium, as well as his skill in capturing the personality of the subject. He has used many lightly applied lines to produce areas in shadow and to define the mass.

Thomas W. Dewing Head of a Young Woman. n.d. Silverpoint, 10 × 8. Courtesy Memorial Art Gallery of the University of Rochester. Photo by Richard Margolis.

17

John Singer Sargent (Florence, Italy, 1856—London, 1925)

John Singer Sargent's success as a society portrait painter is supported by his skill, which is nowhere more apparent than in his watercolors and drawings. This drawing of John Barrymore, who was once an art student himself, demonstrates Sargent's ability to achieve a direct likeness. The charcoal lines define the dark areas of the form while the surface of the paper itself is left white to give the impression of brilliant light. Sargent's manner is similar to that of Chase, but the effect is more controlled and less intimate.

John Singer Sargent Portrait of John Barrymore. 1923. Charcoal, 24 × 18. Courtesy The Fine Arts Gallery of San Diego.

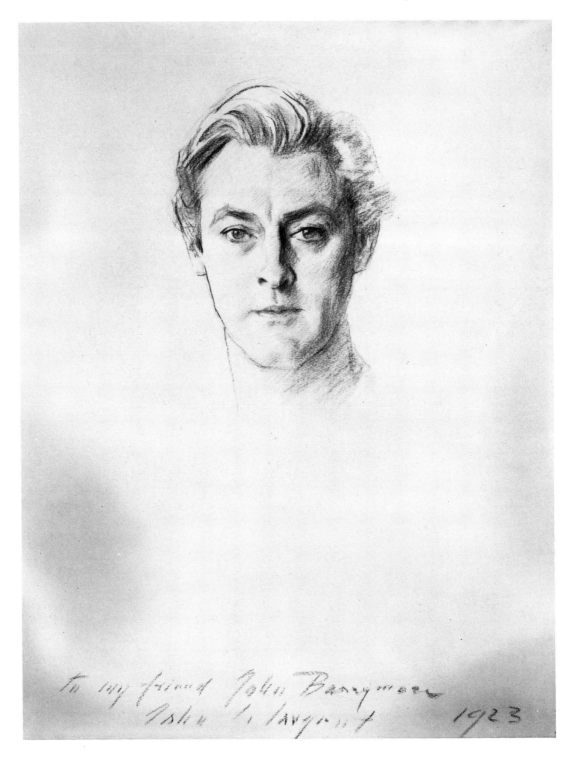

Childe Hassam (Boston, 1859—Easthampton, N.Y., 1935)

The most popular of the American impressionists (who worked in the French tradition but applied it to American subject matter), Childe Hassam in "Against the Light" has posed the problem of defining the features of a figure seated in front of a strong source of light. To enliven what is essentially a silhouette, he uses an overall pattern of bold hatching to indicate the shadow. Areas of light cross-hatching suggest the reflected light and define the features of the model.

Childe Hassam Against the Light. 1907. Pencil and white wash, 7⅝ × 5⅜. Courtesy The Art Institute of Chicago, Carter H. Harrison Collection.

In "An Easthampton Idyll" his line has become more distinctive, but his concern is still with the play of light on surfaces. The trees that frame the picture are drawn in long quiet lines, an effective contrast to the inventive assortment of dashes, hatchings, and choppy lines that make up most of the central portion of the work and give the feeling of movement to the drawing.

Childe Hassam An Easthampton Idyll. 1923. Pencil, crayon, and white wash, 9 × 7¾. Courtesy Kennedy Galleries, Inc.

Joseph Pennell (Philadelphia, 1857—Brooklyn, 1926)

Active as a writer, illustrator, reporter, and printmaker, Joseph Pennell often used drawings as studies for prints or illustrations for his writings. His documentation of monumental industrial undertakings, such as the building of the Panama Canal and various important bridges and buildings, made him one of the last artist-reporters who would soon be replaced by the ubiquitous photographer. "Building the Bridge, Minneapolis," 1915, is an example of his ability to represent great distances and complex forms with both clarity and atmospheric effect. His use of shifting lines in the water's reflection not only defines the water itself but makes for a lively presentation of an otherwise uninteresting visual scene. Pennell's interest in Whistler is apparent in his play of light on surfaces and delicate contrasts.

Joseph Pennell Building the Bridge, Minneapolis. 1915. Pencil, 21¾ × 16¾. Courtesy The William Hood Dunwoody Fund, The Minneapolis Institute of Arts.

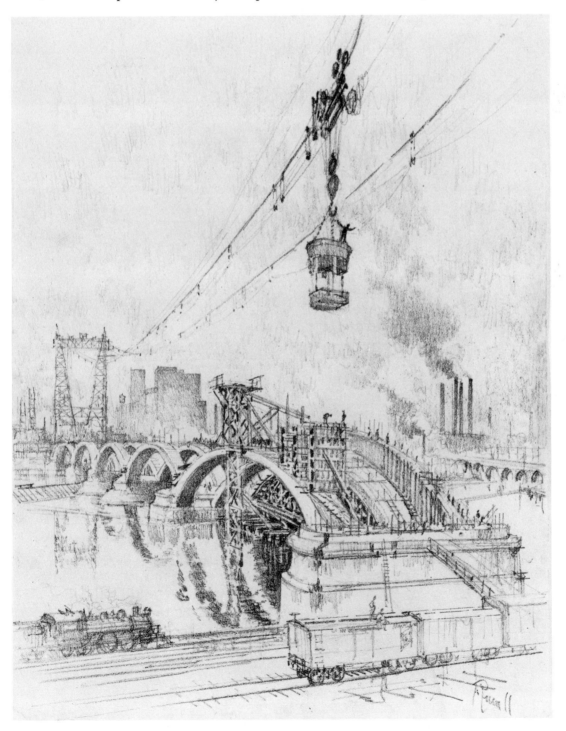

Arthur B. Davies (Utica, 1862—Florence, Italy, 1928)

It is ironic that Arthur B. Davies, a romantic visionary, should have become the prime mover in the presentation of the Armory Show, which included many works quite antithetical to his own art. His "Echoes of Hellas," a pencil drawing enriched with watercolor, shows a modern woman in classical Greek poses. Watercolor is used to produce a play of light over the figures.

In the "Reclining Nude Figure" Davies uses crayon much as he used watercolor in the earlier drawing. The outline is drawn with an even, steady line, and flat areas of tone suggest planes and depth. The passion of Davies' gentle vision is often misunderstood today, since mid-twentieth-century romanticism is increasingly less personal and more overtly erotic.

Arthur B. Davies Echos of Hellas. n.d. Pencil and water-color, 17⅞ × 23¾. Courtesy The Cleveland Museum of Art, Bequest of Lizzie P. Bliss.

Arthur B. Davies Reclining Nude Figure. 1924. Black crayon, 13¾ × 18⅛. Courtesy The Brooklyn Museum, Gift of Frank L. Babbitt.

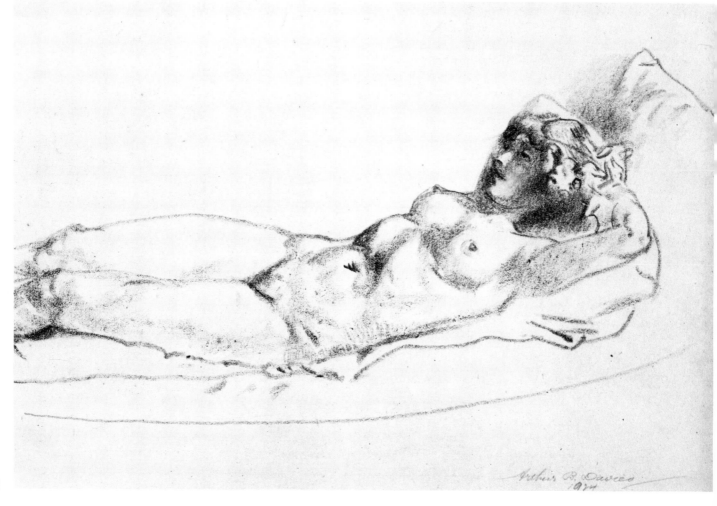

22

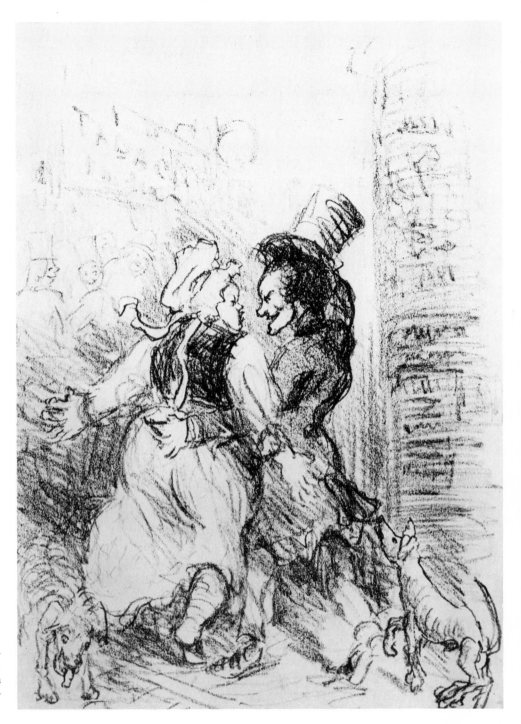

Robert Henri La Vie Bohème. Late 1890s. Pencil, 11 × 15. Courtesy The Hirshhorn Museum and Sculpture Garden, Smithsonian Institution.

Robert Henri (Cincinnati, 1865—New York, 1929)

In the last years of the nineteenth century Robert Henri, one of America's most important teachers, began to evolve a painterly style of drawing that emphasized masses rather than used outline to define form. Manet, Hals, and Velázquez remained the major influences on his work, along with that of Frank Duveneck, a realist who taught in both Cincinnati and Munich. Henri utilized Duveneck's theories in his own art school, which he founded in New York in 1909. His interest in Daumier, as well, is revealed in "La Vie Bohème," where he employs a free-flowing line coupled with a wash technique that suggests the evanescent light of Paris.

Henri's mature style, as seen in the "Spanish Lady," is characterized by high contrasts established by a slashing brush line which stresses the generalized essence of a subject without extraneous details. This broad style

23

has become almost mannered by 1918, as seen in "Monhegan Island," where the large forms are boldly drawn in charcoal, which differentiates the lights and darks.

The late work, "Head of a Girl," from 1924, drawn with a soft pencil, carries further his method of setting down the subject in broad masses. He has used a tight controlled hatching within a soft gentle line for this individualized romantic portrait. Henri's influence as a teacher was widespread and is readily apparent in the work of many of his students, such as William Glackens, George Luks, John Sloan, George Bellows, Glenn Coleman, Edward Hopper, and Rockwell Kent.

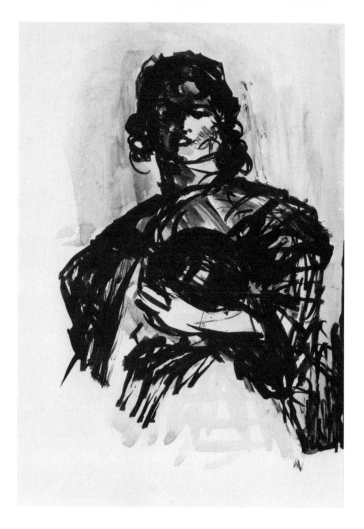

Robert Henri Spanish Lady. c. 1904. Ink, 7⅞ × 5½. Courtesy Dartmouth College Collection. ▶

Robert Henri Monhegan Island. 1918. Charcoal, 14 × 20. Courtesy Chapellier Galleries. Photo by Thomas Feist. ▼

Robert Henri Head of a Girl. 1924. Pencil, 10½ × 8. Courtesy Chapellier Galleries. Photo by Walter Russell. ▶ ▶

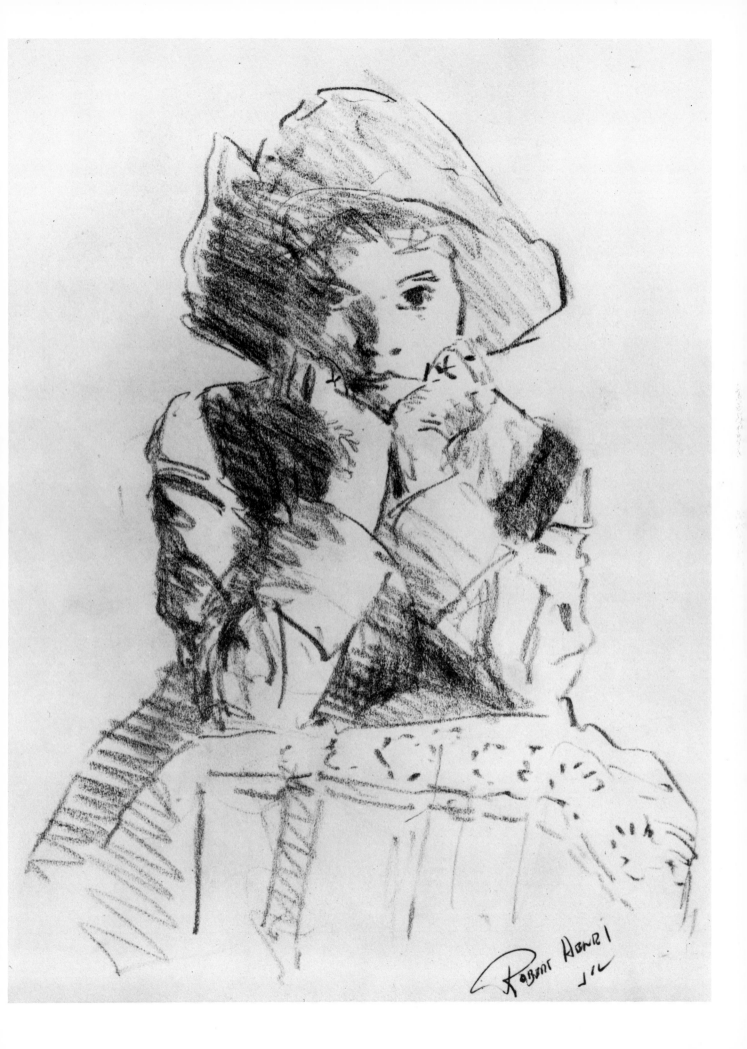

Oscar Bluemner (Hannover, Germany, 1867
—South Braintree, Mass., 1938)

Oscar Bluemner came to the United States from Germany in 1892 and worked for many years as an architect. During an extended visit to his homeland he made this drawing, "Barges on a River." An early work, it already demonstrates his mature use of wash and bland lines to develop nervous angular forms; it also manifests his interest in cubist elements in the overall design. Bluemner's later work is relatively fantastic in its subject matter, which is conveyed in a harsh expressionist style dominated by the obsessive use of red (Bluemner once even termed himself a "vermillionaire").

Oscar Bluemner Barges on a River. 1914. Ink wash, 29½ × 39¼. Courtesy Monique Knowlton-Berkeley. Photo by Helga Photo Studio, Inc.

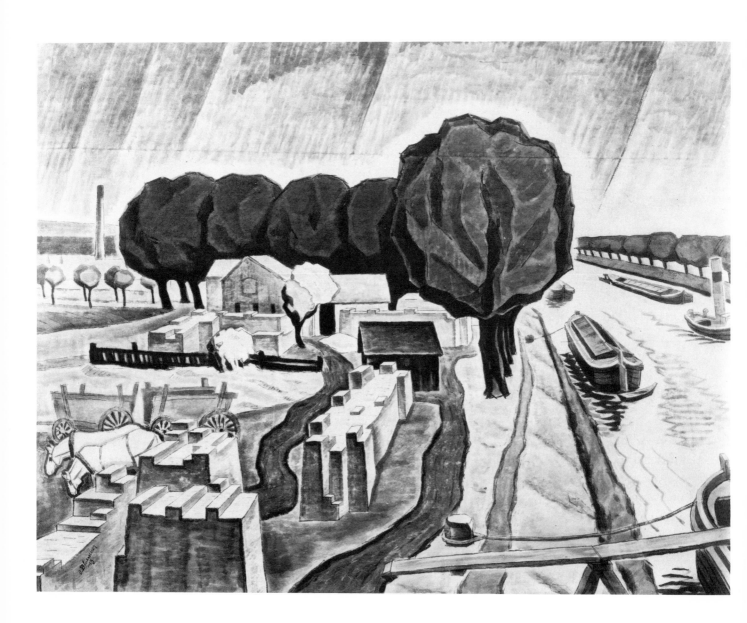

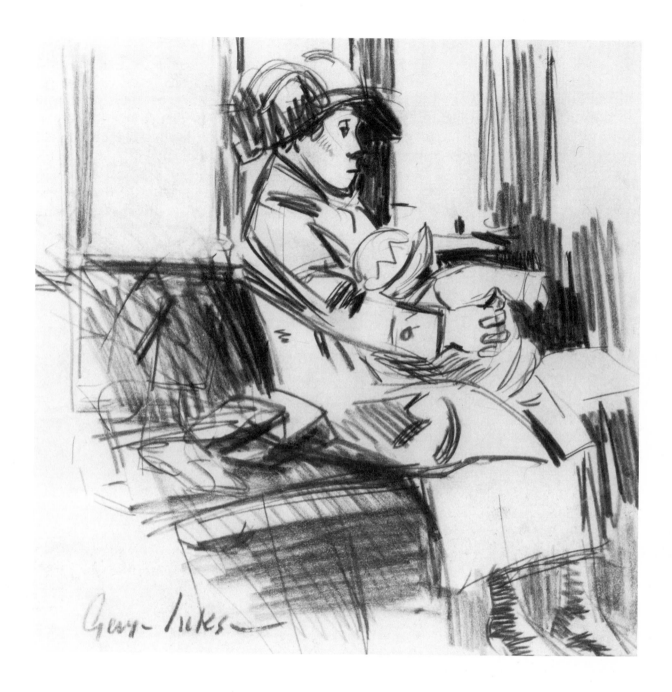

George Luks (Williamsport, Pa., 1867—New York, 1933)

George Luks's personality affected all his undertakings, but his work, surprisingly, lacked the complexity and exuberance of his character. "On the Third Avenue El," a small drawing typical of his style, shows a woman with a child on her lap, yet the brush qualities of the lines interest us more than the subject. Luks's early newspaper experience influenced his work throughout his ca-

reer, and most of his drawings could be considered illustrations rather than pictorial inventions. This drawing exemplifies the application of style to a subject without any regard for the subject's individual qualities.

George Luks On the Third Avenue El. n.d. Pencil, 8½ × 8. Courtesy The Hirshhorn Museum and Sculpture Garden, Smithsonian Institution.

John Marin (Rutherford, N.J., 1870—Cape Split, Me., 1953)

"Drawing is the path of all movement—great and small. The path made visible." So wrote John Marin in 1950 for an introduction to a portfolio of his drawings and watercolors. Even in his earliest mature work the essence of movement, speed, and action is conveyed with brittle, nervous energy. This is apparent even in the early drawing, "Untitled (Barges, Three Master, Grain Elevators)" of about 1898, which shows the influence of such popular late nineteenth-

John Marin Untitled (Barges, Three Master, Grain Elevators). c. 1898. Pen and ink, 10 × 7. Courtesy Marlborough Gallery, Inc. Photo by O. E. Nelson.

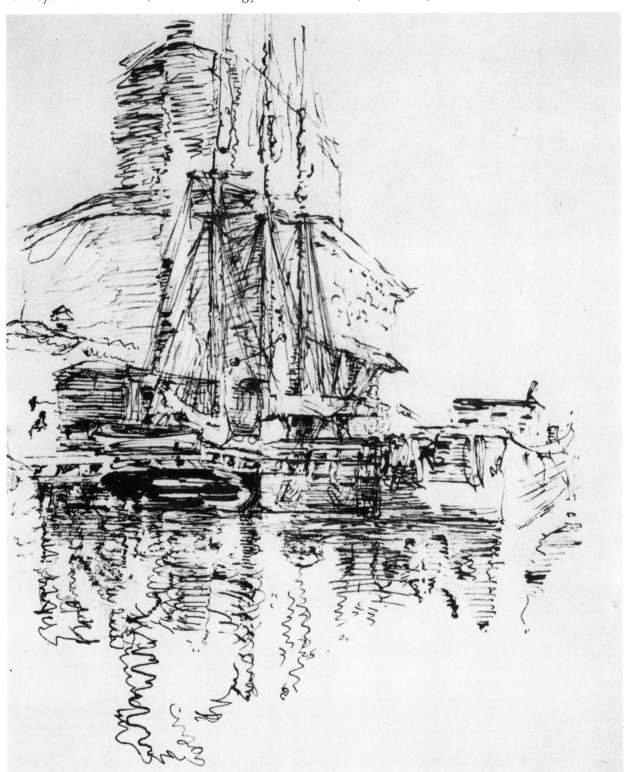

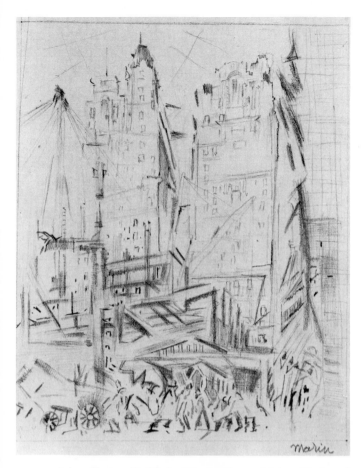

century artists as William Merritt Chase and the magazine illustrators. Early in the twentieth century Marin's form changes, becoming more angular and cubistic, yet retaining the awkwardness and brio of his earlier work. The 1924 drawing, of a construction site in lower Manhattan, is similar in concept to that of Luks's work, yet it is more modern in style, with its heavy weighted lines abstracting the objects in the picture and enlivening the picture plane. "Untitled (Machias, Maine)" is a late work and, though more relaxed, reveals the same basic approach as the one from 1924. The thick pencil line seems to search out the shapes, which are enriched by a contrasting watercolor line and wash. The conflict between abstraction and representation visible in all of Marin's work is particularly apparent in this drawing where the landscape becomes a motif for exercising the gestures of drawing.

John Marin Untitled (Construction, vicinity Woolworth Building). c. 1924. Pencil, 8½ × 6⅝. Courtesy Marlborough Gallery, Inc. Photo by O. E. Nelson. ▲

John Marin Untitled (Machias, Maine). 1951. Pencil and watercolor, 12 x 17½. Courtesy Marlborough Gallery, Inc. Photo by O. E. Nelson. ▼

William Glackens (Philadelphia, 1870—Westport, Conn., 1938)

The tradition of anecdotal subject matter is clearly apparent in this drawing of William Glackens, "Morning at Coney Island." The large crowd of people is drawn with a quick choppy line, and individual figures are treated as caricatures which reflect his years as a newspaper illustrator well known for his rapid sketches. This approach is antithetical to that of his teacher, Robert Henri, whose concept of realism was that popular subject matter was of greater importance than the quality of style.

William Glackens Morning at Coney Island. n.d. Pencil, chalk, and wash, 8 × 11½. Courtesy The Metropolitan Museum of Art, Bequest of Charles F. Iklé, 1963.

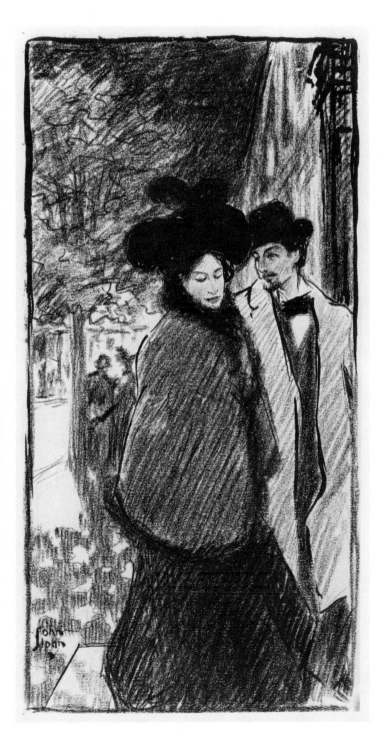

John Sloan Street Scene. 1895. Black chalk and ink, 15¾ × 7¾. Courtesy Chapellier Galleries. Photo by Walter Russell.

John Sloan (Loch Haven, Pa., 1871— Hanover, N.H., 1951)

A successful commercial artist, illustrator, and printmaker, John Sloan also taught painting at the Art Students League from 1914 to 1926, and again from 1935 to 1937. The early black-chalk-and-ink drawing, "Street Scene," was first published as an illustration for a poem in the Philadelphia paper *Gil Blas* in 1895, and was later used as a poster. The style Sloan has used here was derived from the Japanese newspaper artist Beigen Kubota, who influenced other American artists as well.

In November 1899 Sloan's friend, the painter Robert Henri, sent him copies from Paris of *Charivari*, which reproduced some of Daumier's lithographs. Sloan's drawing "Four of the Eight," which is fundamentally a cartoon, shows how Sloan was able to assimilate Daumier's surface qualities, though the insight and trenchant wit of the French artist have not been captured here. The bluff figure of George Luks dominates the scene, with Henri on the left, Maurice Prendergast on the right, and Sloan himself peering from a window.

Later Sloan discovered the flowing rhythms of Renoir and incorporated them in his own work, as in the late drawing "Helen at Sinagua," which is more individualized, more intimate, and less stylized than Sloan's paintings were at this time. Unlike his earlier drawings, there is a greater economy of line and fewer gratuitous flourishes, but there are none of the overlaid striations that can be found in other late paintings and drawings—a technique probably derived from his printmaking techniques.

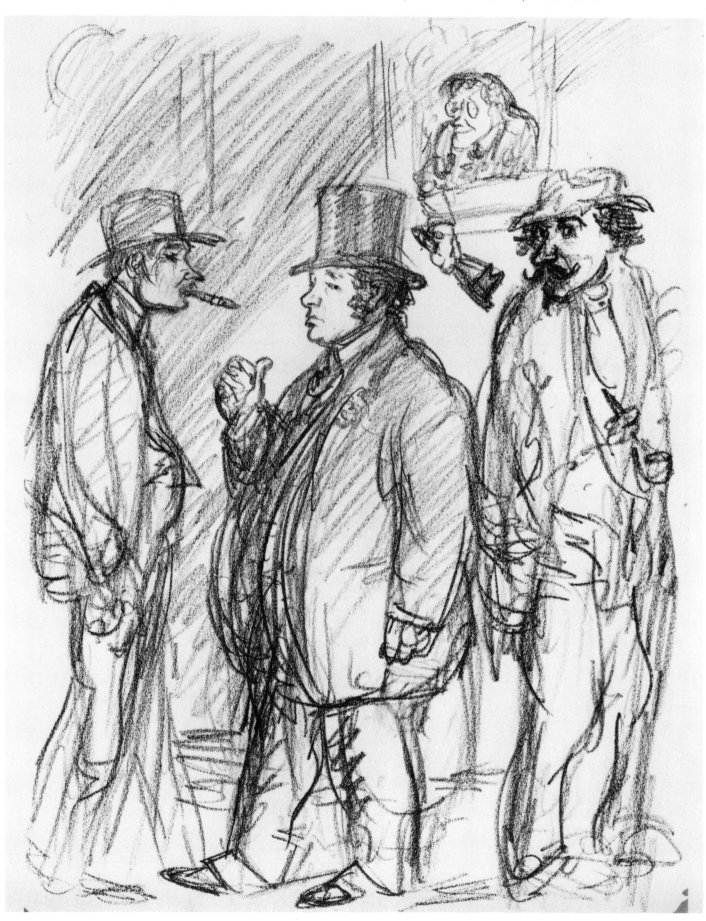

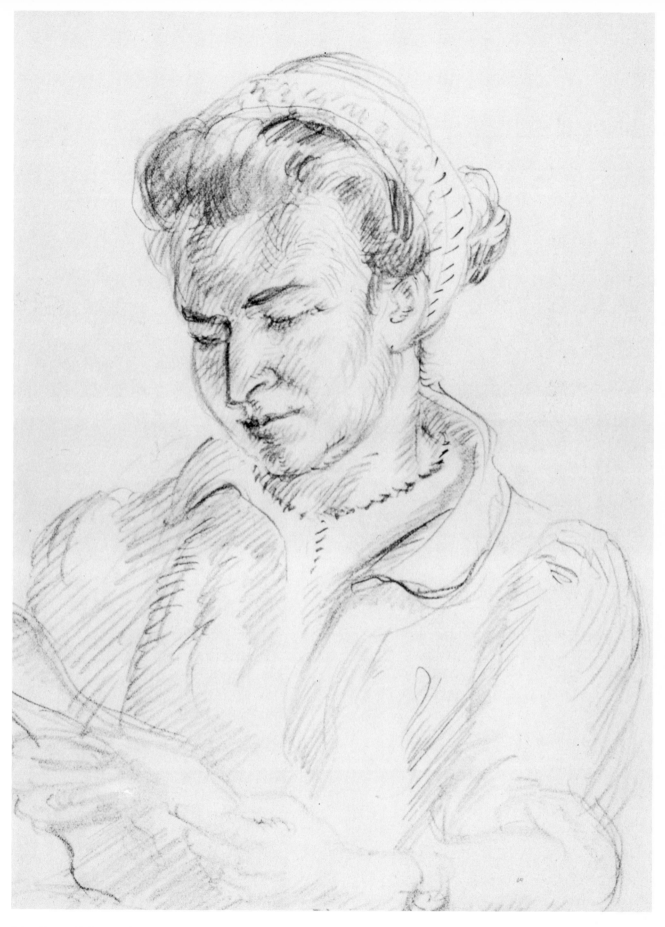

John Sloan Helen at Sinagua. 1944. Pencil, 8½ x 6. Courtesy Delaware Art Museum, John Sloan Trust. Photo by Geoffrey Clements.

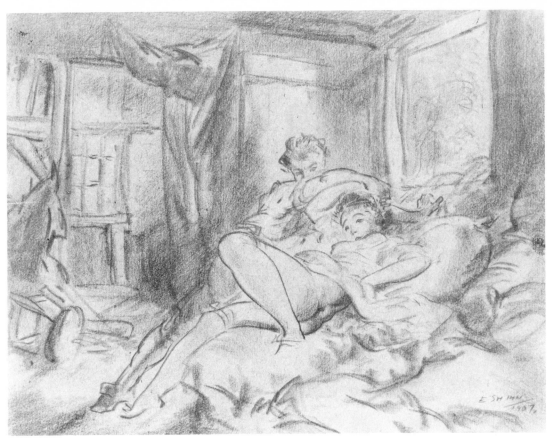

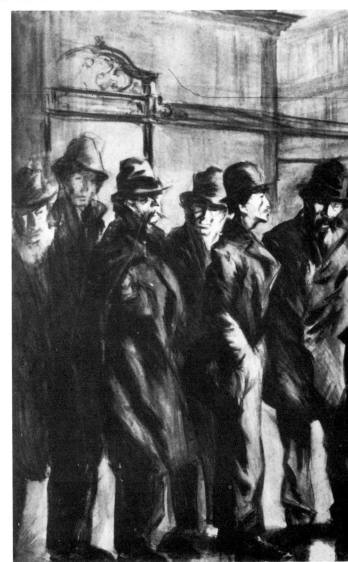

Everett Shinn (Woodstown, N.J., 1876—New York, 1953)

The multi-talented Everett Shinn, playwright, producer, illustrator, and painter, was a highly accomplished draftsman. "Two Lovers" of 1907 is a rapidly drawn illustration showing the influence of the elegant but frivolous aspects of eighteenth-century French art on the style Shinn was to use for the rest of his long career. He delighted in whimsy and, although his later drawings became somewhat mannered, the style retained an eighteenth-century flavor in spite of distinctly modern composition and point of view. In the following year, 1908, Shinn produced a wash drawing, "Out of a Job—News of the Unemployed." He brings the figures to life in much the same way as the young Edward Hopper was able to do. The individual portraits of the foreground figures effectively contrast the increasing anonymity of the group as a whole as it recedes into the background. Though Shinn's work bears stylistic affinities to the Eight, of which he was a member, he still remained very much an individual and produced some of the most thoughtful drawings of the period.

Everett Shinn Two Lovers. 1907. Charcoal, 10¾ × 14¼. Courtesy Dartmouth College Collection.

Everett Shinn Out of a Job—News of the Unemployed. 1908. Ink wash, 13⅞ × 27¹⁵⁄₁₆. Courtesy Private Collection. Photo by Oliver Baker.

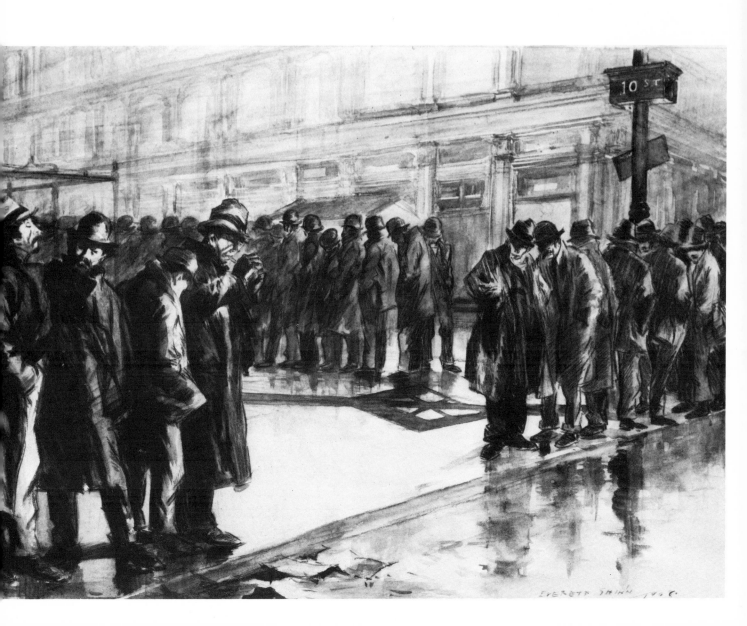

Marsden Hartley (Lewiston, Me., 1877—Ellsworth, Me., 1943)

The passionate eclecticism of Marsden Hartley is evident in his drawings, poetry, and paintings. One of a large series of drawings made with lithographic pencil, "Self-Portrait," 1908, is composed of brisk nervous arcs and bold dashes portraying the artist furiously at work producing other drawings. There is none of the reticence of Sloan or the mannerism of Henri in this individual graphic investigation stated in an expressionist, anti-academic mode.

Hartley was always concerned with representing objects, the human figure, and landscape. Caught in Berlin at the onset of World War I, he remained there until the end of 1915 and produced a series of works that tended toward abstraction. The German Officer series, of which "Symbol #IV" is a related drawing, are compositions of real objects joined in tight interlocking patterns. Hartley's use of the charcoal in this drawing is as highly controlled as the lithographic pencil was freely used in the earlier work.

Always an explosive romantic, Hartley traveled to the south of France in 1924, and in 1926 moved to Aix-en-Provence where the following year he produced a series of drawings in the spirit of Cézanne. His portrait of a Maine fisherman, made in 1941, reflects his continued application of the lessons of Cézanne, with white chalk used to capture the highlights against the deep black of the crayon. Hartley's treatment of the human body, with the broad thick torso, heavy arms, and oddly proportioned head, is typical of work produced during his later years.

Marsden Hartley Symbol #IV. c. 1914. Charcoal, 24 × 19. Courtesy Robert Millonzi. Photo by Geoffrey Clements. ◄

Marsden Hartley Maine Fisherman. c. 1941. Crayon and white chalk, 27½ × 21½. Courtesy Kennedy Galleries, Inc. ▼

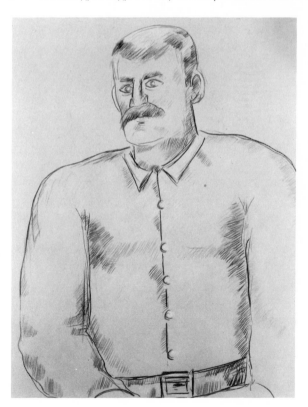

Marsden Hartley Self-Portrait. 1908. Lithographic pencil, 12 × 10⅝. Courtesy Allen Memorial Art Museum, Gift of Oberlin College Class of 1945. ◄

Joseph Stella (Muro Lucano, Italy, 1877— New York, 1946)

Joseph Stella was a provocative and eccentric draftsman. "Boy with Bagpipe," from the end of the nineteenth century, is drawn in the prevailing romantic tradition of his native Italy. Stella first came to America in 1896, at the age of nineteen, and returned to

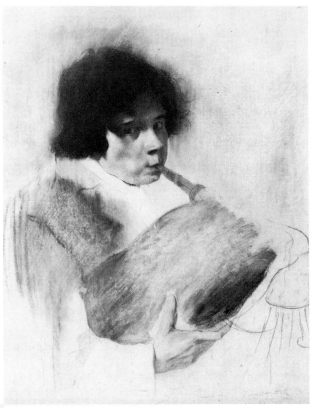

Italy in 1909 for three years, where he associated with the Futurists, whose dictates he later rejected.

The 1920 silverpoint drawing of a male profile is an example of his skill with this demanding medium, which was one of his favorite drawing materials.

The undated drawing of fruit on a plate shows Stella's particular approach to space and depth; he has used a fairly consistent hatching stroke to model the fruit, define the shadows, shape the plate, and cover the background. This consistency of line pattern produces a unified composition which he has dramatized by tipping the plane of the plate toward the spectator.

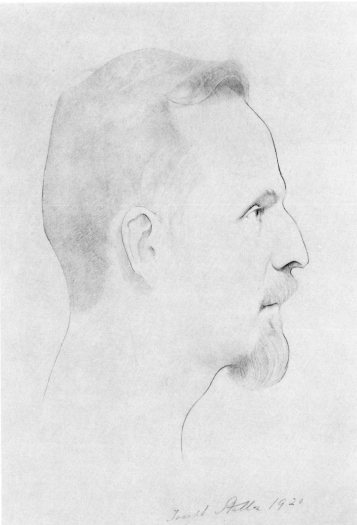

Joseph Stella Boy with Bagpipe. c. 1900. Pastel, 21¾ × 16. Courtesy Private Collection. ▲

Joseph Stella Portrait of an Unknown Man. 1920. Silverpoint. Courtesy Zabriskie Gallery. Photo by John D. Schiff. ◄

Joseph Stella Still-life. n.d. Crayon and pencil, 9¾ × 12. Courtesy Sotheby Parke Bernet, Inc. ►

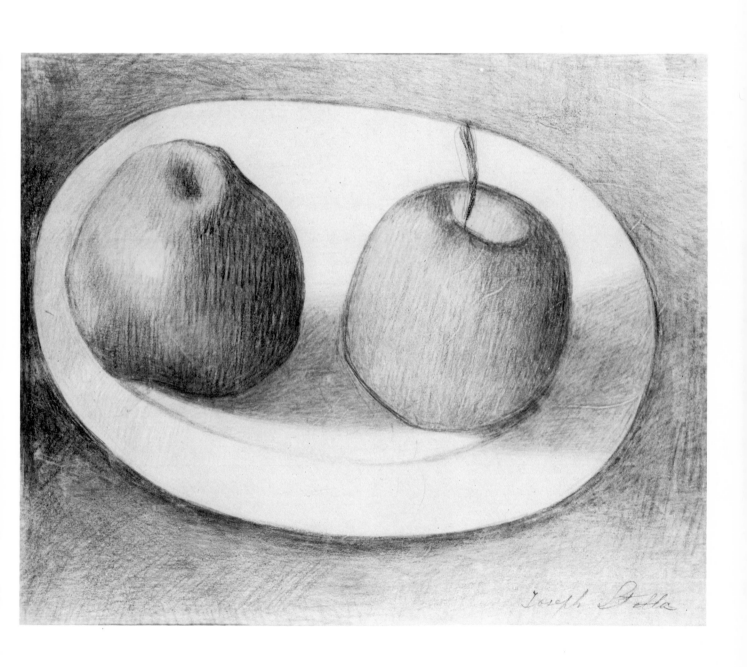

Abraham Walkowitz (Tyumen, Russia, 1878 —New York, 1965)

Isadora Duncan was an important theme for Abraham Walkowitz, and he produced hundreds of drawings of her over the years in much the same style with varying degrees of success. Some, like this one of 1911, use a pencil line enriched by a colored wash and strengthened by the addition of ink. A more expressionist mode prevails in Walkowitz's later painting and drawing, of which "Improvisation of New York," 1912, is an example. This crude brush drawing carries ominous overtones and expresses his attitudes toward the city in a symbolic manner.

Abraham Walkowitz Isadora Duncan. 1911. Pen, ink, and watercolor, 12½ × 8. Courtesy The Metropolitan Museum of Art, Alfred Stieglitz Collection. ▶

Abraham Walkowitz Improvisation of New York. 1912. Ink and wash, 13½ × 7. Courtesy Zabriskie Gallery. Photo by John D. Schiff. ◀

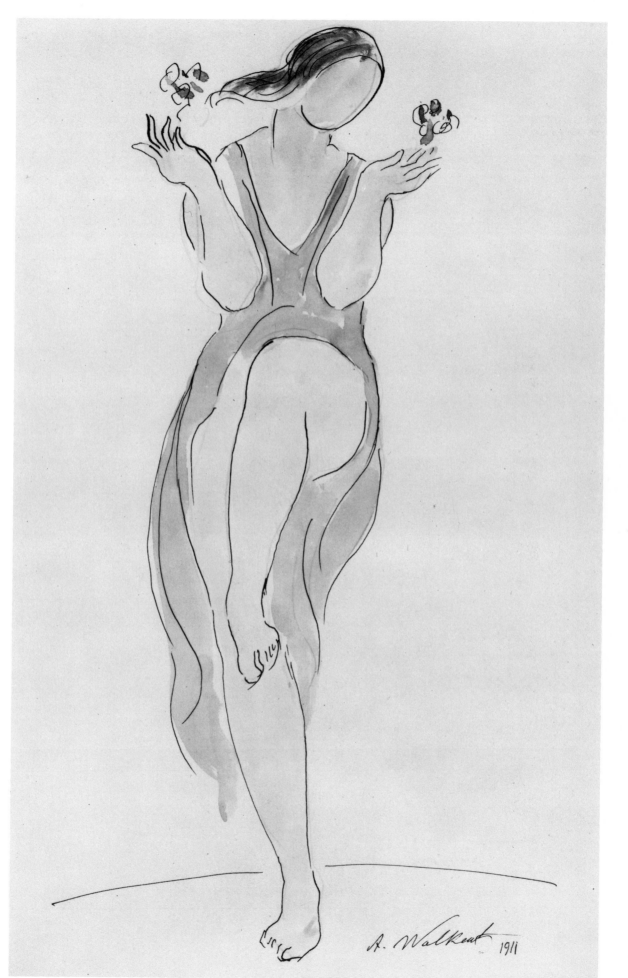

A. Walkent 1911

41

Kenneth Hayes Miller (Oneida, N.Y., 1878—New York, 1952)

Union Square and Fourteenth Street were the major sources of visual data for Kenneth Hayes Miller to which he applied artistic concepts derived from the old masters. The teaming life of this working-class commercial district is seen in his work from the 1920s onward, though his interest was not specifically in terms of reportage. This drawing, based on the traditional theme of the Three Graces, was a study for a now-lost painting, "Fourteenth Street," 1932. Miller taught at the Art Students League for forty years; two of his best known students were Edward Laning and Isabel Bishop.

Kenneth Hayes Miller Shoppers. c. 1932. Pencil, 14½ × 10⅛. Courtesy Cooper-Hewitt Museum of Design, Smithsonian Institution.

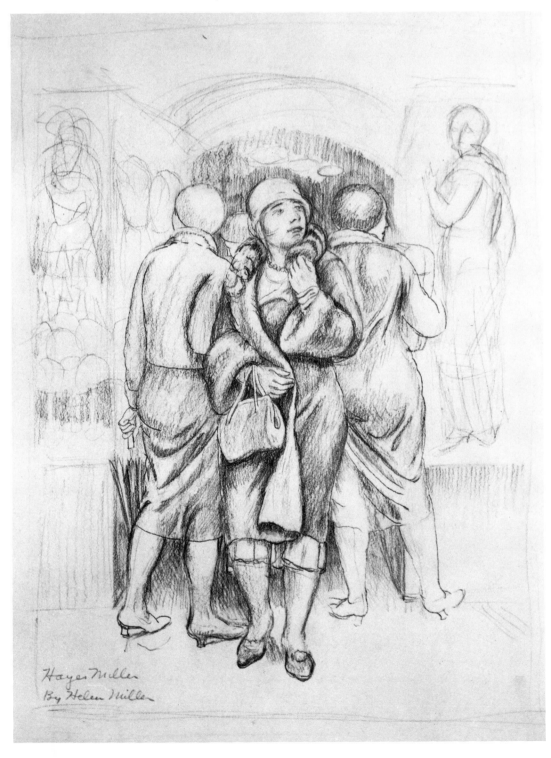

Hans Hofmann (Weissenberg, Germany, 1880—New York, 1966)

Hans Hofmann was the most influential modern teacher in America after William Merritt Chase; like Chase, his students, including Larry Rivers, Allan Kaprow, Wolf Kahn, Robert Beauchamp, Mary Frank, and Richard Stankiewicz, became highly individualistic artists rather than followers. Hofmann himself studied first in Munich. In 1904 he moved to Paris where he spent the following decade absorbing the impact of Cézanne and modern art. Back in Munich in 1915, Hofmann opened his first school, where he taught painting and drawing. In 1932 he came to the United States and eventually opened schools in New York and Province-

town. His own work from the 1920s through the 1940s was characterized by abrupt shifts in light and dark, a pronounced curvilinear rhythm, a flat patterning of the image, and an overall expressionist quality. His drawings, executed with brush and ink, have a rich painterly quality. Although Hofmann frequently stated he never "left the object," his work after 1950 shows a dramatically increased drive toward non-objectivization; in 1958 he closed his schools and devoted the rest of his life to painting full-time.

43

Hans Hofmann Untitled (Provincetown). 1942. Ink, 17 × 14. Courtesy Martha Jackson Gallery. Photo by O. E. Nelson.

Hans Hofmann Drawing for "Fruit Bowl II." 1950. Oil
paint, 17 × 14. Courtesy Fort Worth Art Center Museum,
Benjamin Tillar Trust.

44

Arthur Dove (Canandaigua, N.Y., 1880—Centerport, N.Y., 1946)

The year 1911 is regarded as the date Kandinsky produced the first abstract work of art, a watercolor. But about this same time in the United States, Arthur G. Dove, Marsden

Arthur G. Dove Untitled. c. 1912. Charcoal, 20½ × 17. Courtesy Terry Dintenfass, Inc. Photo by Walter Rosenblum.

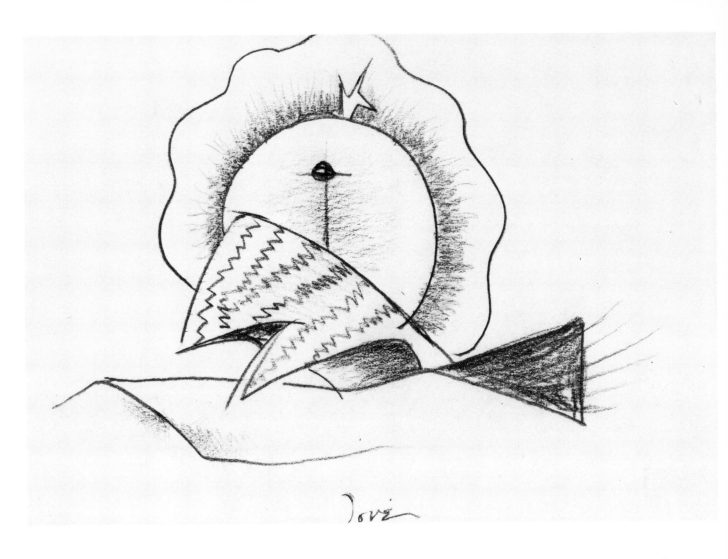

Hartley, and Georgia O'Keeffe were producing works that were essentially abstract. Dove painted a series of six small oils, which he called "abstractions," around 1910, although the date has never been documented. He followed these with a series of large abstract charcoal drawings. Dove always remained close to nature even when his work seemed to be non-figurative. "Abstraction-Untitled," c. 1912, is a charcoal drawing whose image is evolved from a pattern of circles. The somber suspended forms in the foreground are dramatized by the lines extending from behind it and by the ominous play of light and dark in the background. "Gas Ball and Roof," 1932, a small carbon pencil drawing of great delicacy, is similar to those Dove produced as notes for paintings. The forms in this drawing are derived from an actual landscape scene but have been transformed into emotionally charged symbols.

Arthur G. Dove Gas Ball and Roof. 1932. Carbon pencil, 4¾ × 6¾. Courtesy Kresge Art Center.

46

Daniel Garber (N. Manchester, Ind., 1880—Lumberville, Pa., 1958)

A teacher at the Pennsylvania Academy of the Fine Arts for decades, Daniel Garber incorporated the European post-impressionist treatment of light into his teaching and into his own work, but he nevertheless retained a sense of traditional realism. "Saturday Afternoon," a crayon drawing of 1927, shows a delicate rendering of light and shadow, yet the shallow symmetrical relief of the composition is sturdily classical and the details of texture are closely and realistically observed.

Daniel Garber Saturday Afternoon. 1927. Crayon, 15½ × 22. Courtesy The Pennsylvania Academy of the Fine Arts.

John D. Graham (Kiev, Russia, 1887—London, 1961)

Almost from the moment of his arrival in the United States in 1920, the Russian John D. Graham exerted a sophisticated intellectual influence on modern American art, especially on his friends Arshile Gorky, de Kooning, and David Smith, who were attracted to his unconventional theories. His early paintings had been influenced by Picasso, whose ideas he later rejected. His own mature work reflects his rather diverse interests which included naïve paintings, primitive art, mysticism, Renaissance principles, and the dozen languages in which he was fluent. Systems, charts, and arcane schemes were applied to drawing methods as shown in "Puisis in Inferno," c. 1958, a pencil drawing enriched with an iconographer's maze. In his book *System and Dialectics of Art*, Graham says of drawing: "The handwriting must be authentic and not faked. The difference is obvious to an expert."

John D. Graham Puisis in Inferno. 1958. Pencil, pen, and ink, 18¾ × 13¼. Courtesy Peggy Lipton. Photo by Eric Pollitzer.

48

Max Weber (Byelostok, Russia, 1881—Great Neck, N.Y., 1961)

Max Weber traveled to Paris in 1905 and studied at the Académie Julien with Jean-Paul Laurens; in 1907 he joined Henri Matisse's class which he left the following year. "Composition with Four Figures," 1910, a charcoal and pastel drawing, is very similar to a 1907 series of drawings by Georges Braque. In this early work, Weber incorporates elements of the primitivism and cubism that so engrossed his contempo-

raries. Within a few years after he came to New York in 1909, the impetus of Paris had run its course; Weber's modernism was not sustained by the American influences, and thereafter he produced works that were curiously eccentric and apart from the mainstream.

Max Weber Composition with Four Figures. 1910. Charcoal and pastel, 24½ × 18½. Courtesy The Brooklyn Museum, Dick S. Ramsay Fund.

49

Edward Hopper Man with Stick and Package. 1901. Pencil, 10¼ × 8¾. Courtesy Private Collection.

Edward Hopper (Nyack, N.Y., 1882—New York, 1967)

From 1900 to 1906, Edward Hopper was a student at the New York School of Art, whose most important teacher was then Robert Henri. "Man with Stick and Package," a pencil drawing of 1901, shows how quickly the nineteen-year-old Hopper had developed the talents and skills that enabled him to make his living as a commercial artist for a number of years.

Hopper lived on Washington Square in New York City for decades and often drew it. "Town Square," 1932, a heavily worked charcoal drawing, includes the famous Washington Arch, which has been reduced to a flat, highly abstracted billboard-like shape, although its shadow reveals its three-dimensionality. The rooftops form a rough, angular, nearly abstract pattern familiar in Hopper's work.

Hopper always maintained a passionate classical eye. "House on Cape Cod," a sensitive charcoal drawing from the 1930s, might serve as a manifestation of his desire "to paint sunlight on the side of a house."

50

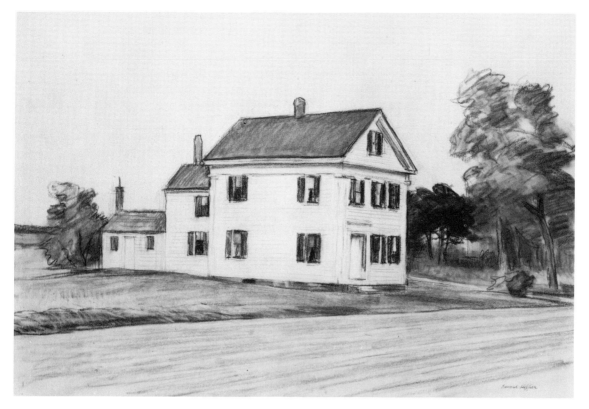

Edward Hopper House on Cape Cod. c. 1930s. Charcoal
pencil, 14½ × 21. Courtesy Kennedy Galleries, Inc. ▲

Edward Hopper Town Square (Washington Square and
Judson Tower). 1932. Charcoal, 12 × 19. Courtesy University
of Nebraska Art Galleries, J. M. Hall Collection. ▼

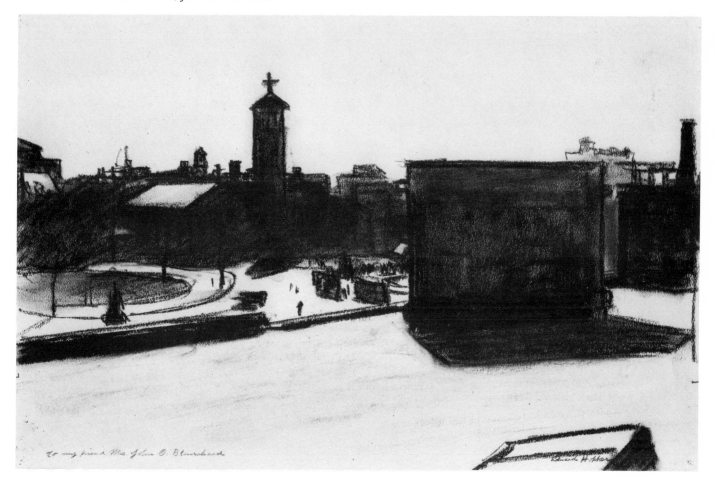

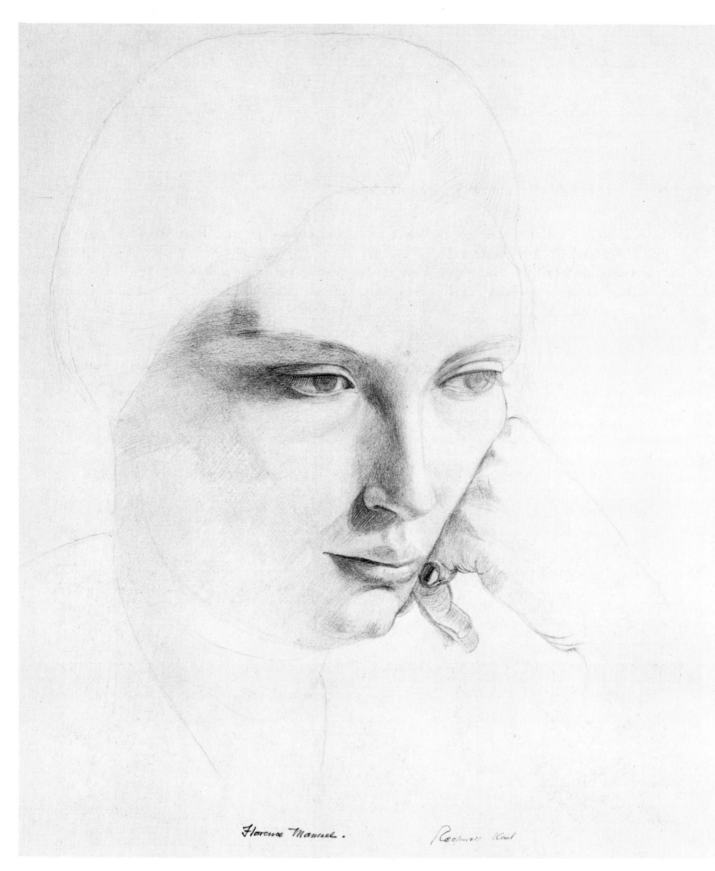

Florence Manuel. Rockwell Kent

Rockwell Kent Florence Manuel. c. 1935. Pencil, 12¾ ×
10½. Courtesy Larcada Gallery. Photo by Geoffrey Clements.

Rockwell Kent (Tarrytown, N.Y., 1882—Plattsburgh, N.Y., 1971)

As painter, architect, writer, illustrator, politician, and traveler, Rockwell Kent was an active and influential man throughout his long life. "Harvesters" of 1935 is an excellent example of his famous mature style, which merged early in his career and influenced a whole generation of artists and illustrators. His technique of using brush and ink to strengthen the light pencil sketch gives the image the look of a woodcut, the medium Kent used for his many book illustrations. Both the subject and the style of this drawing epitomize the romantic expression of the American dream typical of the art of the 1930s. A striking contrast is offered by the informal, pensive drawing of Florence Manuel of the same time. Kent's deft use of the pencil line and delicate cross-hatching is an example of the author's ability to subordinate his own powerful style to the individual personality of the sitter.

Rockwell Kent Harvesters. 1935. Pen and ink, 9½ × 13½. Courtesy Larcada Gallery. Photo by Geoffrey Clements.

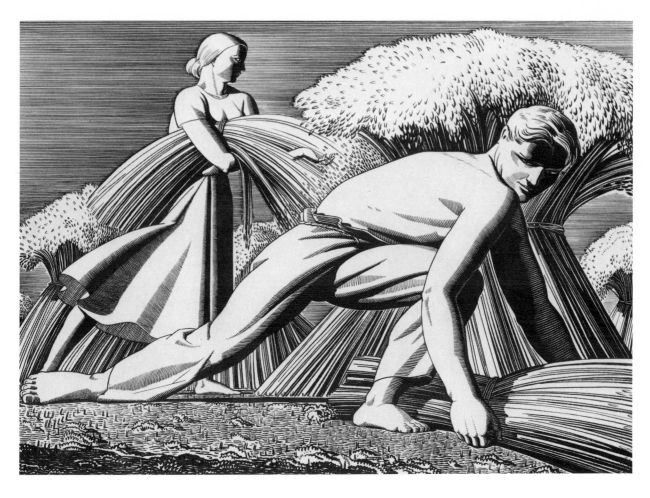

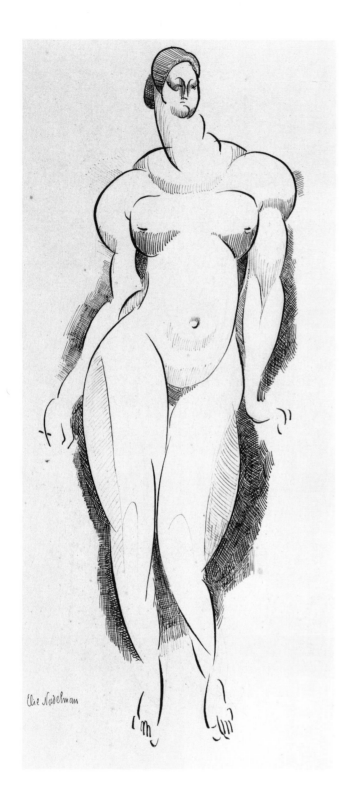

Elie Nadelman (Warsaw, Poland, 1882–New York, 1946)

Elie Nadelman was thirty-one when his work was exhibited in the Armory Show in 1913, just a year before he arrived in America. Unlike the drawings of most sculptors, Nadelman's images are boldly set forth on the page with a line that swells and tapers in defining the forms. Most of his drawings were devoted to the female figure, which he treated with both grandeur and a charming wit. His working method was to make a light pencil sketch first and then to finish the drawing with firm pen-and-ink lines. Differing from his line drawings, and more typical of the drawing style used by other sculptors, is "Head of a Woman," which incorporates a wash to balance and define the outline.

Elie Nadelman Female Nude. n.d. Pencil and ink, 19⅝ × 9½. Courtesy Hirschl and Adler Galleries. Photo by Helga Photo Studio. ◀

Elie Nadelman Head of a Woman. n.d. Pen, ink, and wash, 19⅝ × 12⅜. Courtesy The Museum of Modern Art, Gift of Lincoln Kirstein in Memory of Rene d'Harnoncourt. ▶

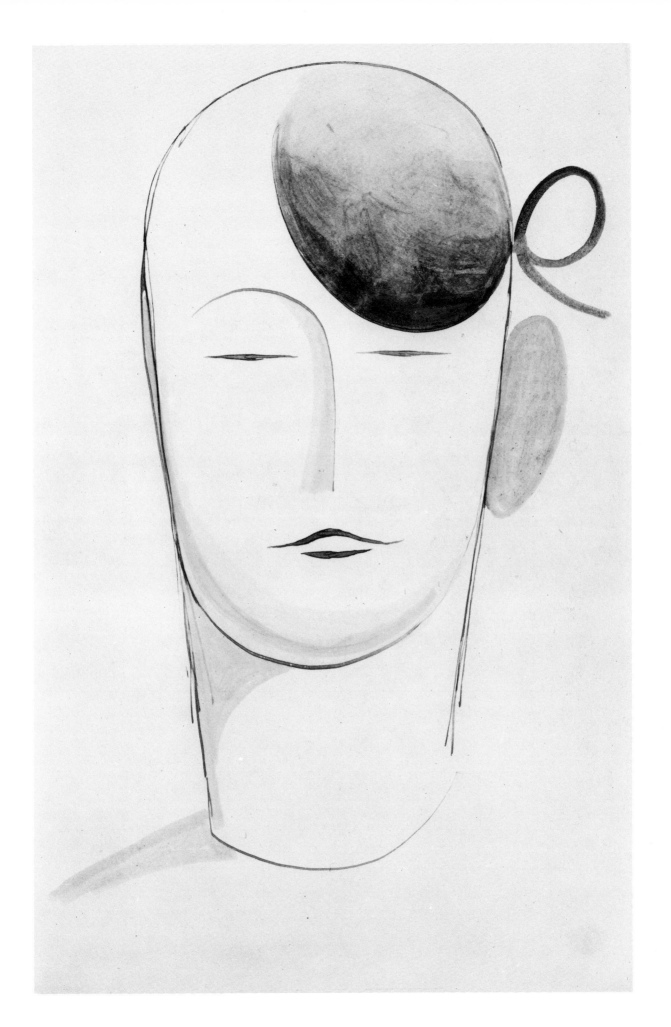

Gaston Lachaise (Paris, 1882—New York, 1935)

Lupercalian pleasures abound in the world of Gaston Lachaise. His figures are embodiments of physical joy. Unlike the tapered engraved line quality of Nadelman, Lachaise relies on consistent pencil line which rhythmically encompasses the forms. He rarely utilizes shading or hatching, but bathes his figures in an even, sourceless light. A productive draftsman, Lachaise was always fascinated with the human form, which appears in his sculpture as well as the drawings.

Gaston Lachaise Seated Female Nude. c. 1920s. Pencil, 17⅞ × 11⅞. Courtesy The Gaston Lachaise Foundation and Robert Schoelkopf. Photo by John D. Schiff. ◄

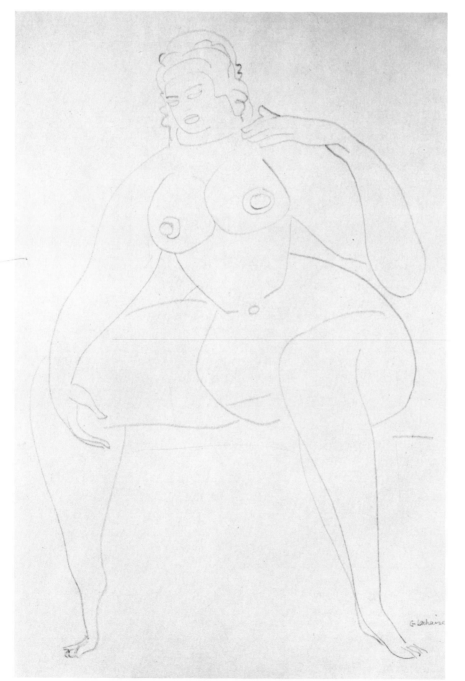

Gaston Lachaise Standing Male Figure. 1930. Pencil, 18½ × 11¾. Courtesy The Memorial Art Gallery of the University of Rochester, Gift of Dr. and Mrs. James Sibley Watson. ►

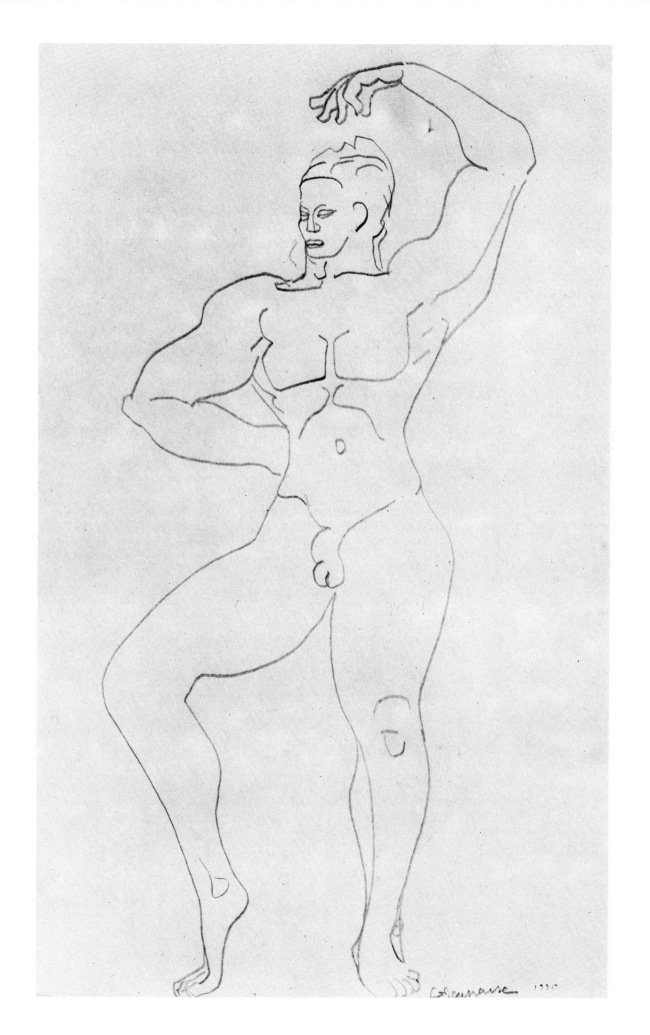

George Bellows (Columbus, Ohio, 1882—New York, 1925).

An early drawing of George Bellows', "Dance in a Madhouse," 1906, reflects his youthful interest in illustration and in the French Barbizon school, which was then popular in America. This drawing, inspired by a visit to an institutionalized friend, is rendered in the gray tonalities of much late nineteenth-century American and French art. He had been a student of Robert Henri at William Chase's New York School of Art for two years when he made the drawing. It was not long after this period that these influences coalesced to form his mature style.

Bellows was always able to catch a likeness and generally followed Henri's admonition to paint from life. In this later drawing, "Emma on the Couch," he uses strong, firm strokes of the conté crayon to define the planes and outlines, setting forth rich darks and relying on the whiteness of the paper to provide luminosity.

George Bellows Emma on the Couch. n.d. Conté crayon,
10½ × 12¼. Courtesy Kennedy Galleries, Inc. ◄

George Bellows Dance in a Madhouse. 1906. Black crayon,
charcoal, and ink, with touches of red crayon and Chinese
white, 18⅞ × 24⅝. Courtesy The Art Institute of Chicago,
Charles H. and Mary F. S. Worcester Collection. ▼

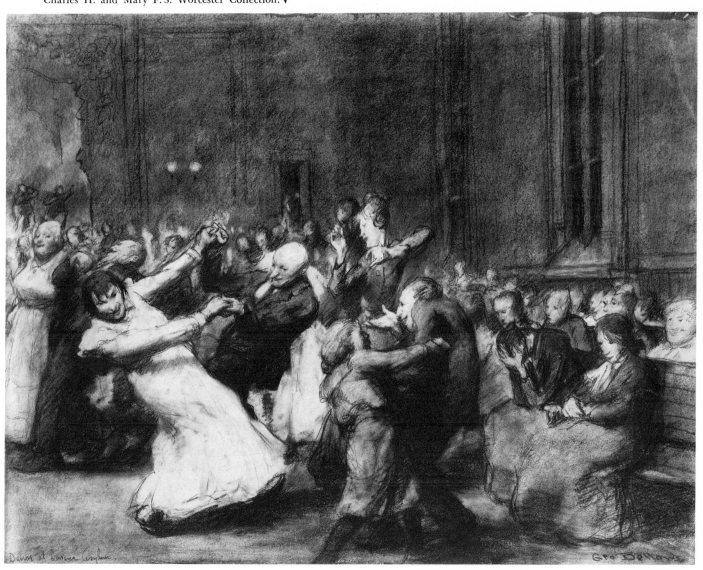

Charles Demuth (Lancaster, Pa., 1883—1935)

There is a kind of sophisticated literary decadence in Charles Demuth's early watercolors, used to illustrate the works of Zola and Henry James. To a slender meandering

Charles Demuth The Green Dancer. 1916. Watercolor and pencil, 11 × 8. Courtesy The Philadelphia Museum of Art, Samuel S. White III and Vera White Collection. Photo by A. J. Wyatt.

line he would add watercolor washes to define the forms and enliven the image. "The Green Dancer," 1916, is typical of his cabaret and acrobatic illustrations, which scarcely prepare one to expect the rigorous influence that cubism was to have on his mature work. Four years later, in 1920, Demuth produced "Lancaster," a surprising contrast with its geometricized clouds, tight flat planes of color, and hard-ruled lines. The building serves as a motif for the drawing, not as a model to be explicitly followed. Demuth was one of the first Americans to work in this style which would later be known as precisionism.

Charles Demuth Lancaster. 1920. Tempera and pencil, 23⅜ × 19½. Courtesy The Philadelphia Museum of Art, Louise and Walter Arensberg Collection.

61

Eugene Speicher (Buffalo, 1883–New York, 1962)

A successful portrait painter and art-world "politician" of the same generation as Demuth and Sheeler, Eugene Speicher worked within a narrow traditional style for decades. "Head of a Young Woman" is a typical charcoal drawing of his workman-like production. The dark charcoal background effectively sets off the close-valued tonal modeling of the face. A frequent prize winner, Speicher reflects the development of official American art from 1910 to the 1930s.

Eugene Speicher Head of a Young Woman. n.d. Charcoal, 12 × 10. Courtesy The Minneapolis Institute of Arts, Rev. Richard L. Hillstrom Collection.

Charles Sheeler (Philadelphia, 1883—Dobbs Ferry, N.Y., 1965)

Charles Sheeler New York 1920. 1920. Pencil, 19⅞ × 13. Courtesy The Art Institute of Chicago, Gift of The Friends of American Art.

A trip to Europe in 1908 introduced Charles Sheeler to the art of Matisse, Picasso, Braque, and Cézanne and catalyzed his reaction against the teachings of William Merritt Chase. In 1912 Sheeler became a commercial photographer working mainly at architectural commissions in Philadelphia, and its influence can be seen in his painting. His interest in abstraction never led to non-objective painting, however, for he always maintained a commitment to specific subject matter.

"Barn Abstraction," 1918, utilizes the simplified structures of cubism, but in certain ways it resembles a photograph printed for high contrast. Sheeler's fine sense of composition, balance, and patterning are readily apparent in these two drawings. "New York, 1920," a pencil drawing, combines strong vertical lines with multiple short horizontals in a gridlike pattern that produces a variety of textures and heightens the sensation of verticality.

Charles Sheeler Barn Abstraction. 1918. Black conté crayon and casein, 17¾ × 24¼. Courtesy The Philadelphia Museum of Art, Louise and Walter Arensberg Collection.

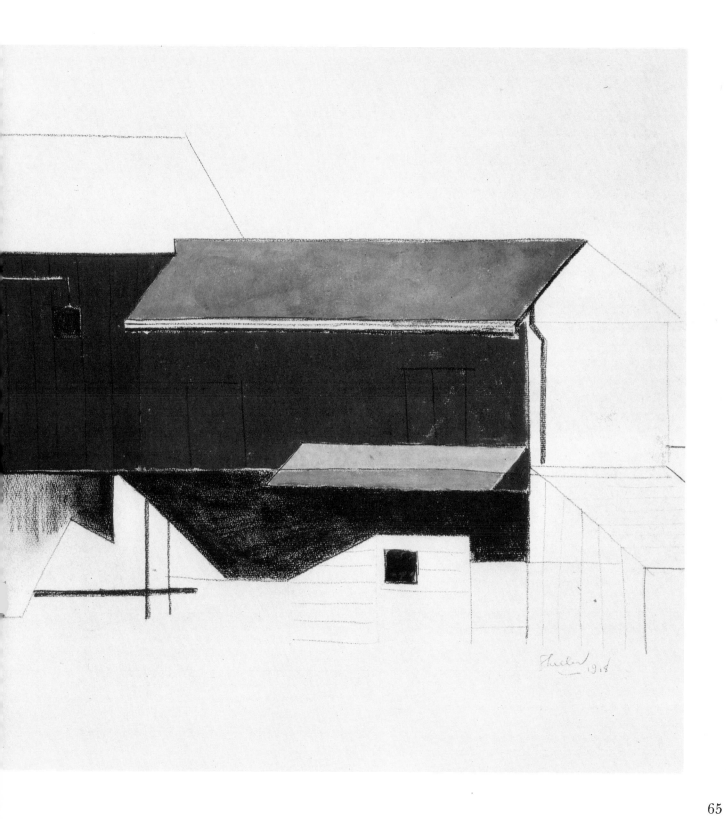

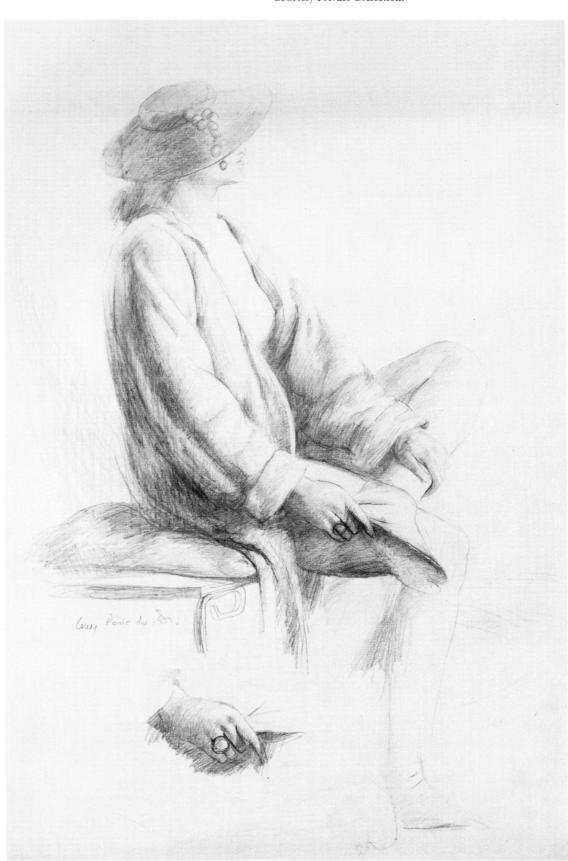

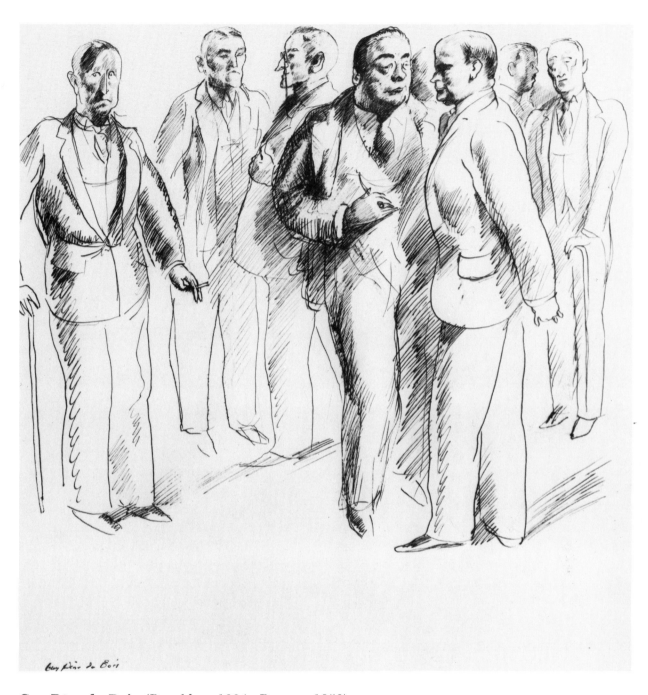

Guy Pène du Bois (Brooklyn, 1884—Boston, 1958)

Guy Pène du Bois, an artist and critic, wrote for several newspapers and magazines and eventually became the editor of the journal *Arts and Decoration*. A student of Chase, Henri, Kenneth Hayes Miller, and in Europe, Théophile Steinlen, he subscribed to their social attitudes toward the role of art in society. "Seated Woman," a pencil drawing with a vignette of a hand, is rendered in close gray values, an important technique in the art of the 1920s. In "Creative Man," an ink drawing, each figure is quickly executed with a contour line and filled out with hatching to indicate light and shade. Although many of the lines seem to be casual, those used to describe the frieze of heads, which is the drawing's focus, are drawn with great variety and careful consideration. Each character in this group of social nonpareils is treated to an equal dose of du Bois's pungent wit.

Guy Pène du Bois Creative Man. 1930s. Pen and ink. Courtesy Mr. L. H. Aricson. Photo by Geoffrey Clements.

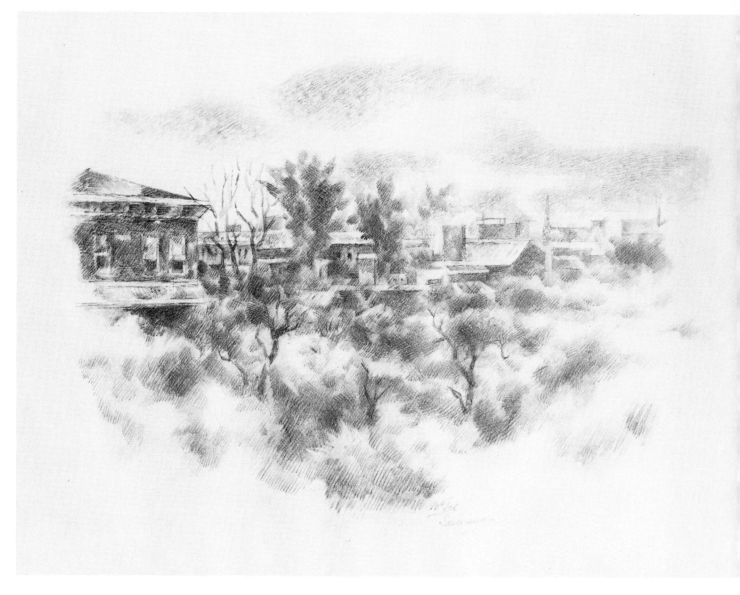

Henry McFee (St. Louis, 1886–Claremont, Cal., 1953)

Henry Lee McFee Savannah. n.d. Pencil, 13⅜ × 18½. Courtesy Private Collection.

This late drawing by Henry McFee is a synthesis of his early interest in impressionism and his later investigations of cubism. An early member of the Woodstock, New York, group of artists, he studied with Birge Harrison and exhibited in the Forum Exhibition of Modern American Painters in 1916. The small cubist facets produced here by cross-hatching are tempered by the artist's desire to retain the specific identity of the landscape elements.

Georgia O'Keeffe (Sun Prairie, Wis., 1887—)

Georgia O'Keeffe Blue Lines. 1916. Watercolor, 25 × 19.
Courtesy The Metropolitan Museum of Art, Alfred Stieglitz
Collection.

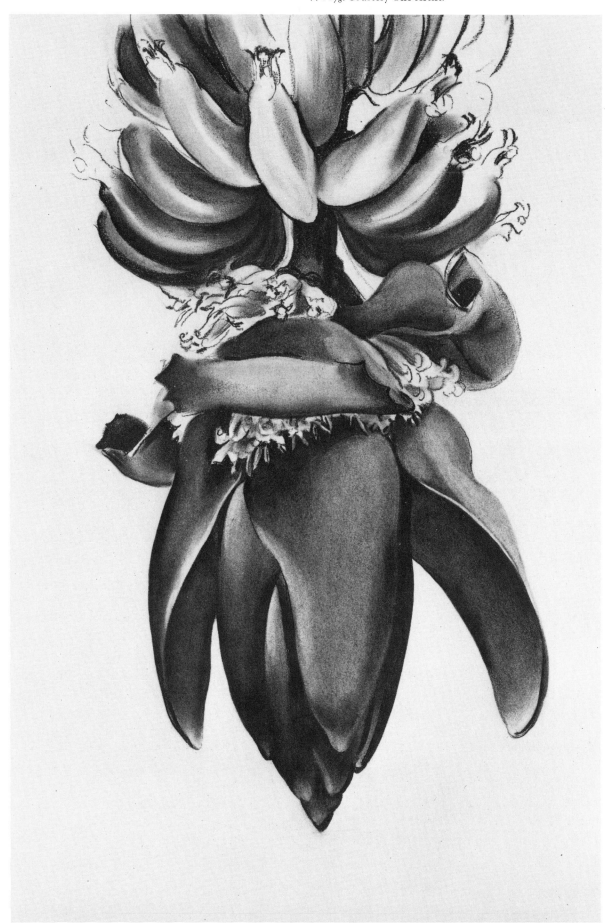

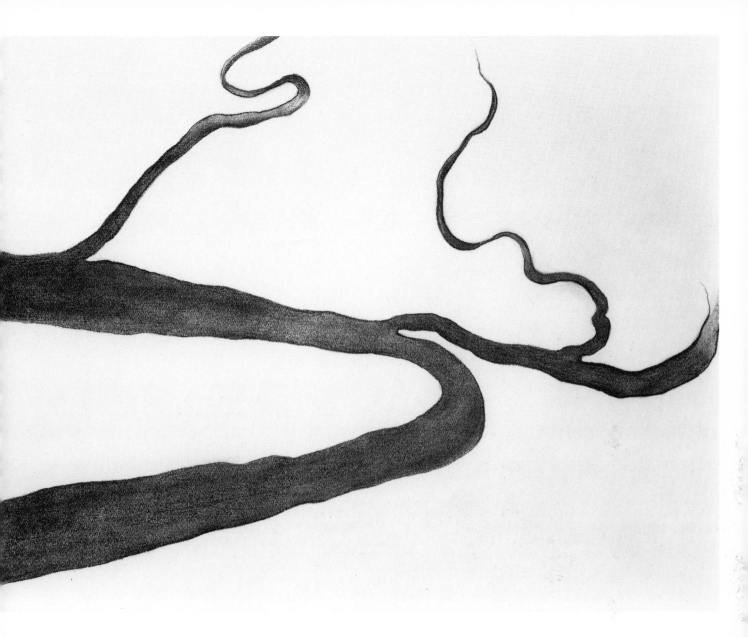

Georgia O'Keeffe produced some of the first abstract drawings in America. "Blue Lines," 1916, a watercolor drawn with spartan simplicity, indicates the direction of her later work. She studied with Arthur W. Dow, whose aesthetic theories had been influenced by Ernest Fenellosa's writings on Oriental art. The Dow influence is apparent in "Banana Flower No. 1," 1933, with its balanced lights and darks, clearly defined outlines, and elegant composition. The most complex of her drawings were produced during these middle years; the forms are handled with cool deliberation, and the charcoal is cleanly worked into a variety of rich grays contrasting with the white paper and the sharp black edges. O'Keeffe's images were appropriated by commercial illustrators during the late 1920s and the 1930s with such enthusiasm that it is often easy to overlook her original contribution.

From 1958 to 1960, O'Keeffe produced a series of drawings inspired by the landscape as viewed from an airplane. "Drawing IX," 1959, a work of this series, is related to the painting, "It Was Blue and Green" of 1960. Rather than a representation of a specific river, the composition is an abstract pattern of a river's natural rhythms.

Georgia O'Keeffe Drawing IX. 1959. Charcoal, 18⅝ × 24⅝. Courtesy The Artist.

Josef Albers (Bottrop, Westphalia, Germany, 1888—New Haven, Conn., 1976)

The early drawing style of Josef Albers, as reflected in his prints, exhibits an expressionist tendency modified by a classic sense of control. During the 1930s and 1940s he concentrated on the rhythmic, flat patterning of curvilinear and geometric forms. Albers would use a straight edge and pen or graph paper to make these drawings in which he explored various ambiguous patterns, such as the "Structural Constellation," 1956, reproduced here. By questioning the traditional concepts of visual perception in drawings, Albers created images that attain their reality in the mind, but cannot be constructed in three-dimensional reality. He used weighted lines to shift the focus within the pattern itself. In Albers' drawings we see the work of the same precise searching mind that produced the "Homage to the Square" series of paintings.

Josef Albers Structural Constellation. 1956. Pen and ink, 15⅞ × 12½. Courtesy The Brooklyn Museum, Dick S. Ramsay Fund.

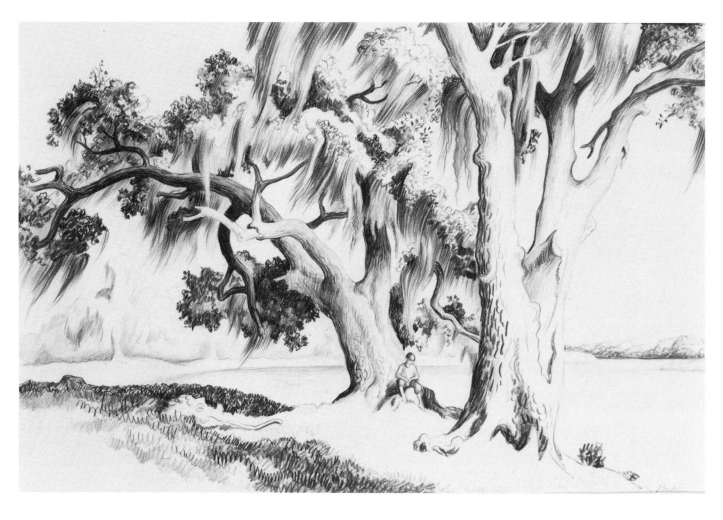

Thomas Hart Benton (Neosho, Mo., 1889—Kansas City, Mo., 1975)

Painter, muralist, writer, and traveler, Thomas Hart Benton was the leading exponent of what has been termed American regionalism. His youthful interest in abstract art was short-lived and he early developed an individual figurative style based on his study of the old masters.

"Live Oaks," 1937, a superb pencil drawing of large moss-covered trees on a river bank, demonstrates his use of contrasting textures for tree bark, leaves, grass, and moss, which serve to unite the composition. The man seated at the base of the central tree is hardly visible; though he is placed at a crucial focal point in the composition, he is overwhelmed by nature.

Another example of Benton's style is "Political Convention," drawn at the 1940 Republican Convention in Philadelphia, which nominated Wendell Willkie. Made for *Life Magazine* but never published, this pencil drawing, to which ink and wash were added later, is drawn with a choppy crabbed line that catches the energy and atmosphere of the convention hall.

Thomas Hart Benton Live Oaks. 1937. Pencil, 15 × 20⅝. Courtesy The Metropolitan Museum of Art, Anonymous Gift, 1945.

Thomas Hart Benton Political Convention. c. 1940. Ink and
watercolor, 12¼ × 14. Courtesy James Graham and Sons, Inc.
Photo by Geoffrey Clements.

Stanton Macdonald-Wright (Charlottesville, Va., 1890—Los Angeles, 1973)

Having formulated the concepts of synchromism in his youth with a friend, Morgan Russell, Stanton Macdonald-Wright applied his new system of rhythmic interlocking forms and color theories to a figurative tradition in his later work. He was attracted to Oriental art and thought, and frequently visited Japan to study. "Dragon Trail No. 4," 1929–1930, is composed of areas of pencil hatching, which describes the trail and the mountainside, with small clusters of dark line accents introduced to enliven the composition. The flowing movement of the work is sustained by the use of gently modeled areas of gray tone. The subject of the drawing is as much the overall atmosphere as it is the billowing landscape.

Stanton Macdonald-Wright Dragon Trail No. 4. 1929–1930. Pencil, 20 × 15. Courtesy The Fine Arts Gallery of San Diego.

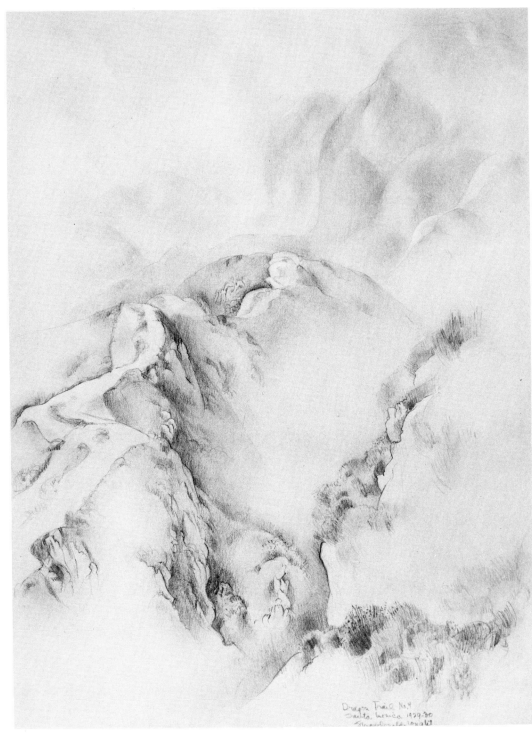

76

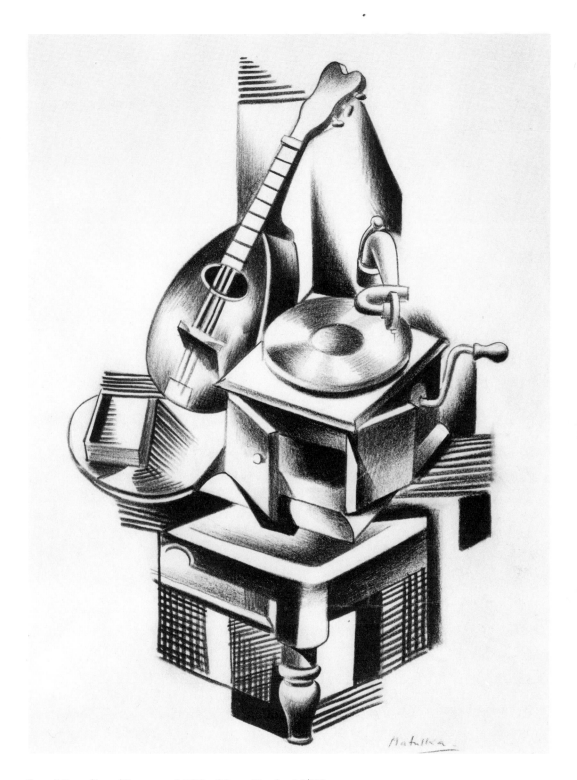

Jan Matulka (Prague, 1890—New York, 1972)

The Czech painter Jan Matulka was one of several artists who introduced modern European art to New York through his teaching at the Art Students League. In this drawing he has adapted cubist principles to a still-life subject, but has also retained a traditional three-dimensional approach. Bold hard lines state the cubist facets which have been enlarged to describe broad planes in deep space. The composition retains the stacked effect of many cubist still-lifes.

Jan Matulka Still-Life. n.d. Pencil and charcoal, 17 × 13¾. Courtesy E. Weyhe, Inc. Photo by Peter A. Juley and Son.

Mark Tobey (Centerville, Wis., 1890—Basel, Switzerland, 1976)

The abilities of Mark Tobey as a draftsman were apparent in his first one-man exhibition of charcoal portraits of social, political, and theatrical celebrities in 1917, at Knoedler's in New York. His world travels are recorded in hundreds of delightful sketches, frequently touched with watercolor, which capture the events of the day. "Mountains," 1952, a major drawing, is related to a small painting "Voyage of the Saints," of the same year, although it is not known which was completed first. Unlike the specific location in the Macdonald-Wright drawing, the subject of this work is an imaginative concept of mountains. The underlying, light charcoal lines have been boldly redrawn to increase the clarity of form.

Mark Tobey Mountains. 1952. Pencil and charcoal, 37⅜ × 47⅞. Courtesy Willard Gallery. Photo by Oliver Baker.

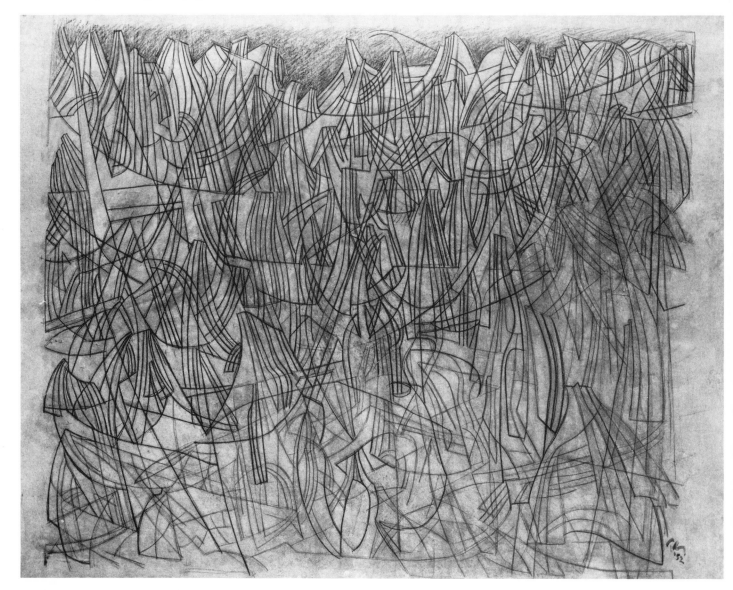

Grant Wood Study for "Ames Mural." 1935. Mixed media, 22¾ × 15¾. Courtesy Mr. and Mrs. George D. Stoddard. Photo by Charles Uht. ▶

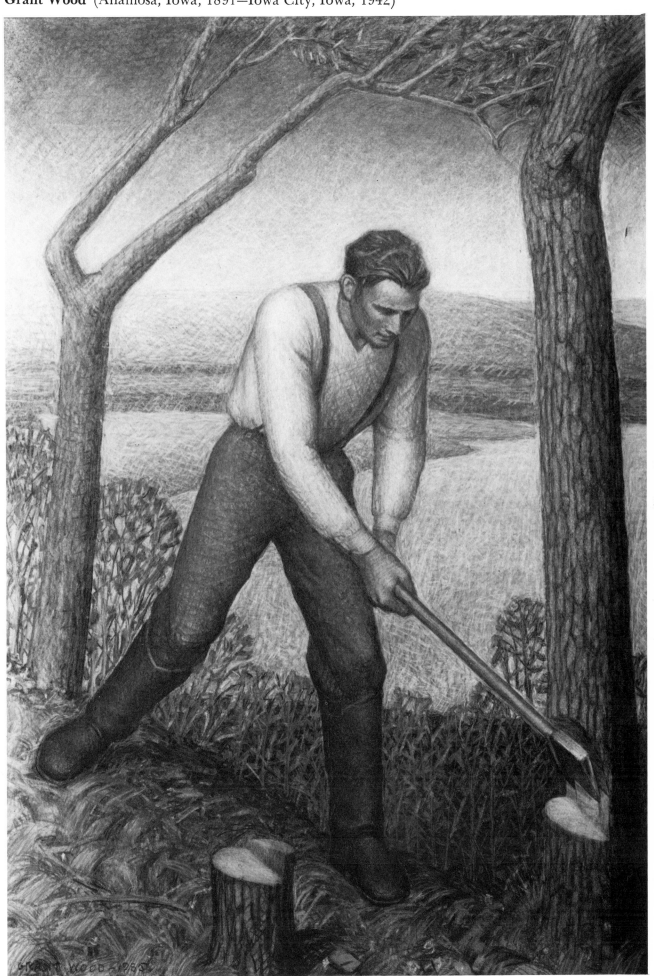

During the 1920s Thomas Craven promoted the idea of an "America First" regionalism, which was to become a dominant concept in the minds of the Federal Art Projects administrators in their role as patrons and public tastemakers. In 1935 Grant Wood, stimulated by Craven's ideas, began a triptych drawing as a mural study for the State College of Agriculture and Mechanical Arts in Ames, Iowa (now Iowa State University). The mural's theme is derived from a quotation of Daniel Webster.

Drawn in mixed media, the essentially uneven network blends to create planes that define the images. The artist maintains the force of the composition by framing the central panel with two wings, each of which uses strong verticals in the form of trees to focus our attention. In the left panel the man has embedded the ax into the tree, forming an arc that carries our eye into the central panel. The right panel shows a man about to swing his ax, a form echoing the tree shape on the far left side of the left panel. The smooth roundness of the figures and animals contrasts with the flatness of the landscape and sky, producing a curious effect of collage.

Grant Wood Study for "Ames Mural." 1935. Mixed media, 22¾ × 15¾. Courtesy Mr. and Mrs. George D. Stoddard. Photo by Charles Uht. ◄

Grant Wood Study for "Ames Mural." 1939. Mixed media, 22¾ × 48¾. Courtesy Mr. and Mrs. George D. Stoddard. Photo by Charles Uht. ▼

WHEN TILLAGE BEGINS OTHER ARTS FOLLOW
THE FARMERS THEREFORE ARE THE FOUNDERS
OF HUMAN CIVILIZATION
— DANIEL WEBSTER

Edwin Dickinson (Seneca Falls, N.Y., 1891–)

Student drawings from life classes are usually uninteresting pieces of work, but occasionally a young artist is able to infuse vitality into these painstaking productions. Edwin Dickinson, a student in Frederick V. Baker's antique class at Pratt Institute, succeeded in bringing life to his early work. "Life Class: Head," 1910–1911, is composed of carefully modeled, subtly massed dark areas drawn with a soft pencil; the delicately blended grays are defined into shapes by abrupt edges and dark outlines. A small sketchbook work, "Nellie," 1925, demonstrates his development of this approach in its reliance on suggestion rather than bold lines.

Dickinson's interest in penumbral atmospheric effects naturally led him to the use of the grisaille technique. "Roses," 1939, is a still-life of flowers that seem to emanate their own light against the blackness of the window. Using only black and white, Dickinson is able to suggest a wide range of color.

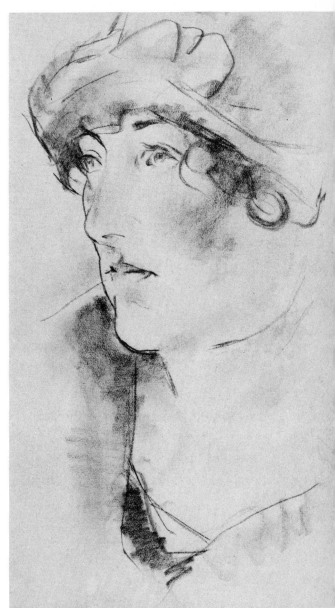

Edwin Dickinson Life Class: Head. 1910–1911. Pencil, 19⅞ × 16⅜. Courtesy Graham Gallery. Photo by Geoffrey Clements. ▼

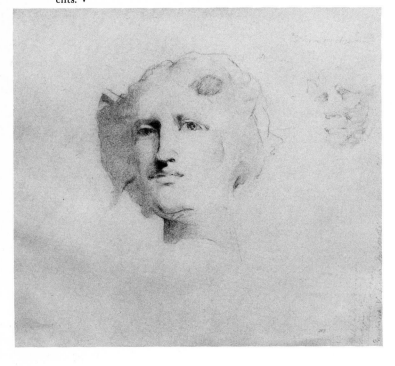

Edwin Dickinson Nellie. c. 1925. Pencil, 8¼ × 4¾. Courtesy
Mr. and Mrs. M. Vanderwoude. ◄

Edwin Dickinson Roses. 1939. Pencil, 11 × 13. Courtesy Mrs.
Robert M. Benjamin.

Yasuo Kuniyoshi (Okayama, Japan, 1893—New York, 1953)

Yasuo Kuniyoshi, a student of Robert Henri and Homer Boss, was one of the most individual talents to emerge from the K. H. Miller classes. He was twenty-nine when he drew "Growing Plants," 1922, the same year of his first one-man exhibition at the Daniels Gallery. This ink drawing of assorted plants combines a fine line with a wash to give weight, tonal contrast, and a slightly ominous aspect to the composition. "Woman with Cigarette and Drink" of 1935 is drawn in an open, free style with an increased expression-

ist overtone, a characteristic of many works of the 1930s. The clear, clean line of his earlier drawing has become abrupt, choppy, and crabbed. "Suzanna," 1944, a late drawing in brushed ink, is a remarkable contrast to the earlier composition; it is as if the fashionable, kohl-eyed lady had become clad in bitter, consuming sorrow. The dry-brushed ink molds the textures of a corroded face, shrouded in a dark, thickly painted shawl. The downturned head and lowered eyes reinforce the shadowed gloom of this dramatic drawing.

Yasuo Kuniyoshi Growing Plants. 1922. Ink, 12 × 9½. Courtesy Mr. and Mrs. M. Vanderwoude. Photo by John A. Ferrari.

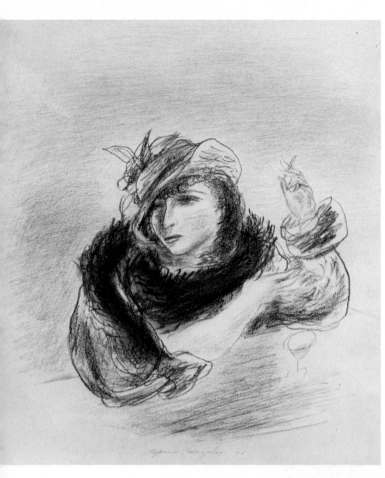

Yasuo Kuniyoshi Woman with Cigarette and Drink. 1935. Charcoal, 15 × 13. Courtesy Jen Hom Fine Arts. Photo by Geoffrey Clements.

Yasuo Kuniyoshi Suzanna. 1944. Ink, 18¾ × 13⅝. Courtesy The Dayton Art Institute, Anthony Haswell Collection.

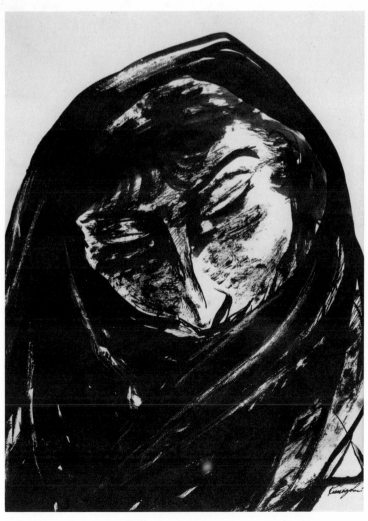

85

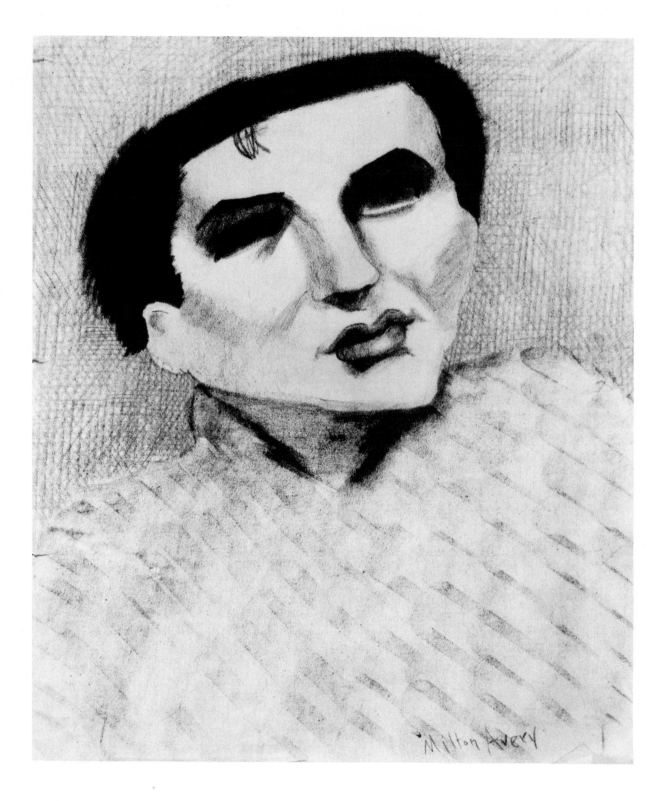

Milton Avery Head. n.d. Charcoal, 17 × 14. Courtesy Mrs.
Sally Avery. Photo by O. E. Nelson. ▲

Milton Avery Landscape, 1957. Ink, 8½ × 11. Courtesy Mrs.
Sally Avery. Photo by O. E. Nelson. ►

86

Milton Avery (Altmar, N.Y., 1893—New York, 1965)

A painter with a superb color sensibility, Milton Avery drew with a delightful, sophisticated simplicity. His usual working method was to draw from the subject, and then to follow that with a watercolor, occasionally an etching, and eventually an oil painting, increasing the degree of abstraction with each step. The portrait shown here exemplifies his early style, in which he displays a fine control of the charcoal, using it for the simple repeated textured patterns of each of the major areas—background, clothes, and hair. The 1957 beach drawing illustrates his later style, with its free-flowing calligraphic line and assorted dots and squiggles. The asymmetrical design recalls Japanese prints in which a bold, positive shape effectively balances a negative space. Avery's lifelong interest in nature helped to maintain a freshness in his work.

Charles Burchfield (Ashtabula Harbor, Ohio, 1893—West Seneca, N.Y., 1967)

A prolific draftsman, Burchfield experimented with natural forms in many styles with a variety of materials, but he remained essentially a worker in watercolor and pencil. A method he developed early and used throughout his career was to make a pencil drawing, adding watercolor later as additional lines or as a wash. He would often take up small drawings and studies years later to amplify them into larger formats or new themes. One of a series of drawings is "Old Inn at Hammonds Port," 1923, a tightly drawn row of weathered buildings whose sturdy horizontal clapboard façades provide a striking contrast to the sketchy, kinetic lines of the tree forms. Figures appear infrequently in Burchfield's work and are ill at ease when they do: the artist preferred to express himself through nature; man's presence remained manifest in his buildings. A charcoal drawing with color annotations, "New Moon in Winter," 1935, is representative of Burchfield's many horizontal compositions. The buildings recede to the right, as if propelled by the horizontal lines, the perspective, and the increasing density of dark shapes.

Burchfield's lifelong interest in nature is displayed in "Goldenrod Spray," 1954–1963, which shows a radically transformed variation of the subject matter of the previous drawing. The glowing shape of the goldenrod is augmented by the nimbus around it, which forms the image of a star. The buildings on either side are sketched simply to frame the picture, fill out the composition, and define the central focus.

Charles Burchfield Old Inn at Hammonds Port. 1923. Ink
and pencil, 13 × 22. Courtesy Private Collection. ◄

Charles Burchfield New Moon in Winter. 1935. Charcoal,
8¾ × 18¾. Courtesy Kennedy Galleries, Inc. Photo by Tay-
lor and Dull, Inc. ▲

Charles Burchfield Goldenrod Spray. 1954–1963. Pencil and
watercolor, 3¾ × 5¼. Courtesy Rehn Gallery. Photo by
Geoffrey Clements. ▼

Stuart Davis (Philadelphia, 1894—New York, 1964)

The Armory Show in 1913 set Stuart Davis on an autodidactic path toward modernism. The artists he most admired in that exhibition, Matisse, Gauguin, and Van Gogh, were considerably more adventuresome than the newspaper illustrators Davis had grown up with and been influenced by. In his notebooks he writes: "There is a rational distinction between good and bad drawing. Good drawing is an attitude of mind. By drawing I mean following the contour of planes." His comments on "pre-modern" drawing were harsh: "The drawing of the past had as intent illusion. Because of this it is subvisual and not operative in the spatial sense."

By the early 1920s Davis was using collage and flat patterning to attempt a synthesis of cubism and the subject matter of traditional painting. Around 1927 he nailed a still-life composed of an egg beater, an electric fan, and a rubber glove to a table top and began a concentrated effort to modernize his painting. His stated purpose was to develop an "invented series of planes, which was interesting to the artist." Utilizing the device of linear perspective, "Egg Beater No. 3," made between January 16 and 31, 1928, contains many erasures, indicating Davis's tireless

Stuart Davis Study for Cliché and Ready to Wear. 1955. Pencil, 14¼ × 10¾. Courtesy Mrs. Stuart Davis. Photo by O. E. Nelson. ▲

Stuart Davis Composition: Gloucester #2. 1931. Ink, 21 × 23½. Courtesy Mrs. Stuart Davis. Photo by O. E. Nelson.

Stuart Davis. Egg Beater No. 3. 1928. Pencil, 19¾ × 14¾. Courtesy Mrs. Stuart Davis. Photo by O. E. Nelson. ◄

quest for the correct line. The discoveries Davis made in that year continued to provide source material for the remainder of his career.

During the early 1930s Davis produced a number of drawings which applied discoveries from the Egg Beater series to other subject matter. "Composition: Gloucester," 1931, is an example. Often his drawings, or elements of them, would serve as studies for more than one painting, as did "Study for Cliché and Ready to Wear," 1955.

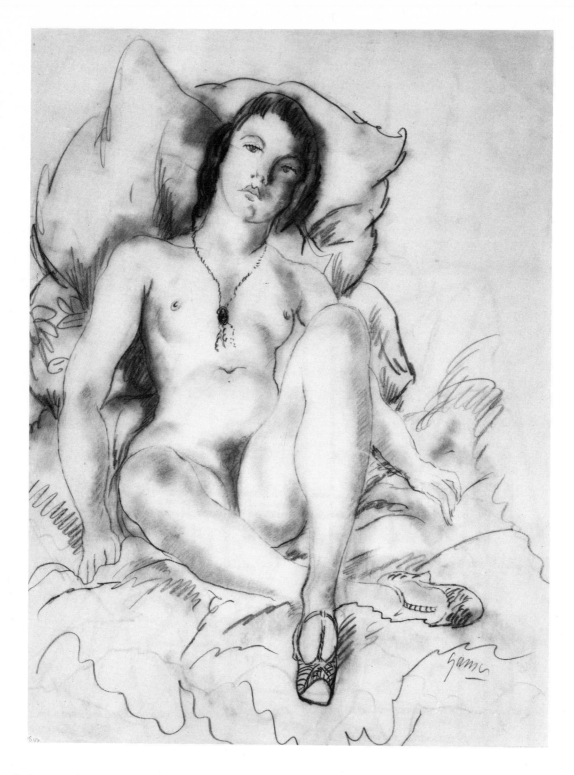

Emil Ganso (Halberstadt, Germany, 1895—Iowa City, Iowa, 1941)

A prevailing influence on American art during the 1920s was the presence in New York of French painter Jules Pascin, whose stylistic qualities were perhaps most clearly reflected in the work of his friend Emil Ganso. A flowing contour line envelopes the figure while a soft smudging of pencil and light hatching are used as tones for modeling. Ganso's line quality is not as brittle nor his attitude as cynical as that of his mentor.

Emil Ganso Untitled. n.d. Pencil and charcoal, 17½ × 14¾. Courtesy E. Wehye, Inc. Photo by Peter A. Juley and Son.

Ben Shahn (Kovno, Lithuania, 1898—New York, 1969)

Ben Shahn, painter, illustrator, photographer, calligrapher and writer, was an artist of social conscience whose works were moral messages. He attributed his highly developed graphic sense to his youthful experience as an apprentice lithographer. "Blind Botanist," a drawing of 1961, exhibits his particular utilization of short, choppy, variformed dashes joined to form a long circumscribing line. Shahn's incorporation of words and lettering into his pictorial images is part of a tradition that now includes such diverse artists as Stuart Davis, Larry Rivers, and Roy Lichtenstein.

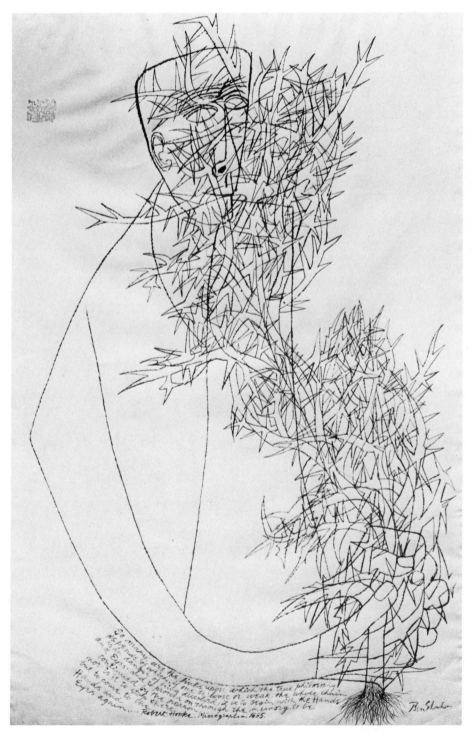

Ben Shahn Blind Botanist. 1961. Ink, 38½ × 25. Courtesy The Minnesota Museum of Art.

Alexander Brook (Brooklyn, 1898—)

Alexander Brook became a student at the Art Students League at the age of seventeen, and worked there with John C. Johansen and K. H. Miller. He later taught at the League and in Georgia, where this drawing was made. The use of a traditional one-point perspective activates the composition, which is carefully framed by the lamppost on the left and the house on the right, both of which are essentially vertical, larger in scale, and lighter in tone than the central forces of the picture. The finely controlled use of the pencil is effective in rendering the light of the sun on the dried boards of the houses.

Alexander Brook Houses—Savannah. 1930s. Pencil, 17½ × 23. Courtesy The Minneapolis Institute of Arts, Rev. Richard L. Hillstrom Collection.

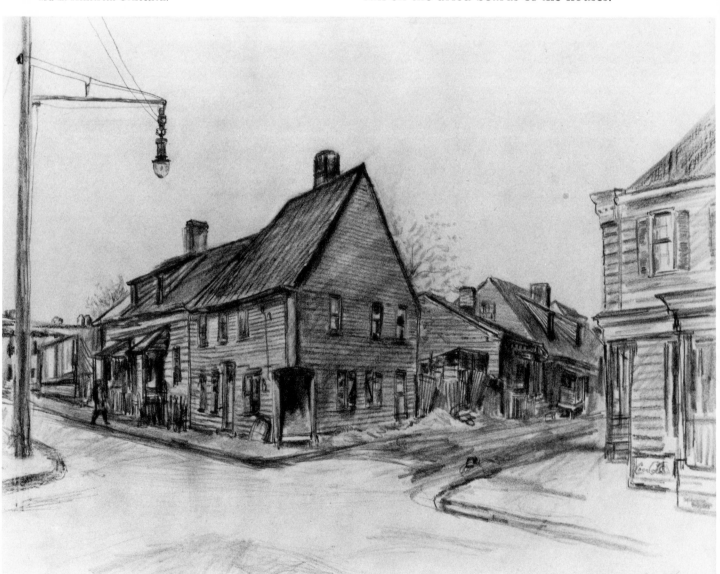

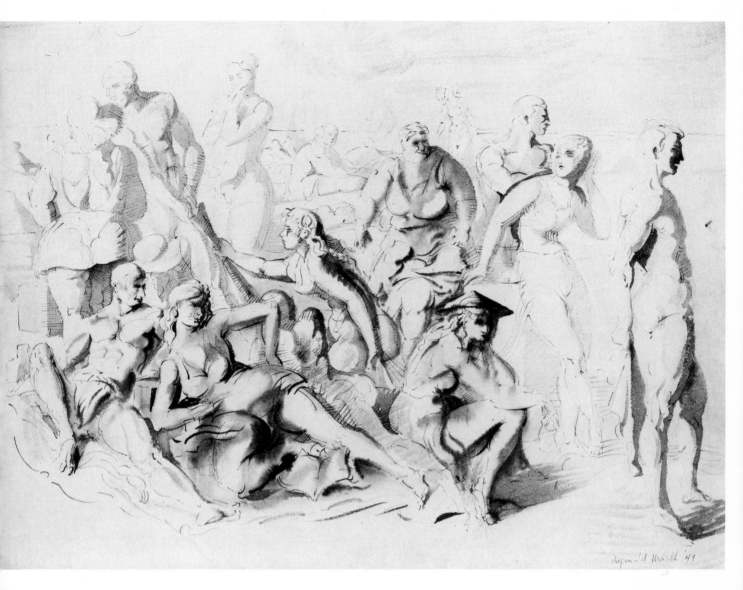

Reginald Marsh (Paris, 1898—Dorset, Vt., 1954)

Reginald Marsh maintained a close association with the Art Students League for two generations during which he was a student of John Sloan, K. H. Miller, and George Bridgman, and later an instructor himself. A proliferant and fluent draftsman, Marsh produced thousands of drawings with baroque compositions teeming with an endless stock of characters. His thin, delicate pen line is strengthened by the use of parallel lines to indicate planes; contrasts of light and dark are rendered in an ink wash. Marsh's persistent social commentary is apparent in his individualization of stock characters as in "The Beach," 1949, with its fat lady, the beach gods and goddesses, and muscle builders. The bold foreground, with its low relief sculptural characteristics, and the cursory treatment of the background are typical of his compositions.

Reginald Marsh The Beach. 1949. Ink, 22 × 30. Courtesy the Rehn Gallery.

Alexander Calder (Philadelphia, 1898–)

Alexander Calder has manipulated wire into a vast assortment of shapes. This drawing, "Balancing Act with Table," 1931, reflects not only his interest in the circus, of which he created a mechanical miniaturized version in wire, but also his ability to retain the feeling of the wire. The continuous line figures clearly express a personality. Calder's most provocative works in wire are his portraits, which can be considered three-dimensional line drawings in space.

Modern sculptors' drawings are traditionally noted for their openness, clarity of form, and simplicity of statement; to all of this Calder adds grace and charm.

Alexander Calder Balancing Act with Table. 1931. Ink, 22¾ × 30¾. Courtesy The Fort Worth Art Center Museum, Tillar Trust.

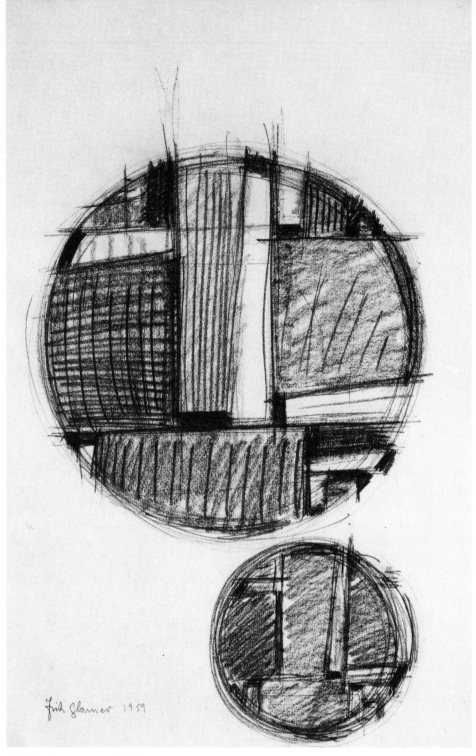

Fritz Glarner (Zurich, 1899—Locarno, 1971)

Fritz Glarner began his tondo drawings in the late 1920s, and continued throughout his life to investigate their particular formal problems. The tondo concept he explained as "a complete space-determination of the circle," thus making the "relational paintings" series an expression of contrasts: light-dark, large-small, colored-uncolored, diagonal-vertical. In 1936 Glarner came to the United States, where he befriended Mondrian and lived until shortly before his death. "Tondo with Echo," 1959, is a typical charcoal drawing of his mature years. The individuality of line and gesture sets in contrast each segment of the drawing in a broad orchestration of grays and blacks.

Fritz Glarner Tondo with Echo. 1959. Charcoal, 20½ × 31⅝. Courtesy Private Collection. Photo by O. E. Nelson.

98

Raphael Soyer (Tombov, Russia, 1899—)

Raphael Soyer Young Woman on a Cot. 1930. Mixed media, 20⅝ × 15½. Courtesy the University of Nebraska Art Galleries, J. M. Hall Collection.

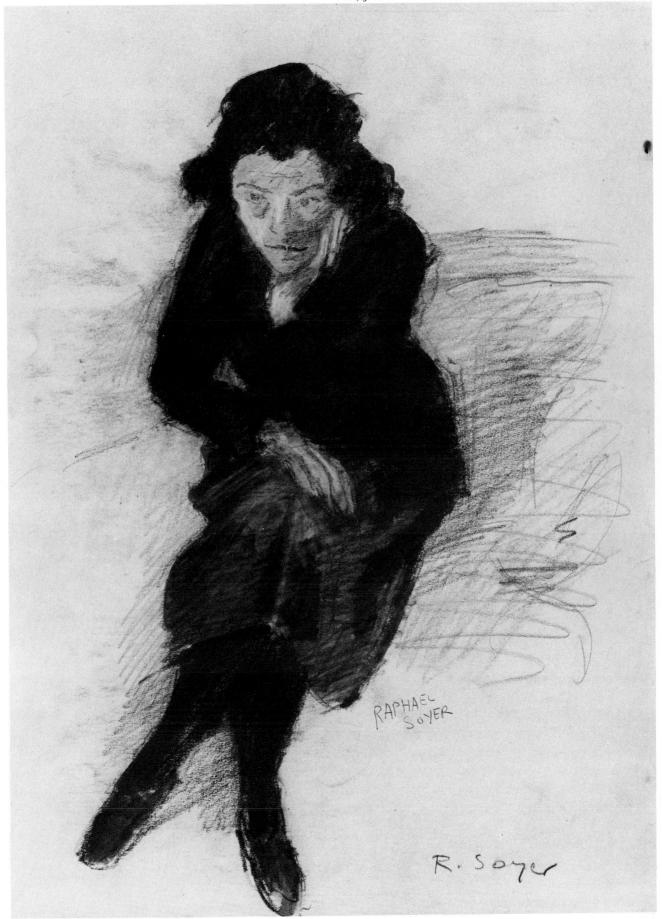

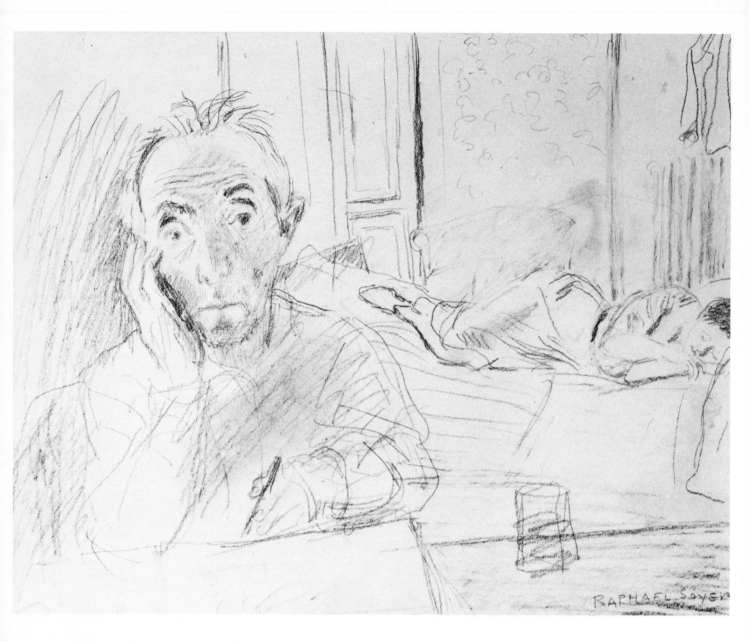

More than three decades separate these two drawings by Raphael Soyer, yet they manifest a tenacious consistency of style, point of view, and personality. The mixed media drawing, "Young Woman on a Cot" of 1930, was drawn soon after his first one-man exhibition at the Charles Daniels Gallery in New York. His use of compact lines to form dense, dark forms and the intense attitude of the seated figure combine to set the depressing mood that would permeate much American art during the 1930s.

In 1961 Soyer and his wife toured Europe where he made a series of drawings that he later published in a travelogue. This "Self-portrait in Hotel" was drawn in Milan during that summer and used as a study for an etching. His dry, searching line is looser than that of the 1930 drawing but the intense private vision remains. Selective groups of dark bunched hatching enliven a composition that otherwise would be composed of fairly even gray lines and tones.

Raphael Soyer Self-portrait in Hotel. 1961. Pencil, 12 × 15. Courtesy The Forum Gallery. Photo by Walter Rosenblum.

Rico Lebrun (Naples, Italy, 1900—Malibu, Cal., 1964)

Drawing skill is often equated with the artist's ability to make the drawn image life-like, whether it is elicited from the imagination or transformed from the visible world. The late drawings of Rico Lebrun for Dante's *Inferno,* for a *Genesis* mural, and for *The Three Penny Opera* are deeply entrenched in the figurative tradition. In "Polly Peachum," 1961, the skein of black lines and the gossamer curtains of ink wash control the paper's whiteness, which thus becomes a luminous, positive presence.

Rico Lebrun Polly Peacham. 1961. Ink, 39 × 27. Courtesy Lee Nordness Gallery, Inc. Photo by Oliver Baker Associates, Inc.

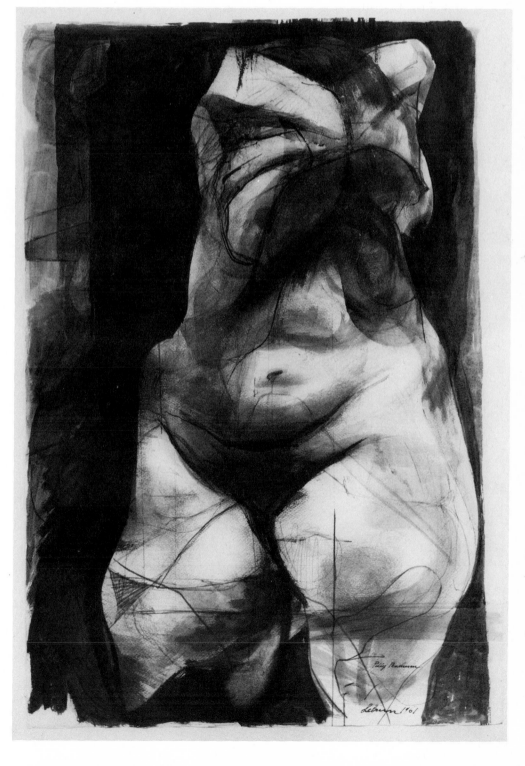

Jack Tworkov (Biala, Poland, 1900—)

Another example of the stylistic possibilities of figure drawing is "Figure," 1957, by Jack Tworkov. The figure provides a motif upon which a structure of bold tense lines creates an abstract image which is more the artist's gesture than the elucidation of a specific figure. The kneaded eraser is used as a drawing tool to produce bold strokes of light by reaching through the stratified charcoal. "ACD #4" (abstract charcoal drawing), 1962, relates to the Barrier series of paintings produced in the 1960s, in which an underlying grid system is obliterated by a dense accumulation of lyrical, gestural lines.

In "R-PT-#1," 1972, the grid system of the Barrier series has emerged and become more explicit. The rule-drawn lines suggest planes which, grayed in with even, rhythmic pencil strokes, create movement across the surface. The ambiguous sense of space is intensified by the tilted wide-based trapezoids fanning out across the bottom edge of the drawing.

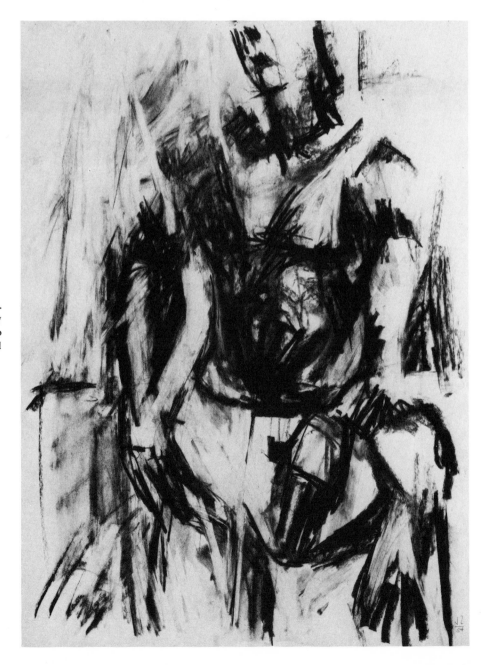

Jack Tworkov Figure. 1957. Charcoal, 25½ × 19. Courtesy Nancy Hoffman Gallery. Photo by Robert E. Mates and Paul Katz.

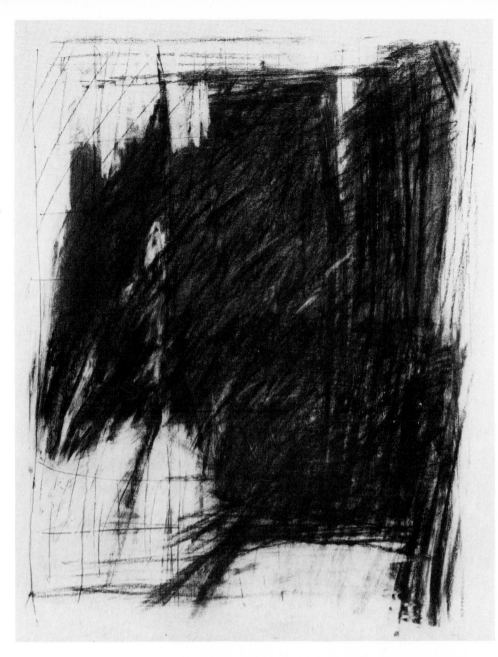

Jack Tworkov ACD #4. 1962. Pencil and charcoal, 26 × 20. Courtesy Oklahoma Art Center.

Jack Tworkov R–PT–#1. 1972. Pencil, 13 × 18¼. Courtesy Nancy Hoffman Gallery. Photo by Robert E. Mates and Paul Katz. ▼

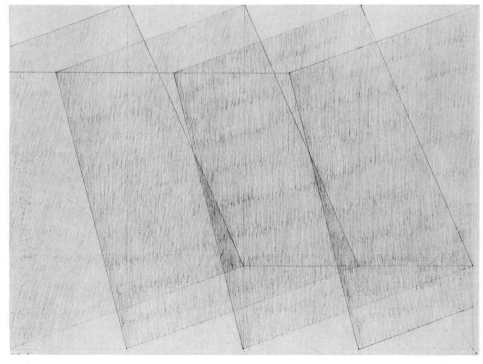

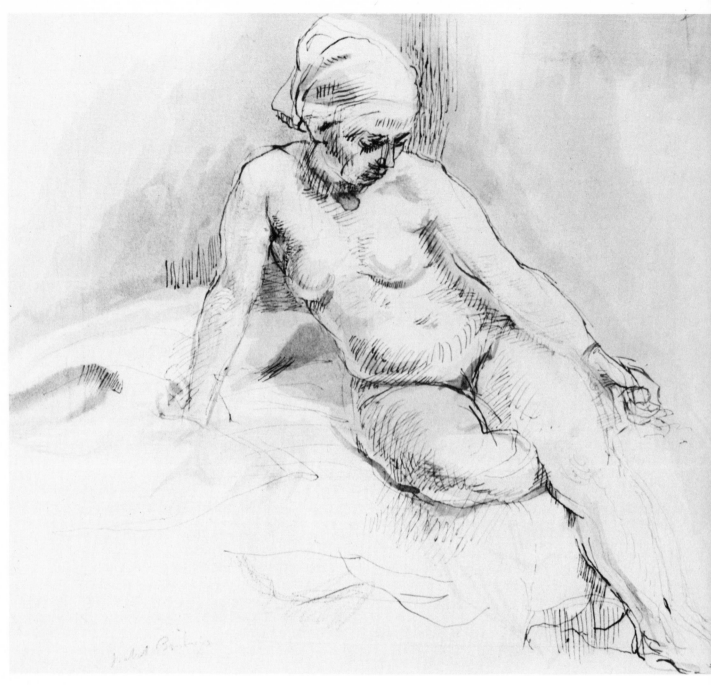

Isabel Bishop (Cincinnati, 1902–)

The challenge of maintaining consistently high standards within a specific tradition for a considerable period of time has been successfully met by Isabel Bishop. A student of Kenneth Hayes Miller at the Art Students League, she soon developed a personal style while retaining an interest in Miller's subject matter—Fourteenth Street, Union Square, and Broadway. A productive printmaker since the mid-1920s, Bishop has maintained a similar quality of line in both media. "Nude," 1938, an ink-and-wash drawing of a semi-reclining figure, manifests an apparent simplicity in the ease with which the strokes skillfully produce the form. The artist's relaxed enjoyment of the figurative tradition is apparent in her sure skill and intimate approach to the subject.

Isabel Bishop Nude. 1938. Ink and wash, 5¾ × 6½. Courtesy Collection of Edward Jacobson.

Willem de Kooning (Rotterdam, 1904—)

Willem de Kooning Elaine de Kooning. 1940–1941. Pencil, 12¼ × 11⅞. Courtesy Allan Stone Galleries, Inc. Photo by Eric Pollitzer.

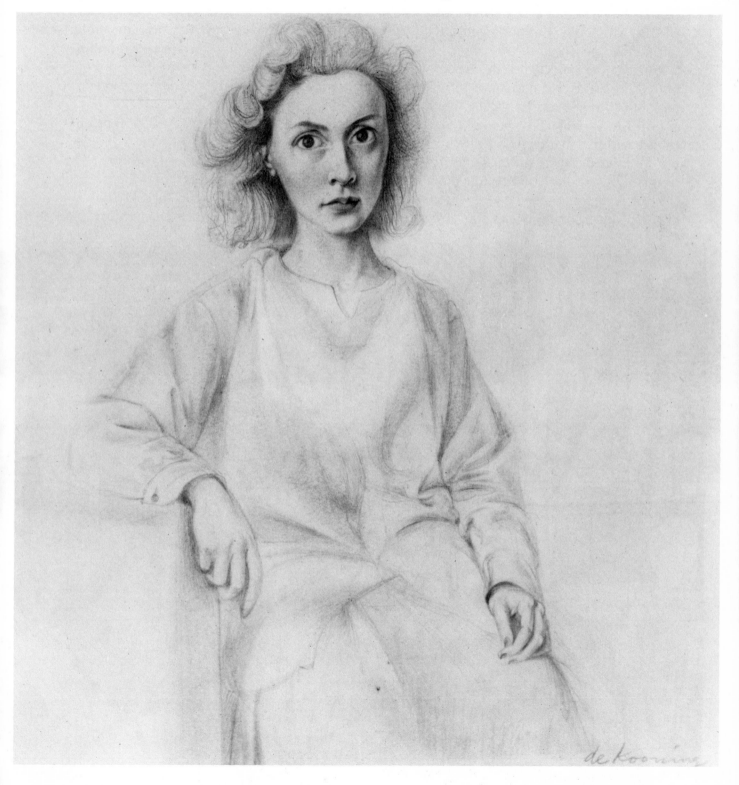

Willem de Kooning's academic training at the Rotterdam Academy of Fine Arts and Techniques is still evident in his 1940–1941 drawing "Elaine de Kooning." The nimbus of hair serves to focus attention on the face, clearly drawn with a delicate Ingres-like pencil line which offers a subtle contrast to the soft sketchy surface of the drapery.

During the mid-1940s de Kooning explored the forms first developed in his paintings of a decade earlier, using bold open gestures to increase the sense of energy and chance within a shallow, controlled space. He has abstracted the traditional motifs of interiors, figures, and still-life into non-objective imagery. "Black and White Abstraction" of 1950 incorporates accidental drips and paint splotches, indicating a new informal attitude toward surface and finish.

Concurrently with these complex abstractions, de Kooning produced a series of dramatic frontal depictions of the female nude. Though related to his abstract works in technique, these women indicate the artist's desire to retain a certain recognizability of subject. De Kooning's woman has become a symbol presented with great psychological and dramatic explosiveness.

The untitled drawing of 1969 continues to explore the female form with a gestural, but now more pleasurable, lyric line. The cluster of lines coalescing on the page presents us with a form transformed from an obsession to a subject for human enjoyment.

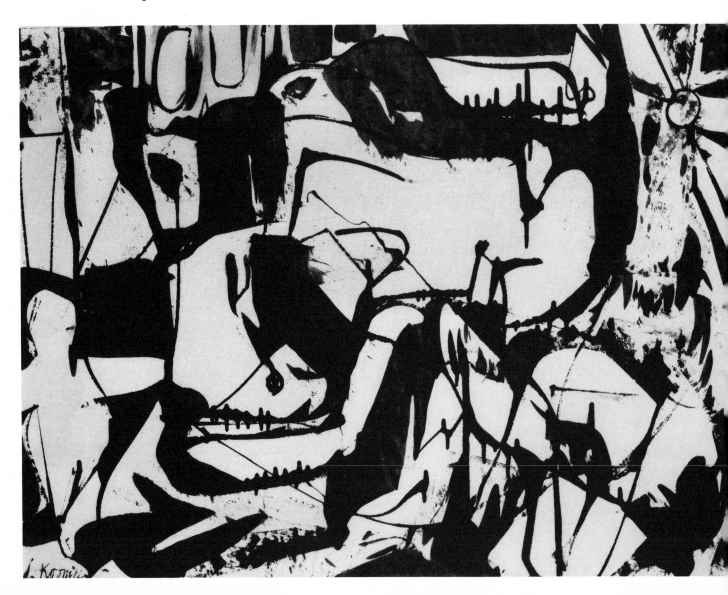

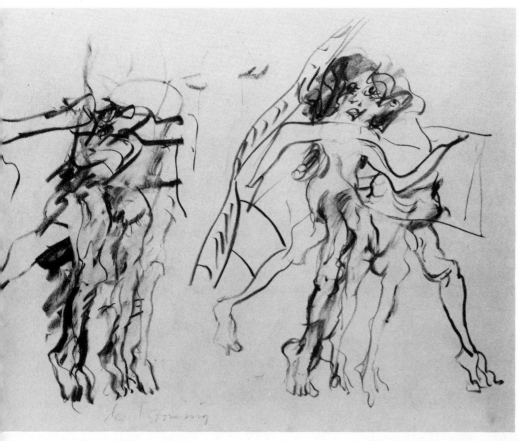

Willem de Kooning Black and White Abstraction. c. 1950.
Sapolin enamel, 21¾ × 29¾. Courtesy Sotheby Parke Bernet,
Inc. ◄

Willem de Kooning Woman. 1953. Charcoal, 36 × 24. Cour-
tesy Allan Stone Galleries, Inc. Photo by Rudolph Burck-
hardt. ►

Willem de Kooning Untitled. 1969. Charcoal, 24 × 18¾.
Courtesy Fourcade, Droll, Inc. ▲

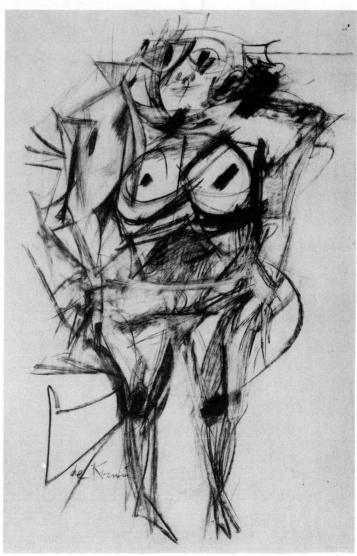

Paul Cadmus (New York, 1904–)

Even as late as the 1930s American attempts at major figurative painting, to be considered valid, had to emulate masterpieces of a distant European tradition without reference to contemporary art. Following this direction is the 1937 drawing "Bewailing of Christ" by Paul Cadmus. The carefully arranged figures are drawn in a heavy pencil outline; internal details are indicated by hatched lines that trace the contours of the figures and define the lights and darks. The consistency of line, varying only in weight and tone, contributes to the unity of the elaborate composition.

Cadmus's later drawings generally feature single figures, as in "Male Nude," drawn in crayon and touched with white highlights. The increased variety in the weight and texture of the lines and the ease of execution characterize the artist's mature style.

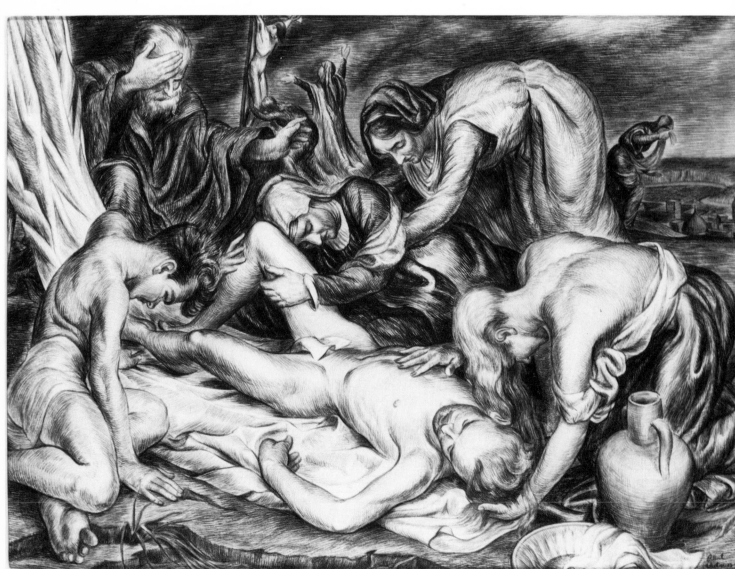

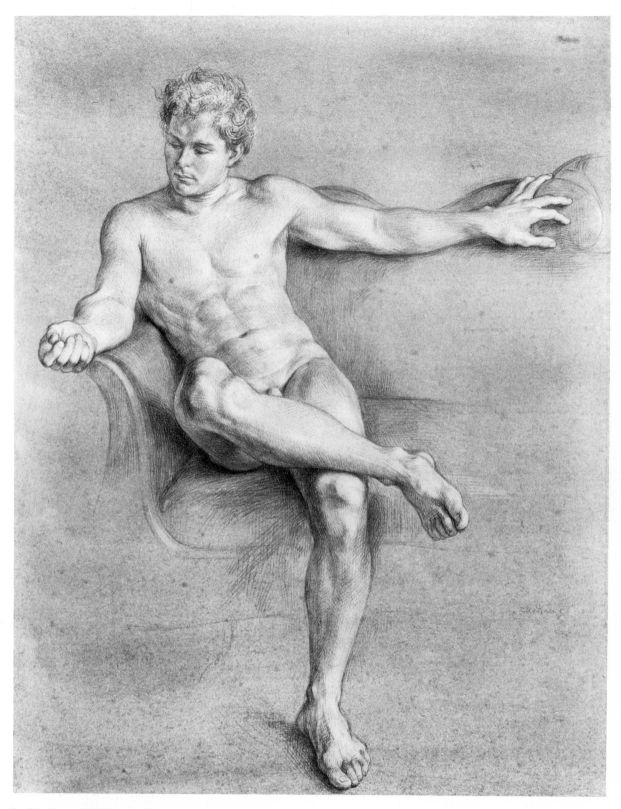

Paul Cadmus Male Nude. 1966. Crayon, 24 × 18⅛. Dr. and
Mrs. Theodore Rosen. Courtesy Midtown Galleries. Photo
by O. E. Nelson. ▲

Paul Cadmus Bewailing of Christ. 1937. Pencil, 9¾ × 13¾.
Courtesy Dartmouth College Collection. ◄

Arshile Gorky (Armenia, 1904—Sherman, Conn., 1948)

Arshile Gorky frequently explored certain motifs in series of drawings, as preparation for major paintings. Reproduced here is a drawing of such a series, which was begun about 1929 and led to the painting "Nighttime Enigma and Nostalgia" of about 1934. In this study, one dominant plane enters from the left and is met by a smaller recessive plane from the right; the composition is completed by shallow bands across the top and bottom. Each panel contains a different image, which changes from drawing to drawing in the series, expressed in Gorky's evenly controlled line, with hatchings, scribbles, and painted areas of ink. Gorky was strongly influenced by Picasso in the early 1930s, yet this drawing bears Gorky's unmistakably individual stamp.

Associated with the Surrealists, John D. Graham, and Willem de Kooning, among others, Gorky exerted a profound influence on American painting during his short career. The sensuousness of his line is apparent in the later drawing "Study for *They Will Take My Island*" of 1944. Gorky often worked from specific sources in nature; his metaphor enriches our observation and experience of nature.

"Summation," 1947 (the title was added after his death), is the largest drawing Gorky produced. The clearly defined images, executed in pencil and pastel, and the grandeur of the complex composition give this drawing a particular monumentality rarely found in drawing.

Arshile Gorky Abstract Drawing with Bust. c. 1929–1932. India ink, 22 × 30. Courtesy Collection of Jerome Forman. Photo by Geoffrey Clements.

Arshile Gorky Study for They Will Take My Island. 1944. Crayon, 22 × 30. Courtesy The Brooklyn Museum, Dick S. Ramsay Fund.

Arshile Gorky Summation. 1947. Pastel and pencil, 79⅝ × 101¾. Courtesy The Museum of Modern Art. Photo by Adolph Studley. ▼

Burgoyne Diller (New York, 1906—New York, 1965)

One of the first American artists to subscribe to Mondrian's ideology was Burgoyne Diller, who evolved an individual style of considerable merit. "Untitled," 1944, is a more personal response to geometricizing than the rigid precision of many later artists who came to rely upon the strictures of prepared graph paper. The dark border frames the drawing's central image; horizontal lines are accepted or restrained by repeated vertical bands, which alternate with white spaces, creating contrast and tension.

A late drawing, "Untitled," 1962, reflects a different attitude and is related to the sculpture Diller began to produce late in his life. Using only the minimal elements of a square containing four rectangles, Diller is able to maintain an intense visual tension. The gray pencil wash produces ambiguous relationships of space, surface, and plane, which Diller fully exploits by delicately balancing the vertical and horizontal rectangles.

Burgoyne Diller Untitled. 1944. Pencil, 10 × 10. Courtesy Noah Goldowsky Gallery. Photo by Nathan Rabin.

112

Burgoyne Diller Untitled. 1962. Pencil, 12 × 11½. Courtesy
Noah Goldowsky Gallery. Photo by Nathan Rabin.

Peter Blume (Russia, 1906—)

Peter Blume Coal Breaker—Scranton. 1930. Pencil, $9\frac{1}{8} \times 11\frac{7}{8}$. Courtesy The Metropolitan Museum of Art, Rogers Fund, 1953.

"Coal Breaker—Scranton," 1930, an early pencil drawing, dates from the year of Peter Blume's first one-man exhibition at the Daniels Gallery in New York. It exemplifies the style of the precisionists and their new romantic view of the industrial landscape. Blume has selected large shapes, treating them with a variety of closely modulated textures and moving light and dark across their surface, while implying that the light has its source inside the subject.

A later drawing, "Early Spring," 1957, composed with a free pen stroke, catches the spirit of an Italian agricultural landscape in a variety of lines, dots, dashes, and squiggles. Through the rich use of graphic textures, Blume enlivens the individual plantings, workers, buildings, animals, and trees in the clear bright light of the Mediterranean.

Peter Blume Early Spring. 1957. Ink, 8⅝ × 11⅛. Courtesy The Metropolitan Museum of Art, Bequest of Stephen C. Clark, 1960.

David Smith (Decatur, Ind., 1906—Bennington, Vt., 1965)

"Drawings usually are not pompous enough to be called works of art. They are often too truthful. Their appreciation neglected, drawings remain the life force of the artist." So spoke David Smith in a 1955 lecture. He produced many studies for his sculptures, although he also made drawings from the model simply because he enjoyed drawing the human figure. This untitled work from the late 1930s, derived from a moving female form, is related to the sculpture "Vertical Structure," 1939. Smith acknowledges his interest in Gonzalez and Picasso's images of the late 1920s and early 1930s. His blunt method of drawing and

shading here indicates his use of the drawing as a means of developing the sculpture's images rather than a primary interest in refined drawing technique.

The bolder style of his later years appears in another untitled oil sketch related to the sculpture "Study in Arcs" of 1959. In this drawing he has inverted the plan of the sculpture and added a massive horizontal bar and a series of disks. Although Smith's drawings exhibit the flat patterning characteristic of most sculptor's sketches, his innate vitality makes them considerable works of art in their own right.

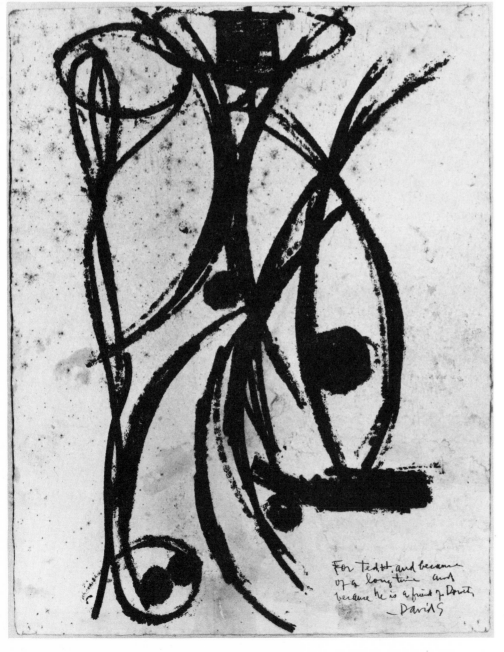

David Smith Untitled. Late 1930s. Ink and pencil, 13^{15}/$_{16}$ × 9^{13}/$_{16}$. Courtesy The Archives of American Art, Smithsonian Institution, The David Smith Papers and The Estate of David Smith. ◄

David Smith Untitled. Late 1950s. Oil, 20^{1}/$_{8}$ × 15^{3}/$_{4}$. Courtesy The Brooklyn Museum, Gift of Louise Nevelson in Memory of Theodore Haseltine.

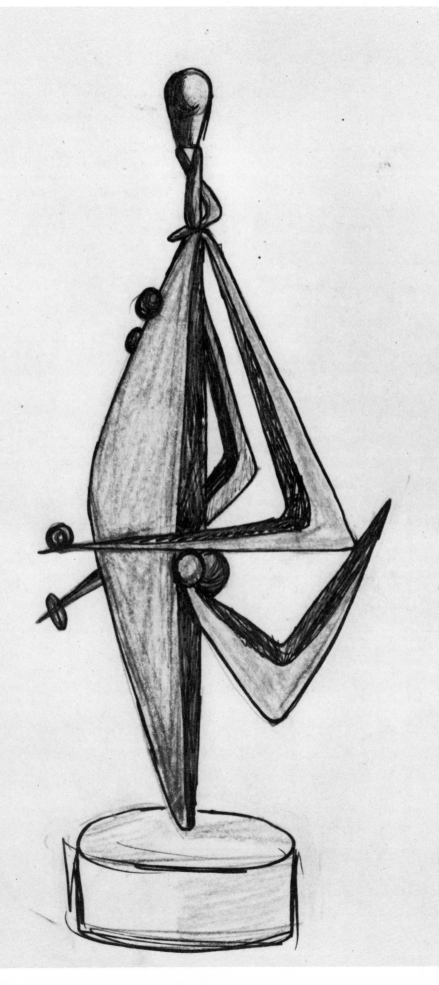

Ludwig Sander (New York, 1906—New York, 1975)

Once a student of Hans Hofmann in Munich, Ludwig Sander had long been an abstract painter. Yet early in his development he drew from nature and created the forms from which he evolved his abstract images. Never a disciple of Mondrian's neo-plastic theories, Sander developed a spartan image in which the lines define broad planes held in check by panels of darker tones. His later drawing style shows an increased freedom of gesture and openness of image.

Ludwig Sander Untitled. 1949. Charcoal, 19 × 25. Courtesy The Artist.

Ludwig Sander Untitled. 1969. Charcoal, 19 × 25. Courtesy The Artist. ▶

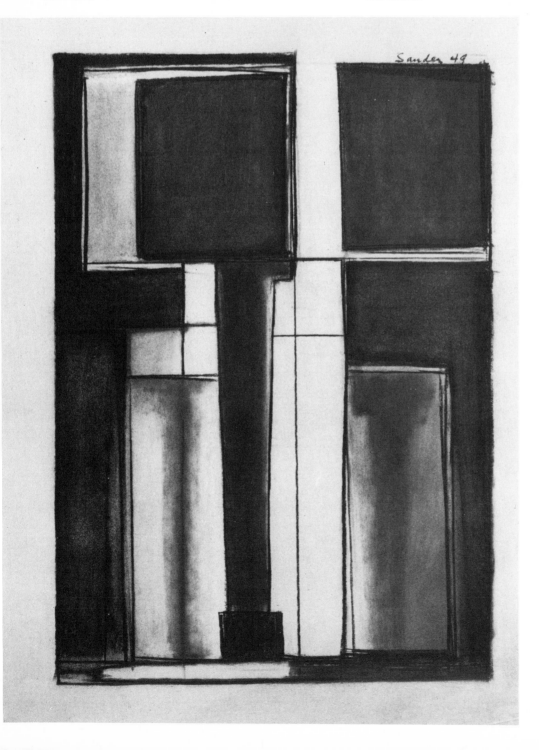

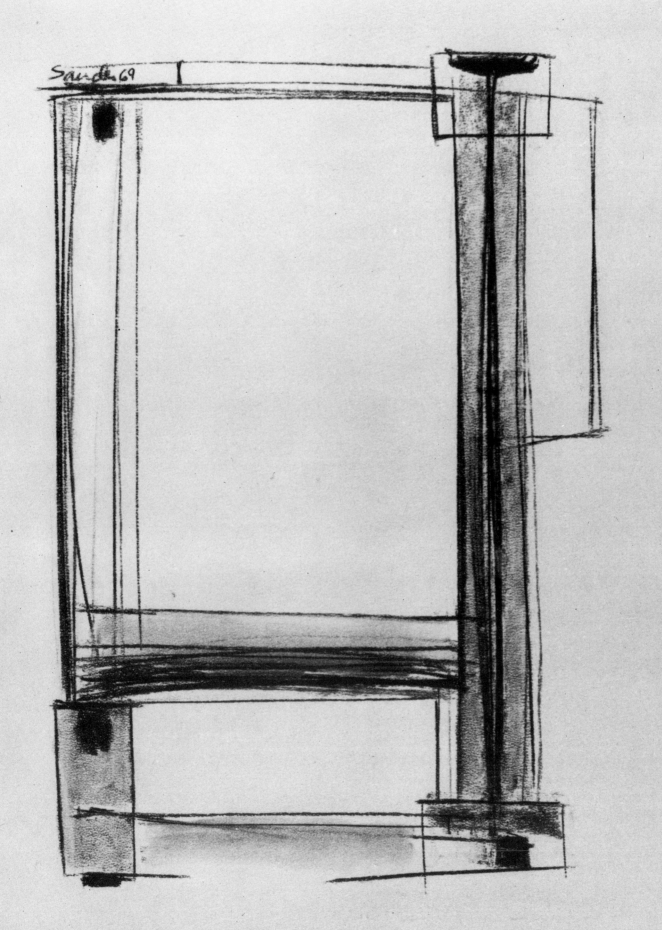

119

Charles Biederman (Cleveland, 1906—)

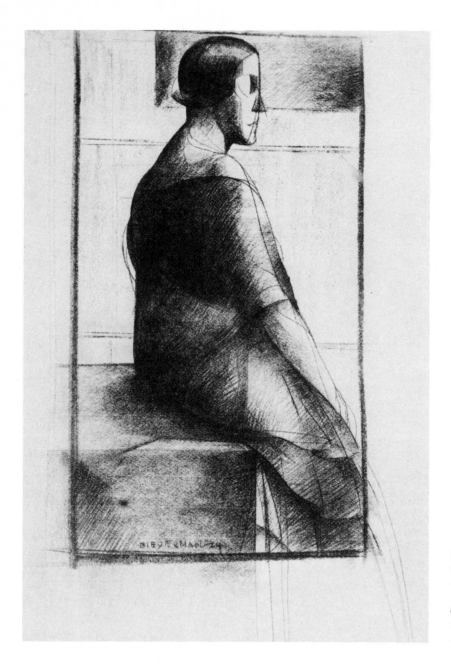

Charles Biederman Figure. 1929. Charcoal, 19 × 10¾. Courtesy The Artist.

Charles Biederman Self-portrait. 1930. Charcoal, 25½ × 20. Courtesy The Artist. ▶

As a student in Chicago from 1926 to 1929, Charles Biederman was influenced by Cézanne and cubist principles. The charcoal drawing, 1929, suggests these influences, although he places the figure in a traditional deep space with more modeling than might be expected in a purely cubist work. Hatching develops the forms created by long flowing lines. A self-portrait of the following year shows increased simplification and a more rigidly controlled use of geometrical planes.

In late 1937, Biederman visited the Paris World's Fair and found the technical exhibits more stimulating than the art displays. This discovery catalyzed his metamorphosis from painter into "structurist." It was the year he ceased to "draw, paint, or sculpt" and began to "use the new medium of art—the machine."

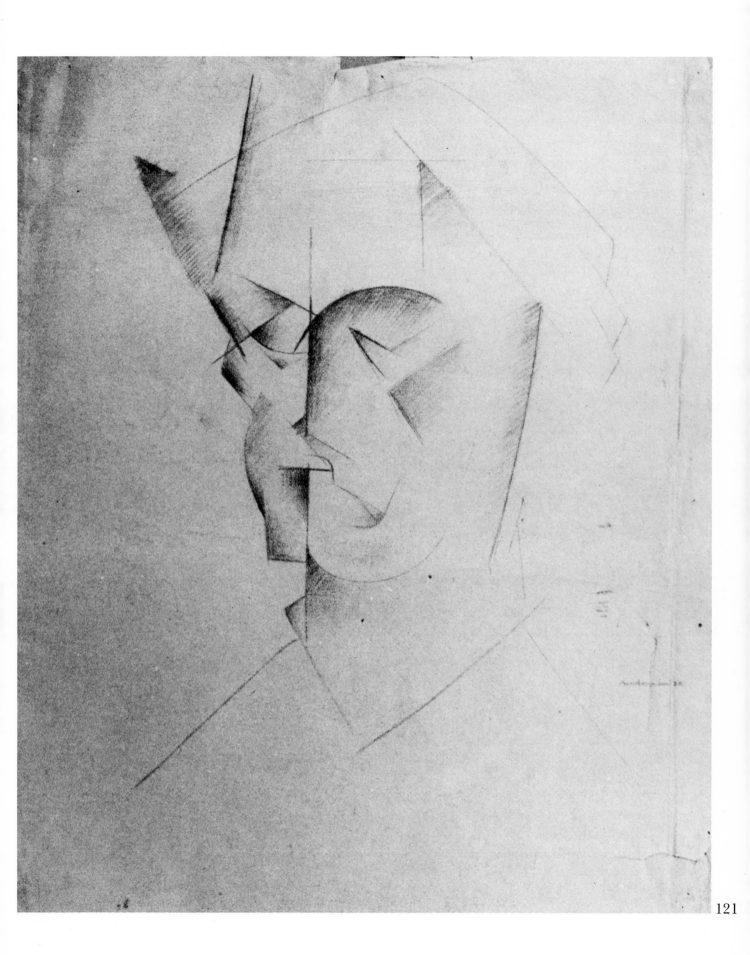

121

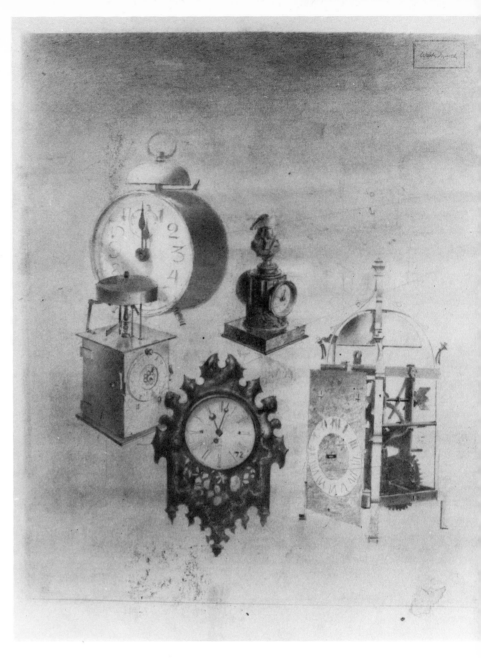

Walter Murch (Toronto, 1907—New York, 1967)

Artists as different from each other as Walter Murch and Edwin Dickinson possess the rare faculty of materializing objects out of light. "Fortune Clocks (Napoleon)," an early commissioned work, combines Murch's fascination with machine fragments, the suspension of objects in light-suffused space, and the drawing of objects in thin delicate lines augmented by a gentle tonal modeling. The gray, folded softness of the fabric is an effective contrast to the cleanly drawn forms of the sundry clocks.

In a late work, "Pressure Gauge," 1966, the objects are rendered in a more painterly style, though they retain a definite solidity in spite of the soft, rather evanescent surface. The gestural markings of the background create an ambiguous space which sets off the clean polished surfaces of the gauge.

Walter Murch Fortune Clocks (Napoleon). n.d. Pencil, 20 × 15. Courtesy Betty Parsons Gallery. Photo by Eric Pollitzer.

Walter Murch Pressure Gage. 1966. Mixed media, 27¾ × 21¼. Courtesy Betty Parsons Gallery, Collection Mrs. Will Connelly. ▶

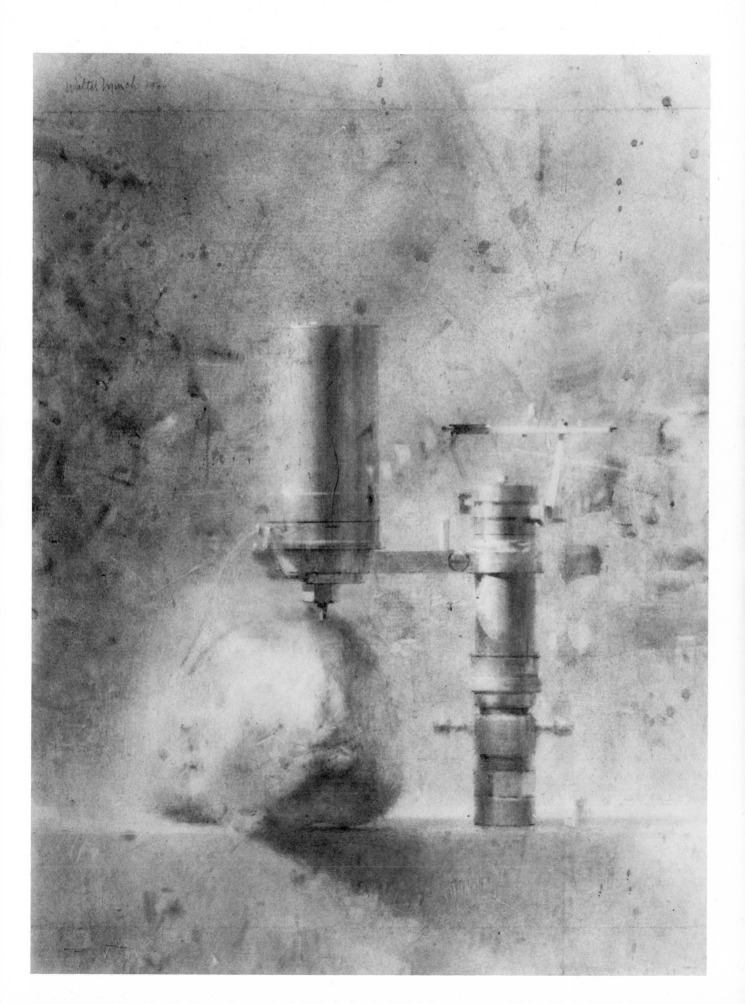

Theodore Roszak (Posnan, Poland, 1907—)

Theodore Roszak's large drawing, "Night Flight" of 1957, is a study for the sculpture of the same title. In it the sculptor develops a series of bold forms which sweep exuberantly across the page. The implication of speed is increased by the sunburst behind the leading edge of the image. Freely drawn with many small parallel arcs defining its curving planes, the image is further dramatized by a wash which indicates the lights and darks of the object and its ambience. The textures in the drawing closely approximate the corruscated surface of the finished sculpture.

Theodore Roszak Night Flight. 1957. Ink, 47 × 61. Courtesy The Minnesota Museum of Art.

Ilya Bolotowsky (Petrograd, Russia, 1907–)

During the late 1930s Ilya Bolotowsky was concerned simultaneously with biomorphism, a style involving free floating curvilinear forms derived from nature, scientific inquiry, or the imagination, and with the neoplastic abstraction of Mondrian. By the early 1940s the concepts of neoplasticism prevailed. This untitled diamond-shaped drawing of 1950 is an example of Bolotowsky's contribution to the evolution of those theories. Although Mondrian usually avoided the diamond shape, Bolotowsky has used it for many years, perhaps for the tensions it affords an otherwise static composi-

tion. The textures of the various gray forms do not activate the spatial relationships in the composition but rather give them solidity.

In a later work, "Blue and Black Vertical" of 1971, Bolotowsky explores the same concepts, and continues to use a straight edge to produce a tough consistent line; but by drawing the lines so closely parallel, he has produced a dense textured surface.

Ilya Bolotowsky Untitled. 1939. Ink, 9 × 10¾. Courtesy Grace Borgenicht Gallery. Photo by Robert E. Mates and Paul Katz.

Ilya Bolotowsky Untitled. 1950. Ink and pencil, 11⅝ × 11⅝.
Courtesy Grace Borgenicht Gallery. Photo by Robert E.
Mates and Paul Katz. ▲

Ilya Bolotowsky Blue and Black Vertical. 1971. Ink, 30 × 22.
Courtesy Grace Borgenicht Gallery. Photo by Robert E.
Mates and Paul Katz. ▶

Fairfield Porter (Winnetka, Ill., 1907—Southampton, N.Y., 1975)

Fairfield Porter Reverse Image. n.d. Ink, 10¼ × 9½. Courtesy Collection of Edward Jacobson.

For more than two decades Fairfield Porter employed two styles of drawing. "Reverse Image" is an ink drawing in which he uses outline—drawn in various densities—to create a dramatic contrast between choppy angular forms broken by light and softer, more lyrical lines which give stability to the composition.

An example of Porter's second style is "Untitled," 1968, a pencil drawing made as a study for a lithograph. Here the outlines are used simply to enclose panels of strong hatching which indicate shifting degrees of light and dark or brittle textural differences. By blending similar pencil strokes into textures, he enriches and unifies the drawing surface.

Fairfield Porter Untitled. 1968. Pencil, 22 × 30. Courtesy Tibor de Nagy Gallery. Photo by Eeva.

Myron Stout (Denton, Texas, 1908—)

A singular quality of Myron Stout's drawing is that the image often results from the areas on the page left uncovered by a dense charcoal texture. In "Three Round Forms" of about 1956, the line is reduced to an edge and the image can be either the white figures on a negative black background or a black screen through which we look into a negative white space. The same visual ambiguity appears in his geometric drawings.

Myron Stout Three Round Forms. c. 1956. Charcoal, 25¼ × 19¼. Courtesy Mr. and Mrs. Robert C. Scull. Photo by Rudolph Burckhardt.

John Koch (Toledo, 1909–)

The drawings of John Koch are often studies or fragments made in preparation for larger compositions. "Figure by an Easel" is a charming study of a model viewing a Koch painting, "The Visit," still in progress on an easel. The figure in this drawing is similar to that in another painting, "The Telephone."

Koch's line delicately builds up surface texture emphasizing the muscle structure and describing the shaded areas; the white of the paper is used to provide the highlights.

John Koch Figure by an Easel. n.d. Pencil, 16¼ × 13½. Courtesy Mrs. Ruth Lloyd. Photo by Oliver Baker.

131

Morris Graves Crane. 1954. Ink, 23¾ × 32½. Courtesy Private Collection. Photo by Walter Rosenblum. ▲

Morris Graves Dying Pigeon. 1937. Pencil, 10½ × 15. Courtesy The Willard Gallery. Photo by Adolph Studley. ▼

Morris Graves (Fox Valley, Ore., 1910–)

Animals, birds, and fishes are more than simple representations of nature in the work of Morris Graves; they have been transformed into symbols. "Dying Pigeon, #7," a pencil drawing of 1937, shows a form against a plain background, drawn with a consistent gray line, augmented by a heavy dark outline that both stabilizes the composition's design and dramatizes the bird's lifelessness.

Obviously influenced by Oriental calligraphy, the drawing of the stalking crane, 1954, shows the bird moving across the picture plane into the space before it. The natural setting is suggested by the brushed background and hazy horizon line, with a few vertical strokes indicating clumps of marsh grass. The variety of open lines in the bird's body contrasts effectively with the patterned feathers, giving a sense of the intensity and determination in the bird's movement.

A familiar ancient symbol, the circle becomes in Graves' hands a deceptively simple, dramatic gesture. "Circle Void," 1970, is a single brushed line which moves from a bold beginning into increasingly lighter grays, suggesting the envelope of the yin-yang symbol in a powerful iconic form.

Morris Graves Circle Void. 1970. Ink, 18½ × 17½. Courtesy The Willard Gallery. Photo by Geoffrey Clements.

Franz Kline (Wilkes-Barre, 1910—New York, 1962)

Franz Kline's abstract style coalesced in the early 1950s when, on a chance suggestion, he placed a drawing in an opaque projector and used the amplified image as a study for a painting. Using a brush, he then developed the open, calligraphic structure into one of thickly and forcefully painted planes, combining a rough expressionist surface with a sense of the medium's liquid quality. The brush stroke itself seems to have become the essential subject matter in his later work.

Drawing served Kline as a method for developing images to be used in his paintings. Works such as "Night Figure," 1959, when enlarged to a monumental scale, change little in motif or basic gestural quality.

Franz Kline Untitled. c. 1950. Ink, 21 × 18. Courtesy Marlborough Gallery, Inc. Photo by Eric Pollitzer. ▲

Franz Kline Night Figure # I. 1959. Ink, 11 × 8½. Courtesy Sidney Janis Gallery. Photo by Oliver Baker. ►

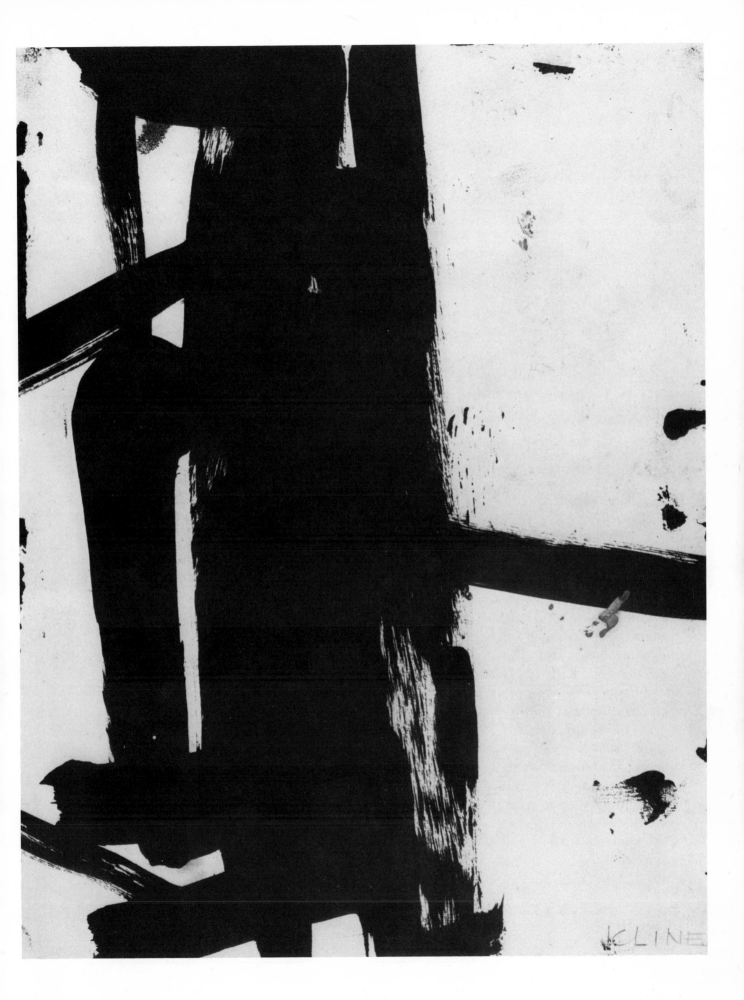

David Park (Boston, 1911—Berkeley, Cal.,
1960)

By 1955 abstract expressionism had be-
come a national American style. This was
the same year that David Park, Elmer
Bischoff, and Richard Diebenkorn began
their figure-drawing sessions which led to
what has become known as the California
school of figure painting. "Interior with
Figure," 1960, one of Park's last works, is rep-
resentative of his mature style. This small ink
drawing on paper is executed in thick lines
laid on in parallels to form panels of textural
contrasts. Shadows suggest plasticity, but the
space remains shallow and the composition
geometric.

David Park Interior with Figure. 1960. Ink, 8½ × 11. Cour-
tesy Staempfli Gallery, Collection of Bertrand Bell. Photo by
John D. Schiff.

136

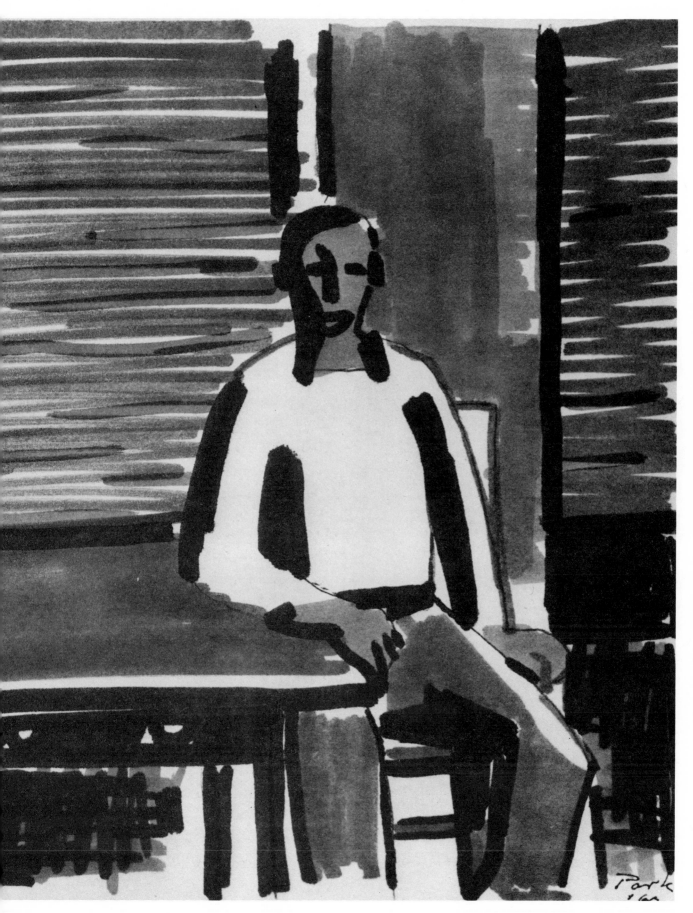

William Baziotes (Pittsburgh, 1912—New York, 1963)

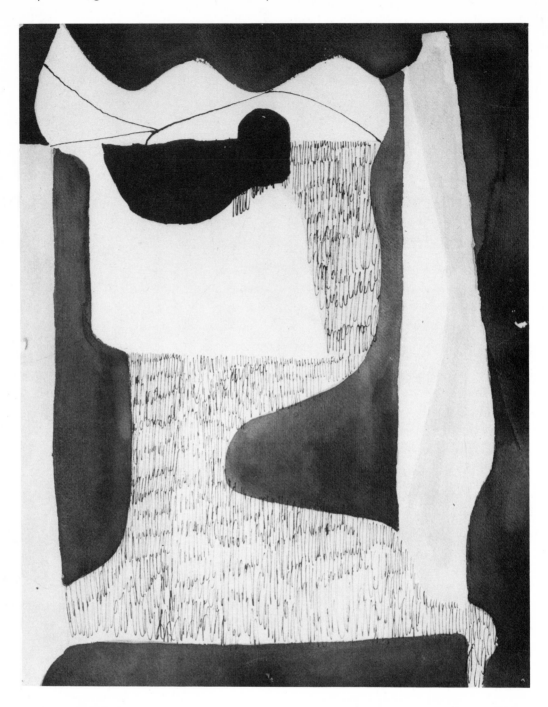

In the late 1930s the paintings of William Baziotes reflected the influence of biomorphism, with their fantastic shapes drawn from underwater forms painted in roughly handled, bright colors. By the mid-1940s his increased use of line gave even greater freedom and variety to these images. An untitled ink and watercolor drawing from this period shows how he differentiated moving, undulating shapes by combining line and wash. Pastel was a particularly effective medium for Baziotes. "Two Suns," 1952, with its contrasting use of repeated, free-form lines is typical of his lyrical mature style.

William Baziotes Untitled. c. 1945–1946. Ink and watercolor, 11 × 13¾. Courtesy Marlborough Gallery, Inc., Estate of William Baziotes. Photo by O. E. Nelson. ▲

William Baziotes Two Suns. 1952. Charcoal and pastel, 16¼ × 12½. Courtesy Marlborough Gallery, Inc., Estate of William Baziotes. Photo by Geoffrey Clements. ►

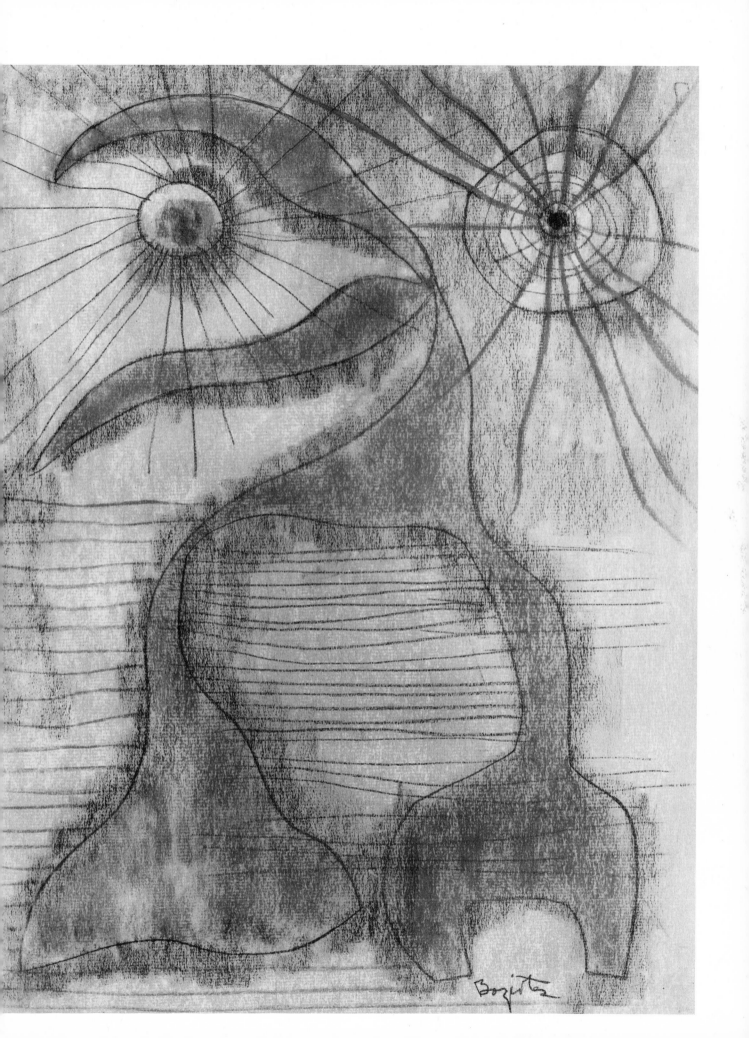

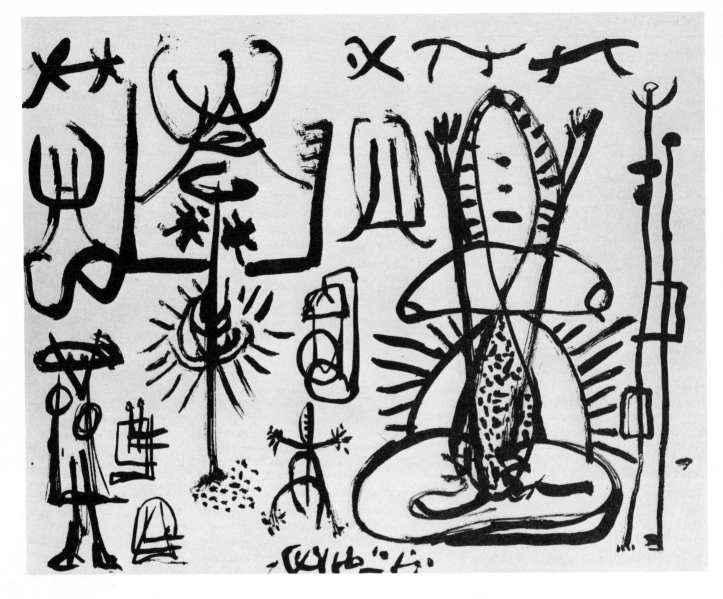

Jackson Pollock (Cody, Wyo., 1912—Southampton, N.Y., 1956)

This drawing of about 1938 by Jackson Pollock contains a repertoire of isolated gestures, shapes, and assorted figures that would later become more fully explored in his paintings. This kind of drawing is reflective of Pollock's style through the early 1940s.

By the mid-1940s the collections of disparate enigmatic images had evolved into more unified compositions. His drawing became a refined statement, moving close to the style of the paintings and reflecting, even in the smaller format, the rhythmic gesture he developed on his large canvases. This development can be seen in the work of 1951 reproduced here. Pollock continued to use ink rather than pencil as a drawing medium, probably for its liquid, paint-like quality.

Jackson Pollock Drawing. c. 1938. Ink, 13⅝ × 17⅞. Courtesy Marlborough Gallery, Inc. Collection of Lee Krasner Pollock. Photo by O. E. Nelson.

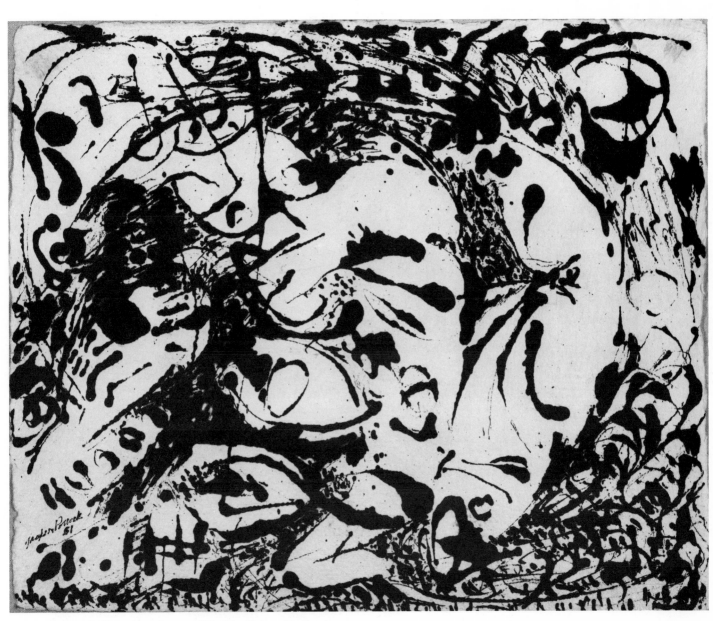

Jackson Pollock Drawing. c. 1951. Ink, 17¾ × 22. Courtesy
Marlborough Gallery, Inc. Collection of Lee Krasner Pollock.
Photo by O. E. Nelson.

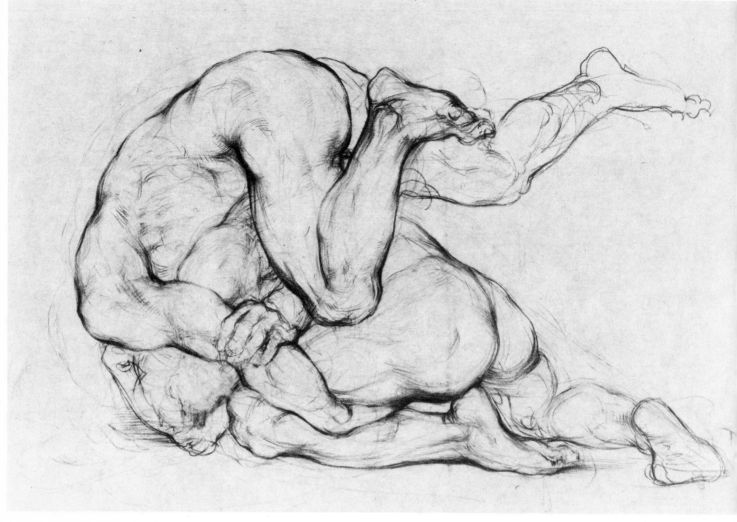

Hyman Bloom Wrestlers. c. 1930. Crayon, 10⅛ × 14⅛. Courtesy Fogg Art Museum, Harvard University, Bequest of Dr. Denman W. Ross.

Hyman Bloom (Riga, Latvia, 1913—)

One of the most interesting aspects of twentieth-century American art is the incredible variety of accomplished styles. It is difficult to imagine a master draftsman such as Hyman Bloom working at the same time and in the same place as such artists as Pollock or Samaras. A student of the influential teachers Harold Zimmerman and Denman Ross, Bloom avidly assimilated their interest in the styles and techniques of old-master drawing. The influence of Leonardo da Vinci and Michelangelo can be detected in Bloom's representation of massive three-dimensional form, exemplified by this drawing of wrestlers. Quite different in style, yet equally accomplished, is "Forest #1," 1971, in which the massed lines produce a dense texture through which intruding light enables us to identify individual forms.

Hyman Bloom Forest # 1. 1971. Ink, 23½ × 18½. Courtesy Terry Dintenfass, Inc., Courtesy Mrs. Jerry Goldberg. Photo by Walter Rosenblum.

Philip Guston (Montreal, 1913–)

Philip Guston Smoker. 1969. Pencil, 19 × 24. Courtesy The
Artist. Photo by Eric Pollitzer. ▶

Philip Guston Black and White. 1953. Ink, 18 × 16¾.
Courtesy Sidney Janis Gallery. Photo by Eric Pollitzer. ▼

In the early 1950s Philip Guston used a linear style represented here by "Black and White," an ink drawing of 1953. The downward movement of the mass of stilted lines is counteracted and stabilized by occasional horizontal strokes. The net of black ink holds a frozen light similar to the atmosphere of his representational murals and paintings of the 1930s and 1940s.

By the early 1960s Guston had moved away from abstract images and there emerged a new figuration reminiscent of his early work.

By the late 1960s these figures became more explicit, and were imbued with a high degree of fantasy and humor. An example of this style is "Smoker," a pencil drawing of 1969, showing a sinister hooded figure smoking a fat cigar and making a commanding gesture. The imposing form is given three-dimensionality and weight through the use of shading, but there is a relaxed quality in the outline and the mocking use of cartoon-like forms.

Henry Pearson (Kinston, N.C., 1914—)

The tradition of drawing images on a one-dimensional surface is broken by Henry Pearson, who covers papier-mâché spheres with undulating ink lines. The surface of the form seems to contract and expand through the subtle and restless variations of the network; the spaces between the lines become as important as the lines themselves, creating rhythms which maintain the surface unity by shifting areas of darks and lights.

Henry Pearson Mochizuki. 1966. Ink on papier-mâché, 9 inch diameter. Courtesy The Minnesota Museum of Art.

Saul Steinberg Railway. 1951. Ink, 19½ × 30. Courtesy Sidney Janis Gallery. Photo by Oliver Baker.

Saul Steinberg (Râmnicul-Sărat, Rumania, 1914—)

Saul Steinberg's ability to grasp the essence of a style or technique becomes superb parody through the wit with which he transforms traditional motifs. Particularly fascinated with architecture, Steinberg can convey the fundamental spirit of a given building in a few clearly drawn lines. "Railway," 1951, is a lively network of lines which captures the vintage European glass house railway station and contrasts it with the solidly drawn engine in front.

The later drawings of Steinberg are rather more complicated in their imagery, though their target is always clear. Official pomp is a frequent recipient of his invective. In "Biog-

raphy," 1968, he comments on the absurdity of red-tape traveling: the passport-like document encrusted with official seals and indecipherable signatures is contrasted with snapshot-like portraits, landscapes, and washy skies through which official seals occasionally move as heavenly bodies. Steinberg utilizes a complex assortment of rubber-stamp forms—lines, arcs, various figures, animals, and emblems—which are used alone or in combination with more traditional drawing methods.

Saul Steinberg Biography. 1968. Ink, watercolor, and acrylic, 30 × 40. Courtesy Sidney Janis Gallery. Photo by Geoffrey Clements.

147

Nassos Daphnis (Krockeai, Greece, 1914—)

Nassos Daphnis 6–57. 1957. Ink, 30 × 40. Courtesy The Artist. Photo by Rudolph Burckhardt.

The early nonfigurative paintings of Nassos Daphnis were of flat, slightly surrealistic organic shapes painted in primary colors and black and white. In the early 1950s he moved toward geometric abstraction; in "6–57," four right angles intrude upon the central space from each corner, forming a single central image. The bold simplicity of this design contrasts dramatically with the abstract expressionist style of Daphnis' contemporaries.

A later drawing, "D–2–74," 1974, executed in pencil on paper, shows the artist's continued control over his medium. The heraldic-like form is composed of mirror images which are related to the visual transformations of Albers.

Nassos Daphnis D–2–74. 1974. Pencil, 32¾ × 48½. Courtesy Leo Castelli Gallery. Photo by Bruce C. Jones. ►

149

Jack Levine (Boston, 1915–)

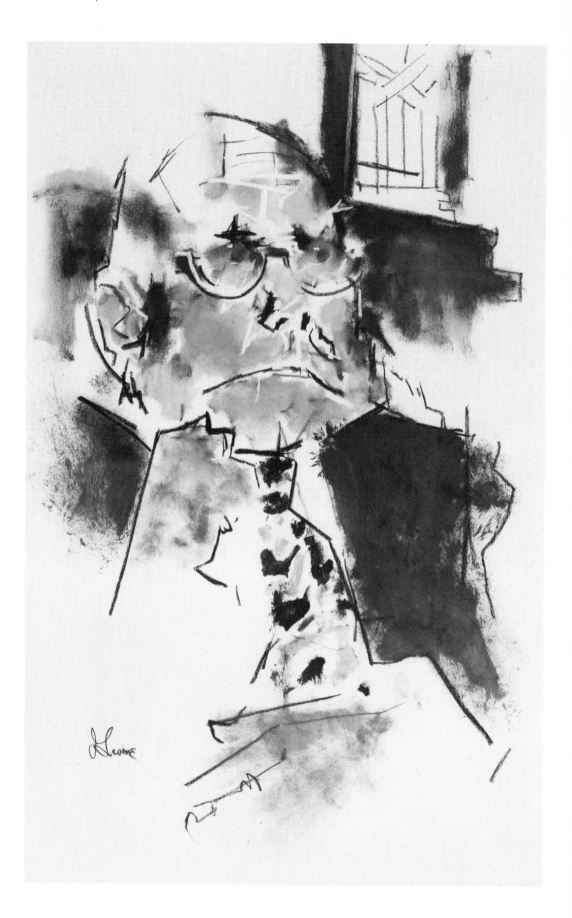

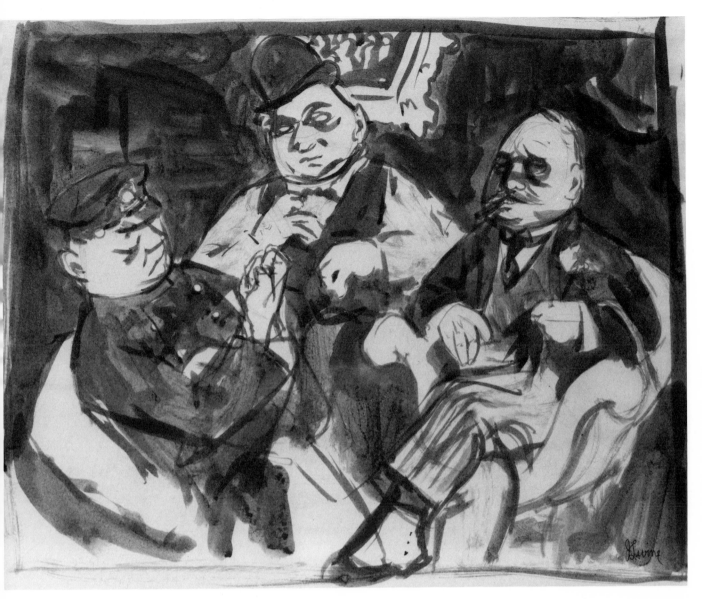

Jack Levine Fashionable Necktie in a Courtroom. c. 1972–73. Oil and pastel, 39¾ × 25¼. Courtesy Kennedy Galleries, Inc. Photo by Taylor and Dull, Inc. ◄

Jack Levine Study for "Feast of Pure Reason." 1937. Ink and gouache, 13 × 16¼. Courtesy Kennedy Galleries, Inc. Photo by Taylor and Dull, Inc. ▲

Jack Levine's painting, "Feast of Pure Reason," 1937, indicts the collusion of business, politics, and crime. In this study for the painting, Levine first divides the page with a pencil into four quadrants and with the resulting series of triangled areas focuses our attention on each subject. He then uses a wash to develop the forms and the patterns of light and dark. Although he is concerned primarily with overall composition at this early stage, Levine cannot resist endowing his characters with individual personalities.

Levine's work has continued to focus on social issues since the 1930s but in the drawing reproduced here, typical of his recent work, his use of line and strong highlights shows a much bolder handling of the materials. Although the drawing is more abstract in conception than his earlier work, the characterization remains powerful.

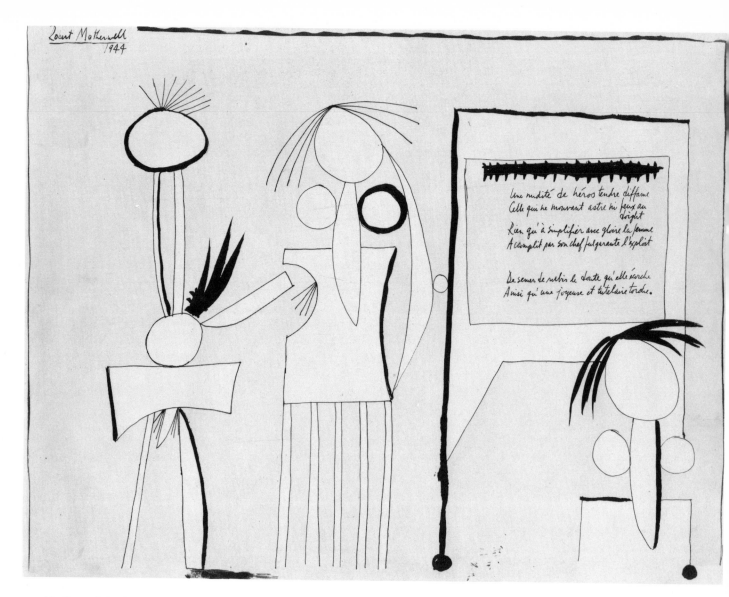

Robert Motherwell (Aberdeen, Wash., 1915—)

The presence of the French surrealists in America during the late 1930s and early 1940s was, for many young American artists, a catalyst of sensibility rather than a direct inspiration of specific imagery. The influence of Picasso was supplemented by an increased awareness of Matisse and Miró. "Une Nudité de Héros Tendre," an ink and wash drawing of 1944, the year of Robert Motherwell's first one-man exhibition, is a rare instance in which we find a single work containing so much information that it can almost suggest a cornerstone to the artist's oeuvre. This drawing contains a repertoire of images to be used in later works and reflects the artist's intense interest in French culture with the quote from Mallarmé's "La Chevelure."

A series that would occupy Motherwell for many years began in 1948 with a small ink on paper drawing entitled "Elegy to the Spanish Republic #1." The flat pattern of alternating rectangles and ovoid shapes forms a plinth which supports a panel of text from a poem by Harold Rosenberg. The painterly quality of the ink is exploited as it is dragged off the brush, producing dry-brush textures and dark solids which are confined within elegant soft edges.

The "Study for Open Series #17," 1968, a drawing with acrylic and charcoal, retains the painterly line quality and the space of the 1944 drawing, though the image is classically simple by comparison.

Robert Motherwell Une Nudité de Héros Tendre. 1944. Ink and watercolor, 18⅞ × 24½. Courtesy The Philadelphia Museum of Art, The Beatrice Pastorius Turner Fund. Photo by A. J. Wyatt.

Robert Motherwell Elegy to the Spanish Republic # 1. 1948. Ink, 10½ × 8⅛. Courtesy The Artist. Photo by Peter A. Juley and Son. ▶

Robert Motherwell Study for Open Series # 17. 1968. Acrylic and charcoal, 30 × 22½. Courtesy The Artist. Photo by O. E. Nelson. ▼

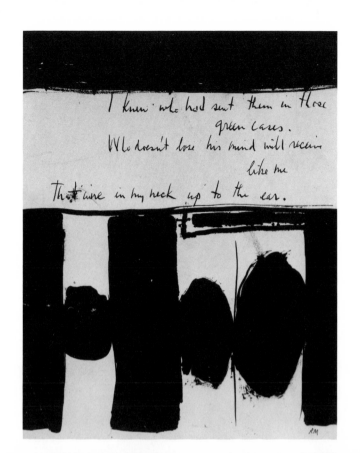

Elmer Bischoff (Berkeley, 1916—)

Elmer Bischoff Nude and Interior. 1962. Charcoal, 16¾ × 14. Courtesy Mrs. Robert M. Benjamin. Photo by Geoffrey Clements.

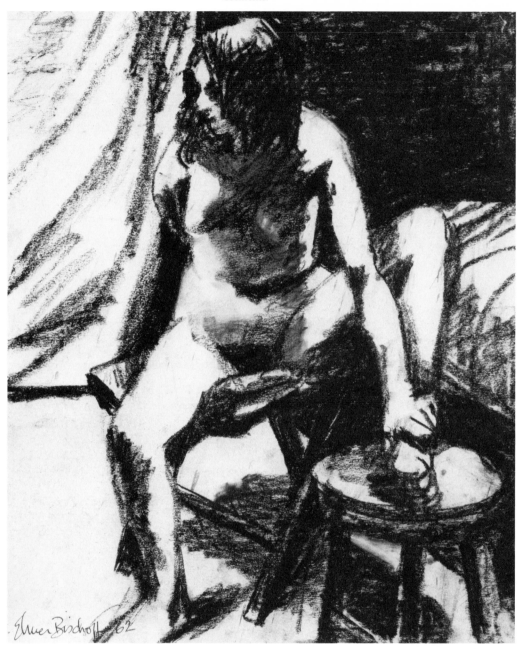

Charcoal provides an extraordinarily wide range of textures and tonalities. In this drawing of a seated nude, Elmer Bischoff utilizes its rough textural qualities to produce a composition with sharp contrasts of light and dark. With a thick even line he briskly constructs the figure out of deep blacks, a few grays, and the whiteness of the paper. The coarse textures and generalized shapes suggest that this is less the portrayal of an individual than a catalyst for the act of drawing.

154

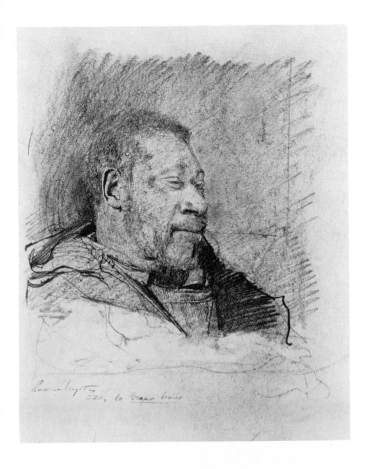

Andrew Wyeth (Chadds Ford, Pa., 1917–)

Akin to the tradition of Albrecht Dürer's meticulous drawing of plants, "The Great Piece of Turf," is the Andrew Wyeth watercolor "Spring Beauty," drawn when the artist was twenty-six. The artist's obsessive attention to natural detail is rendered in a wide assortment of textures and forms, held together by the tiny white flower, the focal center of the work. The artist's interest in light, only slightly evident in this early work, is fully expressed in the "Study for Grapevine," where the depiction of a specific person at a given time takes precedence over the artist's confident use of line.

Andrew Wyeth Study for Grapevine. n.d. Pencil, 13 × 16¾.
Courtesy Kennedy Galleries, Inc. Photo by Taylor and Dull, Inc. ◄
Andrew Wyeth Spring Beauty. 1943. Watercolor, 20 × 30.
Courtesy The University of Nebraska Art Gallery, J. M. Hall Collection. ▼

Wayne Thiebaud (Mesa, Ariz., 1920—)

Wayne Thiebaud's bright, thickly painted, almost-tasteable pies, cakes, candies, and toys offer a happy contrast to the traditionally dour subject matter of the California figure painters of the late 1950s and early 1960s. Thiebaud's drawing of pies has the same overpowering sharpness of light that appears a decade later in the West Coast sharp-focus realists. In order to maintain interest in the repeated image, Thiebaud has used minor variations in the lines and shadow areas.

Wayne Thiebaud Two Slices of Pie. 1964. Ink, 9 × 10. Courtesy Allan Stone Galleries, Inc.

John Hultberg (Berkeley, 1922–)

Machinery and architectural forms provide the discordant elements that John Hultberg combines to evoke the spirit of the modern American landscape. A close look at this untitled drawing will eventually reveal images that remind one of the view from a pilot's cabin or an engineer's tower. The space of the white landscape is made to seem infinite by contrast with the dark foreground which contains its own landscape.

John Hultberg Untitled. n.d. India ink, 19¾ × 29¾. Courtesy Collection of Edward Jacobson.

Leonard Baskin (New Brunswick, N.J., 1922–)

Leonard Baskin Owl. 1958. Ink, 24¼ × 37½. Courtesy Sotheby Parke Bernet, Inc.

The influence of printmaking, especially woodcuts, is evident in the mannered style of Leonard Baskin's drawings. The apparent dramatic flair of his dark haunting images with their ambiguous settings is achieved through the use of choppy repeated lines—a deliberate reflection of the expressionist woodcut line—and his reliance on the contrast of black and white. This opaque-eyed "Owl," 1958, is an escapee from neither bestiary nor barnyard, but an elegant decorative image. "Confused Man," with its appealing dry-brush ink technique, is heir to the expressionist humanist tradition.

Leonard Baskin Confused Man. n.d. Ink, 23 × 31. Courtesy The Memorial Art Gallery of the University of Rochester.

Richard Diebenkorn (Portland, Ore., 1922–)

Richard Diebenkorn is the youngest of the three expressionist figure painters who have been closely associated from their days at the California School of Fine Arts (the other two being Elmer Bischoff and David Park). In "#4," 1961, a seated nude is drawn with a sketchy, scribbled line that seems as often a gesture for its own sake as a descriptive element. Toward the end of the 1960s, Diebenkorn exhibits a more thoughtful control of line and an increased sense of the subject. The seated nude is a generalized, impersonal figure, while the woman in the swivel chair is a definite individual whose characteristics

Richard Diebenkorn #4. 1961. Ink and wash, 17 × 14. Courtesy The Poindexter Gallery.

and mood are expressed rather than obscured by the line.

In recent years Diebenkorn has evolved a non-objective style, influenced by his interest in the painting of Matisse. The line quality of his early work remains, now simplified and elongated; the forms are given additional dimension and texture through the use of erasure and rubbing.

Richard Diebenkorn Woman in Swivel Chair. 1968. Crayon, 17 × 14. Courtesy Mrs. Winthrop Sargeant. Photo by Eric Pollitzer.

Richard Diebenkorn Untitled. 1971. Charcoal, 34⅛ × 22½. Courtesy Lee Gallery. Photo by Steven Sloman.

Roy Lichtenstein (New York, 1923—)

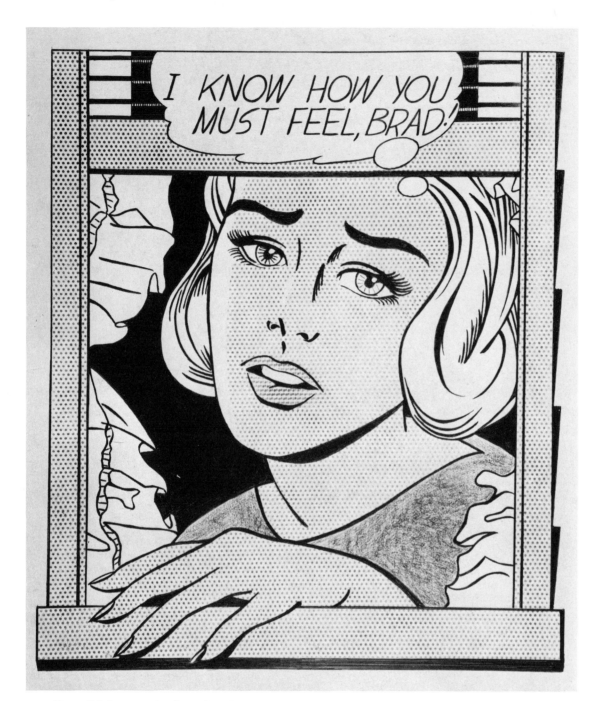

Roy Lichtenstein has developed a distinctive style by adapting subject matter and technique from popular printed cartoons. His use of line reflects modern photomechanical methods based on traditional woodblock printing. He shifts the original purpose of the benday dot, which was to produce tonal modulations, so that it becomes a means of expressing textural variety. In the drawing, "I know . . . Brad," 1963, Lichtenstein formed the dots by pushing stick tusche through a screen onto the page and drawing the lines with brush and ink.

Lichtenstein's informal style is shown in "Drawing for Kiss V," 1964, a freely drawn study for a painting in which he recomposes, tightens up, and re-emphasizes the cartoon images. The bold use of pencil in this drawing clarifies the complex baroque patterns.

Roy Lichtenstein "I know . . . Brad." 1963. Pencil, ink, and tusche, 30 × 22½. Courtesy Leo Castelli, Collection of Mrs. Vera List. Photo by Rudolph Burckhardt.

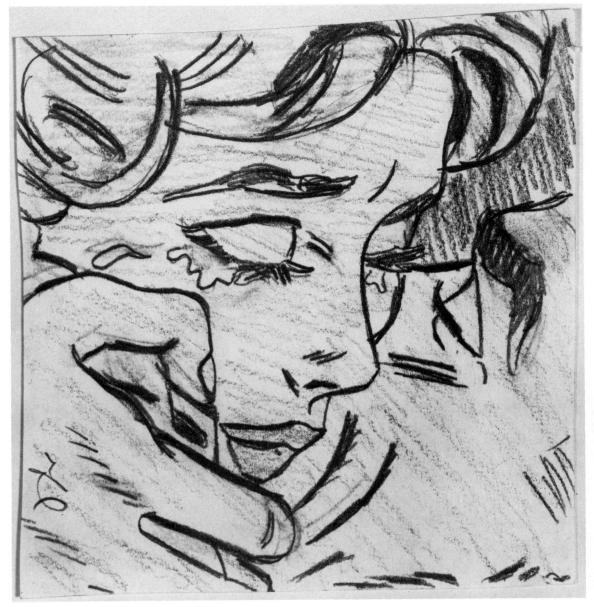

In some of his later drawings, Lichtenstein suspends usage of the benday pattern as in "Entablature #11," 1971. Here, rigidly controlled black pencil lines are used to make a series of verticals and arcs, which are actually shadows rather than positive forms. By implication, he suggests the dimension and weight of the architectural decoration.

Roy Lichtenstein Drawing for Kiss V. 1964. Pencil, 5¾ × 6. Courtesy Leo Castelli, Collection of Linda Stewart. Photo by Shunk Kender.

Roy Lichtenstein Entablature # 11. 1971. Pencil, 21 × 72. Courtesy Leo Castelli. Photo by Eric Pollitzer.

Ellsworth Kelly (Newburgh, N.Y., 1923—)

Ellsworth Kelly began drawing plants in Paris in 1949 but not until 1957 did they become important subjects for investigation along with the abstractions of his paintings. In a pure "contour" drawing, "Avocado," 1967, the overlapping planes indicate depth and volume, but the drawing remains an essentially flat pattern. The pencil line is fairly even throughout the drawing, with only slight variations caused by the shift of the pencil point and the pressure exerted.

Ellsworth Kelly Avocado. 1967. Pencil, 29 × 23. Courtesy Sidney Janis Gallery. Photo by Geoffrey Clements.

Larry Rivers (New York, 1923—)

This early drawing by Larry Rivers of his friend, the poet Frank O'Hara, is an example of his mature drawing style. A light sketchy line is contrasted with darker lines built up by repeated pencil overlays; smudges and erasures change the color values of the pencil strokes and create interesting textures, shifting light effects, and movement in the drawing. These techniques derived from expressionist art effectively capture the intense romantic spirit of the poet.

Larry Rivers Frank O'Hara Seated, Hands Clasped. 1956. Pencil, 18 × 14¼. Courtesy Marlborough Gallery, Inc. Photo by O. E. Nelson.

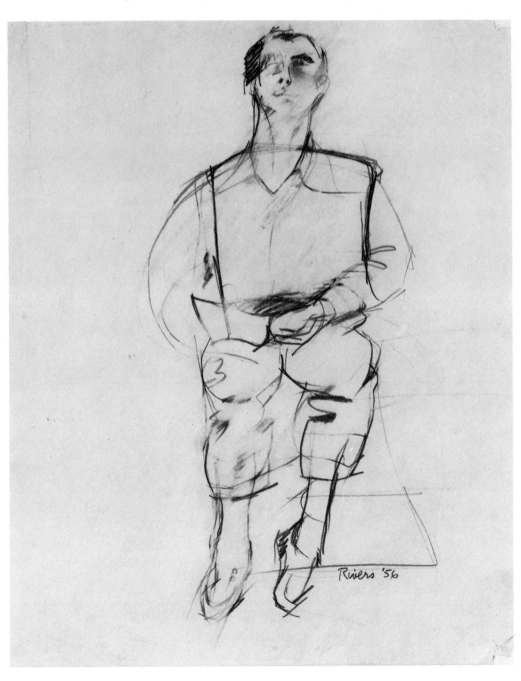

Robert Beauchamp Untitled. 1964. Charcoal and pencil, 18⅞ × 24. Courtesy Private Collection. Photo by O. E. Nelson. ▲

Robert Beauchamp Untitled. 1972. Pencil and watercolor, 36½ × 75⅞. Courtesy Dain-Schiff Gallery. ▶

Robert Beauchamp (Denver, 1923—)

Robert Beauchamp's world is populated by myriad ambiguous animal and human forms that serve to remind us of man's primordial urges existing beneath the veneer of modern civilization. In the 1964 drawing, the apes, horses, and chimerical figures, like wry asides on art history, are unmistakably related to the classic form of the female torso. This dramatic *Walpurgisnacht* is drawn with lively but controlled charcoal and pencil outlines augmented by a watercolor wash. The drawing of 1972 is a rampant Dionysian display of gnomes, maenads, and nymphs which make a striking contrast to the rather simply drawn objects of daily life sprinkled through the composition.

Philip Pearlstein (Pittsburgh, 1924–)

In 1958–59 Philip Pearlstein spent a year in Italy on a Fulbright Fellowship. In Rome he produced a series of wash drawings of the Palatine ruins which he later used as studies for paintings. The cursory use of wash and the broken outline portray these arches set in a shallow space in a manner reminiscent of the abstract expressionists. Dappled light is produced by the varying densities of wash and white paper surface—a technique Pearlstein later brought to the figure drawings for which he is noted.

In "Seated Female Model, Leg Over Chair Arm," 1971, Pearlstein shows a subtle use of broken line to define transitions of light and dark and shifts in the movement of planes. The light falls over the figure from above, producing shadows which are drawn with a tightly compressed, undulating line that provides an effective contrast to the relaxed, casual appearance of the model.

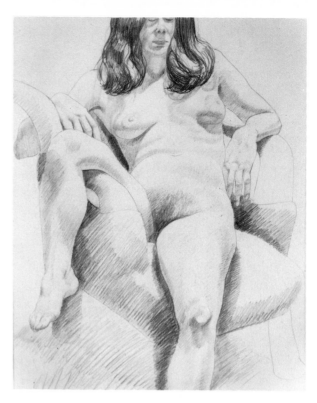

Philip Pearlstein Seated Female Model, Leg Over Chair Arm. 1971. Pencil, 18⅞ × 23⅞. Courtesy Allan Frumkin Gallery. Photo by Eric Pollitzer.

Philip Pearlstein Palatine # 14. 1959. Wash, 20¼ × 27¼. Courtesy Allan Frumkin Gallery. Photo by Eric Pollitzer.

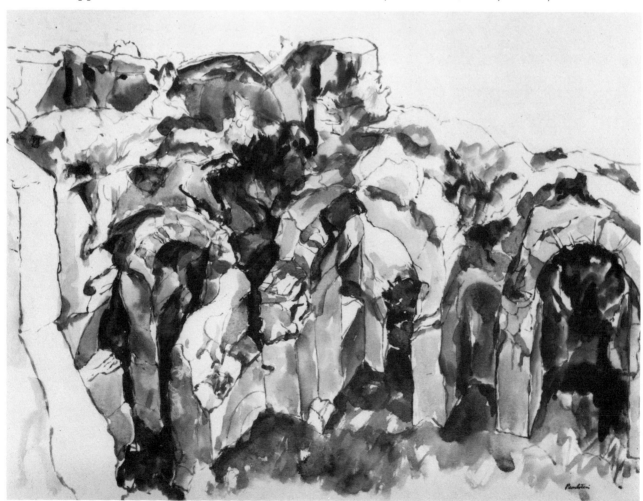

Robert Rauschenberg (Port Arthur, Texas, 1925–)

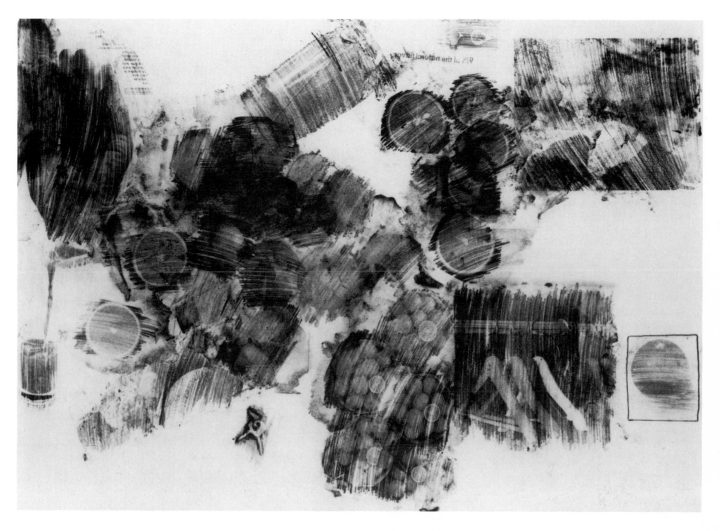

Robert Rauschenberg Battery. 1965. Mixed media, 24 × 36. Courtesy Leo Castelli.

The consistency of concept in Robert Rauschenberg's mature drawings is as remarkable as their resemblance to his paintings and prints. Much of his work reflects expressionist gestures, the shallow space seen in many American paintings of the 1950s, and the techniques of collage. In this combine drawing, he has transferred panels of color by offprinting from newspaper and magazine illustrations; he transforms these everyday images by printing the photograph images in reverse through a transfer method which results in patterns created by the movement of his hand. For all their apparent looseness of execution, these drawings are tightly structured over a grid reminiscent of those found in the work of Hans Hofmann or Josef Albers.

169

Jack Youngerman (Webster Groves, Mo., 1926—)

In this ink and brush drawing, "Dec. 3, 1964," Jack Youngerman is concerned with the balancing of suspended, contained weights consisting of bold shapes and carefully considered edges.

The untitled watercolor drawing of 1972 represents the mature development of this concept. The secure execution of the image and its careful placement on the page indicate that it may be either a study for a specific painting or a presentation drawing. The controlled edges dramatize the long flowing rhythms and sharpen the accents of the repeated short arcs. Youngerman exploits the ambiguity of the figure-ground relationship to enliven the graphic statement.

Jack Youngerman Untitled. 1972. Watercolor, 23 × 29. Courtesy Pace Gallery. Photo by Al Mozell. ▼

Jack Youngerman Dec. 3, 1964. 1964. Ink, 23⅜ × 29¼. Courtesy Pace Gallery. Photo by Rudolph Burckhardt. ▲

170

Constance pregnant almost 4 months April 4-1970 #3

Alfred Leslie (New York, 1927—)

After a successful experience with abstract expressionism in the 1950s and early 1960s, Alfred Leslie turned to monumental single figure paintings, often portraits. In this elegant, smudged charcoal-wash and pencil drawing, the artist has placed the figure slightly below the center of the page so that the viewer sees the model's profile as a horizon line. Light pours gently over the reclining form, whose sensuous appeal is expressed through the subtle modulations of delicate pencil and charcoal hatching which form a contrast to the harsher strokes of the blanket.

Alfred Leslie Constance Pregnant Almost 4 Months. 1970. Charcoal and pencil, 30 × 40. Courtesy Mr. and Mrs. Robert C. Scull. Photo by Eric Pollitzer.

171

Sol LeWitt (Hartford, Conn., 1928—)

Though they are hand-drawn, there is little of the artist's individual personality expressed in the mechanical patterned line drawings of Sol LeWitt. Following a pre-arranged plan, these drawings are executed on walls or other surfaces by himself or his assistants. The ruled lines in each panel produce textures or indicate directional movement, and variations and pattern reversals are accumulated to compose large areas. "Wall Markings," 1969, is a typical example of his basic methodology. The 1972 drawing on the wall done for the Spoleto Festival in Italy introduces the use of arcs and broken lines, all of which function within a rigid grid system. In 1973, LeWitt produced a series of folded and torn paper drawings in which the patterns catch the light in the rough textures produced by the folding or tearing.

Sol LeWitt Folded Paper Drawing. 1973. Folded paper, 13 × 13. Courtesy Private Collection. Photo by O. E. Nelson. ◀

Sol LeWitt All Possible Crossing Combinations of Arcs, Straight Lines, Lines Not Straight, and Broken Lines. 1972. Chalk on painted wall, Spoleto. Photo by Fotocine, Lucarini.

Sol LeWitt Wall Markings. 1969. Ink. Courtesy John Weber Gallery. ▼

172

Robert Indiana (New Castle, Ind., 1928–)

This 1966 frottage drawing, part of Robert Indiana's Great American Dream Series, was made by placing a sheet of paper over the object and briskly rubbing it with conté crayon to produce the design. The richly textured surface is created by slight variations in pressure and length of line. This drawing is essentially an elegant surface pattern with little or no interest in the subject matter—characteristic of much American art of the 1960s.

Robert Indiana The Great American Dream: Freehold. 1966. Conté crayon, 40 × 26. Courtesy The Artist, Collection of William Katz. Photo by Eric Pollitzer.

174

Nathan Oliveira (Oakland, Cal., 1928—)

The persistence of expressionism in the work of California artists is exemplified by the drawings of Nathan Oliveira. The 1960 depiction of a reclining figure contrasts a delicate line used for the bed and legs against a heavy choppy line which obscures the face and defines some of the background.

The 1969 drawing "Head," from the Miramar Series, demonstrates the artist's increased control of his materials; the dense lithography ink applied to the hard surface of the transfer paper produces a variety of fluid textures. The stark fragmented image is an essential element of Oliveira's style.

Nathan Oliveira Reclining Female Nude. 1960. Pencil, ink, and crayon, 13½ × 16¼. Courtesy The Artist. Photo by Schopplein Studio. ▲

Nathan Oliveira Miramar Series: Head. 1969. Lithographic ink, 30 × 22. Courtesy The Artist. Photo by Schopplein Studio. ►

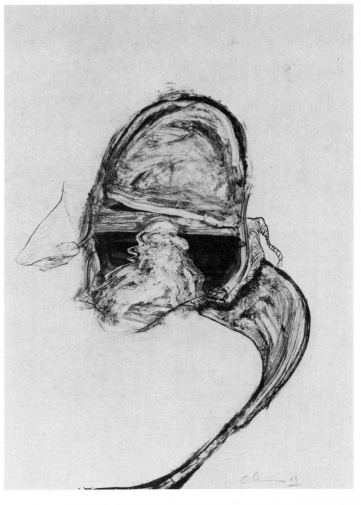

Claes Oldenburg (Stockholm, 1929—)

In the late 1950s the kinetic qualities of Claes Oldenburg's mature style were already apparent in drawings such as "Pat from Behind in Lenox Studio," 1959. The soft pleasing line seeps in, out, and around objects, being either specific or suggestive.

The 1965 drawing for one of the artist's colossal monuments, which, in spite of their subjects, are in the grand tradition of fantasy architecture, is done with the same moving line. The image is established on the page with lines indicating perspective; its form is enriched with contrasting tones of watercolor; the surface is enlivened by small dots, arcs, squiggles, and other unconscious incidental graphic elaborations.

In 1969 *Time* Magazine commissioned Oldenburg to design a cover which remains unpublished. The drawing is a rare self-portrait in which the collage of his freely drawn face contrasts with the mechanically drawn images on the graph paper.

"Proposal for Colossal Structure in the Form of a Sink Faucet for Lake Union, Seattle, Washington," 1972, skillfully combines mechanical with free-hand drawing. Oldenburg transforms an everyday object through a monumentality of concept and classically refined drawing.

Claes Oldenburg Proposed Colossal Monument, Good Humor for Park Avenue. 1965. Crayon and wash, 23½ × 17½. Courtesy Sidney Janis Gallery, Collection of Carroll Janis. Photo by Geoffrey Clements. ►

Claes Oldenburg Pat from Behind in Lenox Studio. 1959. Crayon, 14 × 16½. Courtesy The Artist. Photo by Nathan Rabin. ▼

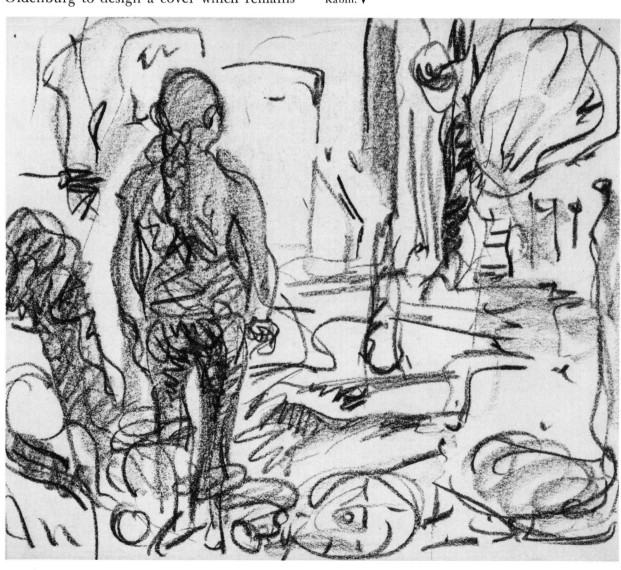

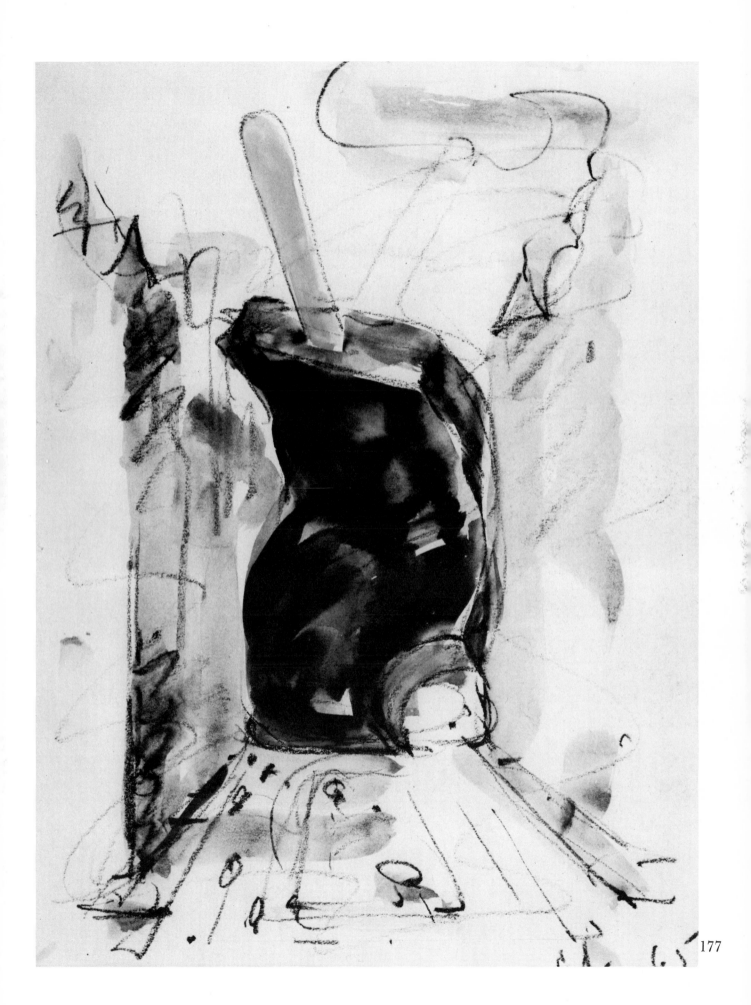

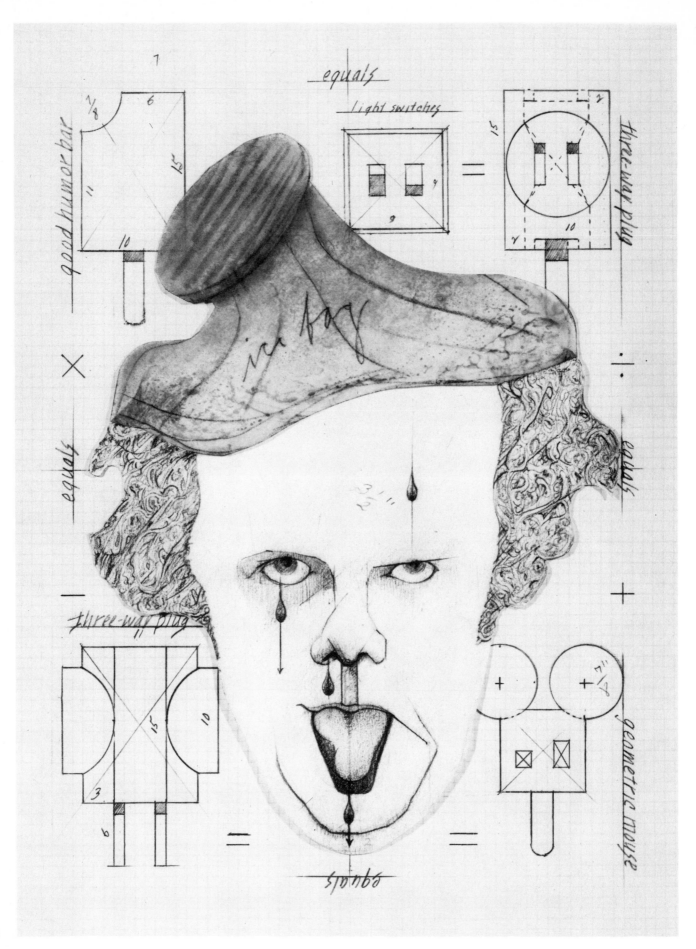

equals

light switches

good humor bar

three-way plug

ice bag

equals

equals

three-way plug

geometric mouse

equals

Lake Union, Seattle, Wash.

CO. 1972

Claes Oldenburg Self Portrait for Time Magazine Cover Not Used. 1969. Pencil and spray enamel, 11 × 8¼. Courtesy The Artist and Sidney Janis Gallery. Photo by Geoffrey Clements. ◄

Claes Oldenburg Proposal for Colossal Structure in the Form of a Sink Faucet for Lake Union, Seattle, Wash. 1972. Crayon, pencil, and watercolor, 28⅞ × 22⅓. Courtesy The Artist. Photo by Nathan Rabin. ▲

179

Cy Twombly (Lexington, Va., 1929—)

The drawings of Cy Twombly have always maintained a close affinity with the rhythmic gestural forms of handwriting. Scattered numbers, letters, and Spencerian letter-forming rituals combine into indications of a pseudo-language. The metamorphosis of these letters and symbols into cryptic ciphers differs radically in intent from the use of direct words by artists such as Claes Oldenburg, Stuart Davis, or Jasper Johns. The lettering gesture and its line produces an all-over evocative pattern of suggestion, rather than direct statement. It is this ambiguous pattern rather than the drawing of letters into specific words that is the essence of Twombly's image.

Cy Twombly Untitled. 1971. Mixed media, 31¼ × 30. Courtesy Leo Castelli. Photo by Eric Pollitzer.

Deborah Remington (Haddonfield, N.J., 1930—)

Contradictions and emblematic images are employed by Deborah Remington in her drawings and paintings. In this drawing from her 1971 Adelphi Series, straight edges are countered by articulated lines; forms molded by tonal shifts are juxtaposed with those created by outline; floating images abut anchored shapes. Movement is suggested by the use of the push-pull counterbalance principle.

Deborah Remington Adelphi Series. 1971. Crayon and pencil, 11⅛ × 12⅞. Courtesy The Artist. Photo by O. E. Nelson.

James McGarrell Untitled.
1971. Pencil, 22½ × 14¾. Cour-
tesy Allan Frumkin Gallery.
Photo by Eric Pollitzer.

James McGarrell (Indianapolis, 1930–)

Drawings are visualizations of ideas and images; they can be unique expressions or steps in the development of other works— paintings, sculptures, or prints. In this untitled fantasy drawing, James McGarrell accumulates disparate images upon a page in a suspended Joycean still-life. A gray light pervades this image which is tightly packed into a shallow airless space. McGarrell maintains his stylistic statement even when the techniques vary. The extensive range of textures is reminiscent of his printmaking experiences. Its enigmatic theme provokes exploration of this surreal meeting of strange objects and personages in an ambivalent chamber.

Andy Warhol (Pittsburgh, 1930—)

The controversial and public aspects of pop art have often obscured the important visual contributions of the artists in the movement. Andy Warhol's wit is evident in this pencil portrait of a ten-dollar bill, which demonstrates his ability to present his subject matter in a clean, clear style. The quality of the line in the drawing suggests the engraver's method of representation.

Andy Warhol Ten Dollar Bill. 1962. Pencil, 15¾ × 24. Courtesy Jonathan D. Scull. Photo⸱ by Eric Pollitzer.

183

Jasper Johns (Augusta, Ga., 1930–)

Jasper Johns Broken Target. 1958. Conté crayon, 15½ × 15. Courtesy Leo Castelli, Collection of Mr. and Mrs. Ben Heller. Photo by Rudolph Burckhardt. ▼

Jasper Johns According to What. 1969. Graphite, 29¾ × 41¼. Courtesy Leo Castelli. Photo by Rudolph Burckhardt.

In the early drawing "Broken Target," 1958, Jasper Johns's mature gestural line is already evident. The easy flowing line is condensed, increasing the textural differentiations of the planes or the balance of the composition. The use of conté crayon enables Johns to maintain the quality of individual lines. This method relates directly to his painting technique of accumulating a network of strokes rather than areas of blended tonal contrasts.

Johns produces drawings both before and after the completed work to which they re-late. In his iconography, Johns maintains a dialogue with art history, with references to his own past work and to the works of other artists. An example of this is "According to What," 1969, which incorporates an annotated profile from a Marcel Duchamp self-portrait and fragments from Johns's previous paintings. Like a still-life painter, he rearranges his objects—stencil letters, rubber stamps, theatrical color slides, a wire coat hanger, and panels of gray tones—and knits them together in a subtle combination of lines over a geometric grid.

Robert Morris (Kansas City, Mo., 1931–)

During the twentieth century the shapes of letters, with or without reference to their meaning as words, have been used by many artists as subject matter, either in handwritten form as in the work of Allan Kaprow or Claes Oldenburg, or in stenciled form as used by Robert Indiana or Jasper Johns. Robert Morris's "Memory Drawing," 1963, is one of a series of programmatic drawings which utilize the same text but differ from each other in the quality of the handwriting, the amount of ink in the pen, and the physical exhaustion of the artist.

Morris also produces drawings related to his individual sculptures. "Ottawa Project," 1970, is a catalogue of the elements to be used in a monumental outdoor work, with written instructions an integral part of the visual ideas expressed in simple line drawings.

The physiological basis for memory has not been determined. Theories advanced to explain memory fall mainly into two classes: (1) Those which seek explanation in changes in composition of the brain cells; and (2) those which seek explanation in changes in patterns of electrical currents between cells. If one leaves the analogy at a crude level, comparisons can be made to the two basic ways in which man establishes a cultural memory, i.e. either spatially through preservation of models, pictures, maps, etc., or temporally through sequential records in print, audial recordings, and more recently by electronic means. Theories have also been advanced which attempt to combine these two processes. Such theories attempt to discriminate between types of memories, assigning the coding of some to physical alteration of the molecular structure of brain cells and others to reflex electrical circuits. The latter process is sometimes appended with a hypothesis of a mechanical nature, viz. through minute changes of synaptic fibers which grow larger or closer together and facilitate electrical pathways. Analog computing machines can be made to learn - a process impossible without storage of information. This storage is effected by specific variations in a time series together with a scanning device. Recent investigations in electroencephalography seem to point to such a scanning mechanism responsible for oscillating currents which tend to fade with concentration and attention. However the storing of visual images can be more easily ascribed to protein molecule alterations. All suggestions as to the locus of memory, either in terms of composition or action agree on the point that it is not held in any specific area of the cortex. Decimations of the cortex do not cut out particular memories, but the severing of neural pathways between the visual cortex and the frontal regions, while not disturbing vision, reduces to the unrecognizable that which is seen. The richness of and necessities for the interconnections of all parts of the cortex will undoubtedly be part of whatever theory is eventually established.

Drawing established and memorized 9/5/63, 8 pm. R. Morris

Lee Bontecou (Providence, R.I., 1931–)

Lee Bontecou Untitled. 1962. Pencil and soot, 36¾ × 60.
Courtesy Leo Castelli. Photo by Rudolph Burckhardt.

The drawings of sculptor Lee Bontecou are done on raw muslin in pencil and soot, a method which enables her to achieve a rich variety of blacks. Although the drawings relate directly to the images in her sculpture, they are not necessarily studies for specific pieces, but rather drawings produced either for their own sake or as a method of increasing the range of her imagery. Cylindrical pipes with gaping orifices, and biomorphic forms derived from modern aerodynamics merge to produce a forceful visual statement.

Tom Wesselmann (Cincinnati, 1931—)

Tom Wesselmann, like many of the pop artists, is a still-life painter of considerable invention. An early work, "Drawing for Still-Life No. 35," 1963, presents a close-up view of kitchen objects against a background window which, opening onto a dimly suggested landscape containing an airplane, introduces space into the dense frontal composition. Images are defined by distinct outlines and shapes richly modeled with both delicate charcoal washes and bold hatching.

A typical Wesselmann nude is used as a frame for the richly worked still-life in "Drawing for Nude on a Couch," 1971. Wesselmann uses evenly modulated tones of charcoal wash in describing the figure as a foil for the dense textured quality of the still-life and the house in the background.

Tom Wesselmann Drawing for Still-Life No. 35. 1963. Charcoal, 30 × 48. Courtesy Sidney Janis Gallery. Photo by Geoffrey Clements.

Tom Wesselmann Drawing for Nude on a Couch. 1971. Charcoal, 41¾ × 96. Courtesy Sidney Janis Gallery. Photo by Eric Pollitzer.

Jack Beal (Richmond, Va., 1931–)

In the mid-1960s Jack Beal produced a series of charcoal drawings to study problems of light, texture, and design. An example of this series is "Wooden Construction," in which the bold composition counters the soft design of the wood's grain. Beal's controlled drawing of the refined finish of the armchair is an effective contrast to the texture of the raw wood and the patterns of the delicate shadows.

Beal's success as a portraitist is clear in this introspective un-flattering "Self-Portrait" of 1972. The dynamic use of a diagonal line moving from left to lower right forces us to focus our attention on the face. The drama of the composition is enhanced by the cold light pouring over the figure's shoulder. By partially eliminating the features on one side of the face in dark shadows, the artist increases the sense of honest and penetrating self-perception.

Jack Beal Wooden Construction. 1964. Charcoal, 19 × 24. Courtesy Allan Frumkin Gallery. Photo by Eric Pollitzer.

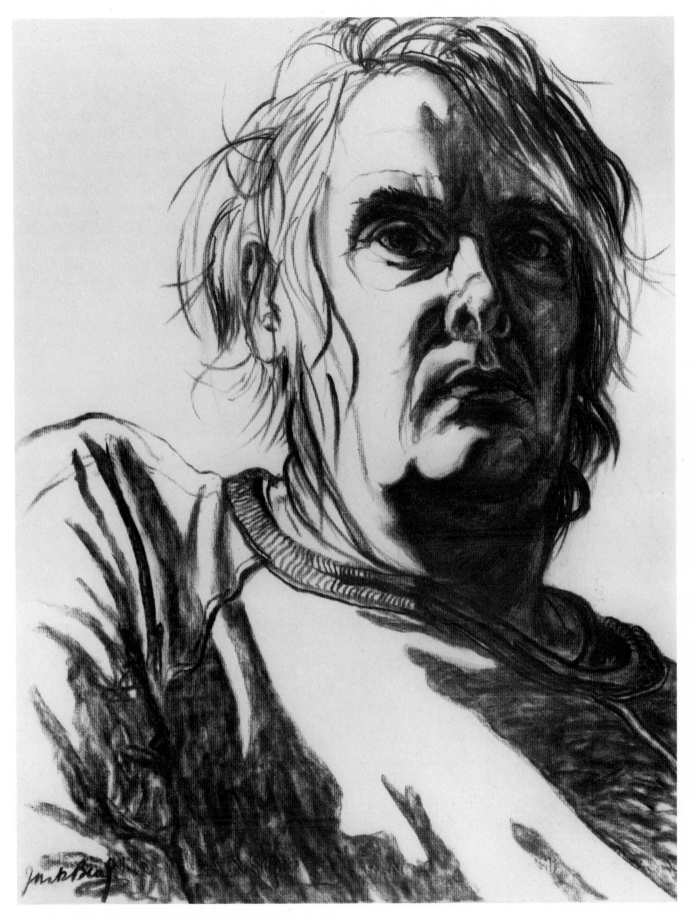

Jack Beal Self-Portrait (Worked Up). 1972. Charcoal, 25½
× 19½. Courtesy Allan Frumkin Gallery. Photo by Eric Pol-
litzer.

191

Mark Di Suvero (Shanghai, China, 1933—)

Sculptors often use drawing to set down their ideas, rarely pursuing the refinements of drawing for its own sake. Di Suvero exhibits this tendency here, rendering the thrust and dynamics of this sculpture by indicating the inter-relationships of the massive forms. He does not state the individual characteristics of each beam or timber: that is irrelevant to the realization of the sculpture. This large drawing captures the space-shape relationships in sweeping gestures, but still remains a sketch in terms of its intended function and in its style.

Mark Di Suvero Untitled. 1972. Ink, 44½ × 46⅛. Courtesy Rijksmuseum Kröller-Müller.

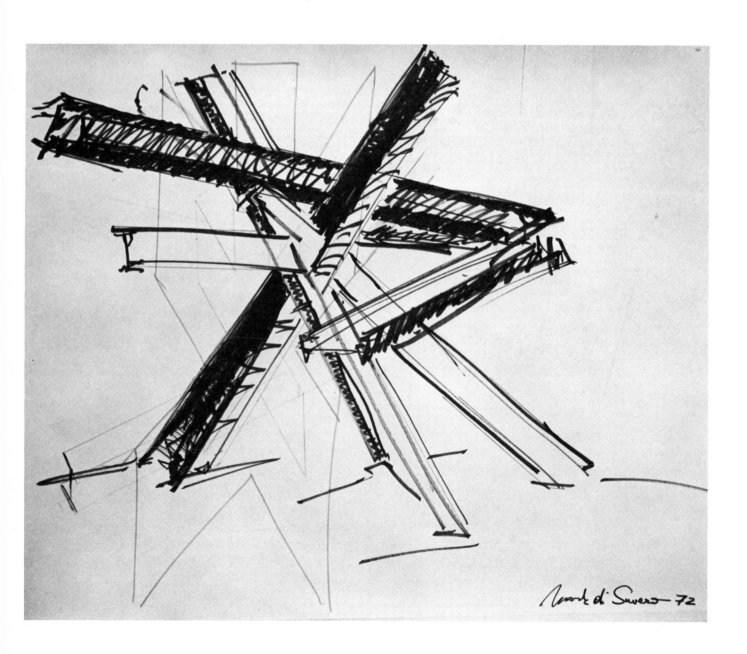

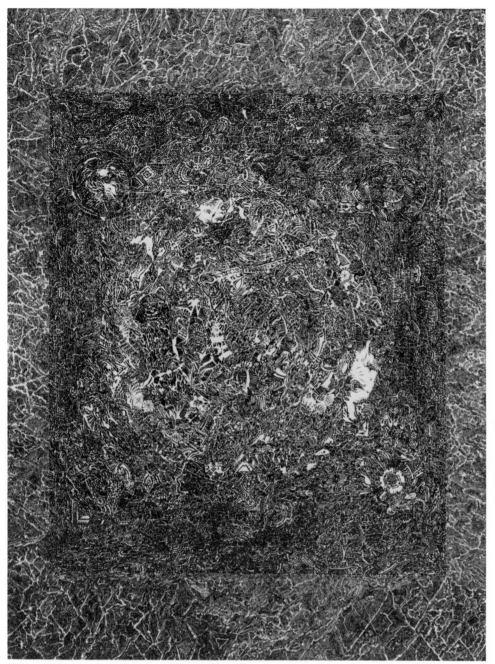

Bruce Conner 23 Kenwood Avenue. 1963. Ink, 26 × 20. Courtesy Private Collection. Photo by O. E. Nelson.

Bruce Conner (McPherson, Kansas, 1933—)

Our success in "reading" or accurately describing a drawing often requires a statement of intent from the artist himself, yet it is occasionally true that the observations and alternative interpretations of others will add much to our understanding of the work. An example of this is "23 Kenwood Avenue," 1963, an ink and crow-quill drawing by Bruce Conner. This composition can be observed as a flat patterned intarsia image, or interpreted as, in the artist's words, "a study of positive and negative space set forth in a marvelous array of lines." The structure of the drawing can also be described as a mandala—which the writer Nancy Wilson Ross defines as "a diagrammatic picture used as an aid in meditation or ritual; sometimes a symbol of the universe, or a representation of a deed of merit." The choice of a mandala structure and its complex enrichment proclaim the artist's desire to produce a contemplative icon.

193

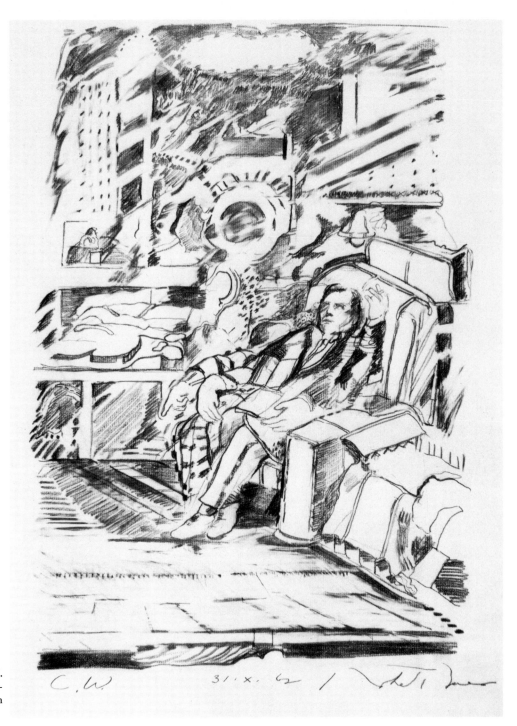

Robert Barnes Portrait of C. W. 1962. Pencil, 25½ × 19¾. Courtesy The Museum of Modern Art, Ethel R. Scull Fund.

Robert Barnes (Washington, D.C., 1934–)

"Portrait of C.W.," 1962, a pencil drawing by Robert Barnes, shows a Vishnu-like subject set in a room of scintillating lights, before a highly patterned background. While the objects are closely observed, the textures and spatial relationships are drawn in an allusive, ambiguous manner which obscures an easy reading of the subject. This richly embellished interior with its enigmatic overtones is drawn with authority.

194

Jim Dine (Cincinnati, 1935—)

Jim Dine's "Self-Portrait with Day-Glow #4," 1964, is executed with a relaxed, skillfully handled line, which moves over a roughly textured paper. A charcoal wash gives weight to what would otherwise be a simple line drawing. The wire coat hanger brings a third dimension to the drawing, casting a real, but changing, shadow which resembles the drawn line. The robe seems animated and full of personality in this simple pleasing work.

Jim Dine Self-Portrait with Day-Glow #4. 1964. Wash, charcoal, and collage, 34½ × 26. Courtesy Sidney Janis Gallery. Photo by Oliver Baker.

Christo (Gabrovo, Bulgaria, 1935—)

Christo Wrapped Coast (Project). 1969. Pencil and charcoal, 23⅝ × 29⅛. Courtesy The Artist, Collection of Meshulam Riklis. Photo by Shunk Kender.

The projects of Christo require extraordinary planning, so he develops his ideas in series of small sketches with larger drawings and photo collages of the actual sites. He then has these incorporated into mechanical drawings which are produced under his direction by consulting engineers. This drawing, "Wrapped Coast," 1969, shows the land transformed into new bulky shapes by being wrapped in soft flowing fabric. Relying on the tonal difference between pencil and charcoal, he is able to differentiate the fabric from the network of ropes hiding the natural shape of the seacoast.

Sidney Goodman (Philadelphia, 1936—)

The ominous overtone suggested in this charcoal drawing, "Woman with Legs Raised," 1967, by Sidney Goodman is strengthened by his formal presentation of the figure in an ambiguous geometric setting. His stark point of view is dramatized by a cold direct light which creates strong shadows that swallow up the form. The ab- stract structure of the drawing makes overt literary associations impossible, and though the method of drawing is somewhat academic, the overall impression remains boldly menacing.

Sidney Goodman Woman with Legs Raised. 1967. Charcoal 29¾ × 25¾. Courtesy Terry Dintenfass, Inc., Collection of Mr. and Mrs. Bernard Green. Photo by John D. Schiff.

197

Larry Zox (Des Moines, 1936—)

Larry Zox's use of graph paper in this study for a painting in the "Big Bang Series" is both practical, as a means of transferring the design for the final painting, and aesthetic, in its contribution of texture, color, and compositional elements. The basic proportional division is elaborated from the two mid-tip-touching horizontal diamonds and the central horizontal line which divides the four vertical panels to produce eight small horizontal rectangles which are inter-divided into triangles. The illusion of the reversal of the two horizontal planes is nullified by the unpainted lines which control the central unpainted horizontal line which cannot be directly repeated. Here the use of the grid system substructure has not prohibited the production of an excellent drawing.

Larry Zox Big Bang Series. 1965–1966. Pencil and crayon, 17 × 22. Courtesy Kornblee Gallery. Photo by Jay Cantor.

"BANG series" Zox 65-1966

Lucas Samaras (Kastoria, Greece, 1936—)

Lucas Samaras Large Drawing #4. 1966. Colored pencil and ink, 17 × 14. Courtesy Pace Gallery, Private Collection. Photo by Ferdinand Boesch. ◄

Lucas Samaras Cut Paper Drawing #37. 1968. Cut paper, 23 × 18. Courtesy Pace Gallery. Photo by Ferdinand Boesch.

The self-investigations of Lucas Samaras have required the use of movie and still cameras, room reconstructions, photographs, and the X-ray, which was the basis for "Large Drawing #4," 1966. The self-portrait aspects of this drawing seem to be more clearly expressed in the Byzantine obsessiveness of the woven patterns than in the skeletal profile of the head.

A stark contrast to this portrait is "Cut Paper Drawing #37," 1968, in which the negative and positive profiles both project or recede from the picture plane with ambiguous ease. Modernizing an eighteenth-century French technique, the artist cuts the silhouette line through the paper to make panels of white light against the black background.

201

Edward Ruscha (Omaha, 1937—)

Ed Ruscha constructs his word models with standing ribbons of paper held in place with straight pins. Transformed by light and ambiguous scale, these letters have become monuments in the grainy desert sands, or perhaps letters from a game spilled out upon a carpet. The line is simply an edge, highlighted by the controlled use of gunpowder, which produces a silky texture in contrast to the paper's rough surface. Ruscha isolates words, treating them singly as signs in deep illusionistic space, rather than as word or dialogue fragments, as other artists so frequently do.

Edward Ruscha Motor. 1970. Gunpowder, 23 × 29. Courtesy Stephen Mazoh.

Larry Poons (Tokyo, 1937—)

The size and direction of the ovals and circles in Larry Poons's op paintings from the early 1960s were charted on graph paper. He used the grid system to program the color vibrations of the painting and, with these graphic devices, estimated the location of the ghost images they produce. Later he rejected this confined structure and patterning in favor of a method of direct application of thick paint of pastel hue which no longer required preparatory drawings.

Larry Poons Untitled. n.d. Ink. Courtesy Richard Bellamy.

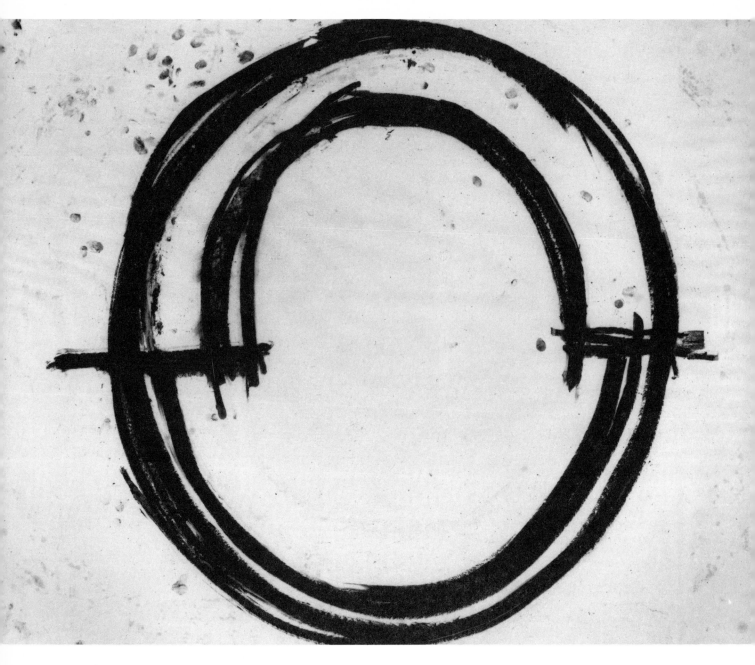

Richard Serra (San Francisco, 1939—)

The powerful primary images of Richard Serra's sculptures are evoked also in his drawings. The form is forced into the page with its quickly applied thick hard line. The mottled page declares his disaffection for a tradition demanding refined finishes for drawings. This image can be read as a circle containing facing arcs or as a central shape composed of two abutting semi-circles of different dimensions. This major drawing served as a study for a print made the same year.

Richard Serra Untitled. 1972. Charcoal and paintstick, 31 × 42½. Courtesy Leo Castelli. Photo by Eric Pollitzer.

204

Selected Bibliography

Agee, William C. *Synchronism and Color Principles in American Painting 1910–1930*. New York: M. Knoedler and Co., Inc., 1965.

Alloway, Lawrence. *American Drawings*. New York: Solomon R. Guggenheim Foundation, 1964. Preface by Thomas M. Messer.

Ashton, Dore. *One Hundred Contemporary American Drawings*. Ann Arbor: The University of Michigan Museum of Art, 1965. Foreword by Albert Muller.

Baro, Gene. *Claes Oldenburg: Drawings and Prints*. Lausanne: Publications I.R.L., 1969.

Brown, Milton. *American Painting from the Armory Show to the Depression*. Princeton: Princeton University Press, 1970.

———. *The Story of the Armory Show*. New York: The Joseph H. Hirshhorn Foundation, 1963.

Bucher, Francois, and Albers, Josef. *Despite Straight Lines*. New Haven: Yale University Press, 1961.

Burchfield, Charles. *CB His Golden Year*. Tucson: University of Arizona Press, 1965. Foreword by William E. Steadman.

———. *The Drawings of Charles Burchfield*. New York: Frederick A. Praeger in association with The Drawing Society, 1964. Preface by James Biddle.

Burton, Naomi; Hart, Brother Patrick; and Laughlin, James, eds. Chakravarty, Amiya, consulting ed. *The Asian Journals of Thomas Merton*. New York: A New Directions Book, 1973.

Cubism: Its Impact in the USA 1910–1930. Albuquerque: University of New Mexico Art Museum, 1967.

David Park Memorial Exhibition: The University Years 1955–1960. Berkeley: University of California Press, 1964. Preface by Paul Mills.

Drawings of Joseph Stella from the Collection of Rabin and Krueger. Newark: Rabin and Krueger Gallery, 1962. Preface by William H. Gerdts.

Goodrich, Lloyd. *Pioneers of Modern Art in America*. New York: Whitney Museum of American Art, 1946.

———. *The Decade of the Armory Show: New Directions in American Art 1910–1920*. New York: Whitney Museum of American Art, 1963.

———. *Edwin Dickinson*. New York: Whitney Museum of American Art, 1965.

Goodrich, Lloyd, and Bry, Doris. *Georgia O'Keeffe*. New York: Whitney Museum of American Art, 1970.

Goossen, E. C. *Ellsworth Kelly*. New York: The Museum of Modern Art, 1973.

Graham, John D. *System and Dialectics of Art*. New York: Delphic Studios, 1937.

Huber, Carlo. *Fritz Glarner*. Bern: Kunsthalle Bern, 1972. Preface by Max Bill.

Hayes, Bartlett H., Jr. *The American Line: 100 Years of Drawing*. Andover: Addison Gallery of American Art, 1959.

———. *American Drawings*. New York: Shorewood Publishers, Inc., 1965.

Henderson, Helen W. *Thomas Anshutz Memorial Exhibition*. Philadelphia: Philadelphia Art Alliance, 1942.

Homer, William Innes. *Robert Henri and His Circle*. Ithaca: Cornell University Press, 1969.

John Sloan. Boston: Boston Book and Art, 1971. Foreword by Helen Farr Sloan.

Johnson, Una E. *20th Century Drawings: Part II: 1940 to the Present*. New York: Shorewood Publishers, Inc., 1964.

Kelder, Diane, ed. *Stuart Davis*. New York: Praeger Publishers, 1971.

Lee, Katharine C. *John LaFarge: Drawings and Watercolors 1835–1910*. Toledo: *Museum News* (New Series), Vol. II, No. 1, Winter 1968.

MacAgy, Douglas. *Plus by Minus: Today's Half-Century*. Buffalo: Albright-Knox Art Gallery, 1968. Preface by Gordon M. Smith.

Marin, John. *John Marin: Drawings and Watercolors*. New York: The Twin Editions, 1950.

McCausland, Elizabeth. *Marsden Hartley*. Minneapolis: University of Minnesota, 1952. Foreword by H. Harvard Arnason.

Medford, Richard Carl. *Guy Pène du Bois*. Hagerstown: Washington County Museum of Fine Arts, 1940.

Mendelowitz, Daniel M. *Drawing*. New York: Holt, Rinehart and Winston, Inc., 1967.

Millier, Arthur. *Henry Lee McFee*. Claremont: The Fine Arts Foundation of Scripps College, 1950. Foreword by Frederick Hard.

Mitchell, William J. *Ninety-Nine Drawings by Marsden Hartley 1877–1943*. Lewiston: Bates College Art Department, 1970.

Morse, John D., ed. *Ben Shahn*. New York: Praeger Publishers, 1972.

Morse, Peter. *John Sloan's Prints*. New Haven: Yale University Press, 1969. Foreword by Jacob Kainen.

Reich, Sheldon. *John Marin Drawings 1886–1951*. Salt Lake City: University of Utah Press, 1969. Foreword by E. F. Sanguinetti.

Rickey, George. *Constructivism: Origins and Evolution*. New York: George Braziller, 1963.

Sachs, Paul J. *Modern Prints and Drawings*. New York: Alfred A. Knopf, 1954. Preface by Alfred H. Barr, Jr.

Slatkin, Charles E., and Shoolman, Regina. *Treasury of American Drawings*. New York: Oxford University Press, 1947.

Sloan, John. *John Sloan Retrospective Exhibition*. Andover: Addison Gallery of American Art, 1938.

Stevens, William B. *Boston Painters 1720–1940*. Boston: Boston University School of Fine and Applied Arts, 1968. Preface by Sidney Hurwitz.

Stuart Davis Memorial Exhibition. Washington, D.C.: National Collection of Fine Arts, 1965. Introduction by H. H. Arnason.

Sweeney, James Johnson. *Stuart Davis*. New York: Museum of Modern Art, 1945.

Thomas Anshutz. New York: Graham Gallery, 1963.

Vigtel, Gudmund. *The New Tradition: Modern Americans Before 1940*. Washington, D.C.: The Corcoran Gallery of Art, 1963. Foreword by Hermann W. Williams, Jr.

When Attitudes Become Form. Bern: Kunsthalle Bern, 1969. Preface by Harold Szeemann.

White, Nelson C. *Thomas W. Dewing 1851–1938*. New York: Durlacher Brothers, 1963. Preface by Lloyd Goodrich.

Wight, Frederick S. *Hans Hofmann*. Berkeley: The University of California Press, 1957. Foreword by John I. H. Baur.

William Baziotes. New York: Solomon R. Guggenheim Museum, 1965. Introduction by Lawrence Alloway.

Knoedler, 78
Koch, John, **131**
Kootz, Sam, 14
Kroll, Leon, 9
Krushenick, Nicholas, 13
Kubota, Beigen, 31
Kuhn, Walt, 10, 11, 13
Kuniyoshi, Yasuo, 13, **84–85**

Labaudt, Lucian, 13n
Lachaise, Gaston, **56–57**
LaFarge, John, 9
Laning, Edward, 42
Lasansky, Mauricio, 13n
Laurens, Jean-Paul, 49
Lebrun, Rico, 13n, **101**
Lefebvre, Jules, 9
Léger, Fernand, 12, 13, 14
Leibl, Wilhelm, 9
Leonardo da Vinci, 142
Leslie, Alfred, **171**
Levine, Jack, **150–51**
Levy, Julien, 14
LeWitt, Sol, **172–73**
Leyendecker, J. C., 10
Lichtenstein, Roy, 93, **162–63**
Lindner, Richard, 13n
Lipchitz, Jacques, 13n
Low, Will H., 9, 10
Luks, George, 10, 24, **27,** 29, 31
Lye, Len, 13n

Macdonald–Wright, Stanton, 10, **76,** 78
Malevich, Kazimir S., 12
Mallarmé, Stéphane, 152
Man Ray, 12
Manet, Édouard, 23
Manship, Paul, 12
Manuel, Florence, 53
Marc, Franz, 11
Marin, John, 10, **28–29**
Marsh, Reginald, **95**
Matisse, Henri, 10, 12, 13, 49, 64, 90, 152, 161
Matta, 13
Matulka, Jan, **77**
McCarter, Henry, 9
McFee, Henry, 11, **68**
McGarrell, James, **182**
Michelangelo, 142
Miller, Kenneth Hayes, 10, 12, 13, **42,** 67, 84, 94, 95, 104
Miró, Joan, 12, 152
Moholy-Nagy, Laszlo, 13n
Mondrian, Piet, 12, 13, 98, 112, 118, 125
Montross Gallery, 12
Morris, Robert, **186–87**
Motherwell, Robert, 14, **152–53**
Mowbray, H. Siddons, 9
Munich school, 9, 16
Murch, Walter, **122–23**
Museum of Modern Art, 12

Nadelman, Elie, 13n, **54–55,** 56
Neoplasticism, 11, 15, 118, 125
Nevelson, Louise, 13
New realism, 14, 15
New York School of Art, 50, 58

New York University, 12
Newman, Barnett, 14
Nivola, Constantino, 13n

O'Hara, Frank, 165
Okada, Kenzo, 13n
O'Keeffe, Georgia, 46, **69–71**
Oldenburg, Claes, 14, **176–79,** 180, 186
Oliveira, Nathan, **175**
Op art, 203
Orozco, José Clemente, 13
Ossorio, Alfonso, 13n
Ozenfant, Amédée, 13, 14

Park, David, **136–37,** 160
Parsons, Betty, 14
Pascin, Jules, 92
Pearlstein, Philip, **168**
Pearson, Henry, **146**
Pennell, Joseph, **21**
Pennsylvania Academy of the Fine Arts, 9, 47
Philadelphia Museum, 12
Phillips Memorial Gallery, 12
Picasso, Pablo, 12, 13, 48, 64, 110, 116, 152
Piloty, Karl von, 9
Pollock, Jackson, 14, **140–41,** 142
Poons, Larry, **203**
Pop art, 183, 189
Porter, Fairfield, **128–29**
Pratt Institute, 82
Precisionism, 61, 115
Prendergast, Maurice, 31

Rauschenberg, Robert, 14, **169**
Regionalism, 11, 74, 80
Rehn Gallery, 12
Reinhardt, Ad, 14
Remington, Deborah, **181**
Remington, Frederic, 10
Renoir, Pierre Auguste, 31
Rivera, Diego, 13
Rivers, Larry, 13, 43, 93, **165**
Rosenberg, Harold, 152
Rosenquist, James, 14
Ross, Denman, 142
Ross, Nancy Wilson, 193
Roszak, Theodore, **124**
Rothko, Mark, 14
Rotterdam Academy of Fine Arts, 106
Ruscha, Edward, **202**
Russell, Morgan, 10, 76

Samaras, Lucas, 14, 142, **200–201**
Sander, Ludwig, 13, **118–19**
Sargent, John Singer, 9, **18**
Scharg, Karl, 13n
School of Paris, 11
Schwitters, Kurt, 12
"Second Post-Impressionist Exhibition," 11
Segal, George, 14
Seligmann, Kurt, 13n
Serra, Richard, **204**
Shahn, Ben, **93**
Sharp-focus realism, 15, 156
Sheeler, Charles, 10, 11, 12, 62, **63–65**

Shinn, Everett, 10, **34–35**
Siqueiros, David Alfaro, 13
Sloan, John, 10, 13, 24, **31–33,** 37, 95
Smith, David, 48, **116–17**
Société Anonyme, 12
Soyer, Raphael, 13, **99–100**
Speicher, Eugene, 12, **62**
Spoleto Festival, 172
Stankiewicz, Richard, 13, 43
Steichen, Edward, 10
Steinberg, Saul, 13n, **146–47**
Steinlen, Théophile, 67
Stella, Joseph, 12, 13n, **38–39**
Sterne, Maurice, 10
Stieglitz, Alfred, 12
Still, Clyfford, 14
Storrs, John, 11
Stout, Myron, **130**
"Structurism," 120
Surrealism, 11, 12, 13, 14, 110, 148, 152, 182
Synchromism, 10, 76

Tanguy, Yves, 13
Taylor, Francis Henry, 15
Tchelitchew, Pavel, 13n
Thayer, Abbott, 9
Thiebaud, Wayne, **156**
Tobey, Mark, 10, **78**
Twombly, Cy, **180**
Tworkov, Jack, **102–103**

University of California, 13

Van Gogh, Vincent, 90
Vantongerloo, Georges, 12
Velázquez, Diego de Silva y, 23
Villon, Jacques, 12
Vicente, Esteban, 13n

Walkowitz, Abraham, 10, **40–41**
Warhol, Andy, **183**
Weber, Max, 10, 49
Webster, Daniel, 80
Weir, J. Alden, 9
Wesselmann, Tom, **188–89**
Whistler, James A. M., 21
Whitney Museum of American Art, 12
Whitney Studio Gallery, 12
Willkie, Wendell, 74
Wood, Grant, **79–81**
Woodstock group, 68
Wyeth, Andrew, **155**
Wyeth, N. C., 10

Yale University, 12
Youngerman, Jack, **170**
Yunkers, Adja, 13n

Zadkine, Ossip, 13, 14
Zervos, Christian, 12
Zimmerman, Harold, 142
Zola, Émile, 60
Zorach, Marguerite Thompson, 10
Zorach, William, 10
Zox, Larry, **198–99**

207